MY TEDDY

BEAR

MY TEDDY

MUSÉE DES ARTS
DÉCORATIFS

BEAR

Edited by
Anne Monier Vanryb

Johannes Huth
President of Les Arts Décoratifs

The toy department of the Musée des Arts Décoratifs was founded in 1975 by its then director, the great François Mathey, who influenced the museum's history through his profoundly open and interdisciplinary vision of the arts, with the help of curator Monica Burckhardt. Since then, the collection has continued to grow and live through many installations, while several exhibitions on toys and the world of childhood have made the Musée des Arts Décoratifs a leader in these fields. The last ten years have seen many successful exhibitions, such as "Barbie" in 2016, "Les Drôles de Petites Bêtes" [The Funny Little Beasts] by Antoon Krings in 2019, and "À la Rencontre du Petit Prince" [Meet the Little Prince] in 2022.

This is why I responded enthusiastically to Museum Director until October 2024 Christine Macel's proposal to hold an exhibition on teddy bears, especially since our collection is so strong in this area. I would like to thank her, along with the current Interim Museum Director, Bénédicte Gady, and Anne Monier Vanryb, the curator of the toy department, who curated the exhibition, for this original idea that looks beyond the toy to study the anthropological roots of the triumph of the teddy bear. This toy evokes our connection to an animal that has become a symbol of tenderness, which has been feared as well as loved, and is now a threatened species.

Many thanks go also to all the museum teams who contributed to this exhibition, to the directors of production, development, and communication, and to its patrons and partners: the International Council of the Musée des Arts Décoratifs, Andrew J. Martin-Weber and Beejan Land on behalf of The Divine Charlotte, and Frank Rheinboldt, CEO of Margarete Steiff GmbH.

This exhibition and its catalog are intended not just for children but also for adults, who often, in a bedroom or an attic, still keep this dear childhood friend.

Bénédicte Gady
Interim Director of the Musée des Arts Décoratifs

The Musée des Arts Décoratifs is unique among French museums in that it holds a national collection of toys. There are over 15,000 pieces ranging from the iconic to the ordinary, including dolls, cars, games, stuffed animals, and more. The collection contains over 400 bears. Through which historical circumstances did this fearful animal come to embody a gentle companion for children? The magic began in 1902. In the United States, President Theodore Roosevelt refused to shoot a defenseless bear cub. The tale was quickly repeated, and the animal became known as a Teddy Bear. The same year, with no apparent connection, in Germany an enterprising woman named Margarete Steiff created the first stuffed bear, with articulated limbs, for the company that still bears her name today. While other types of toys can be dated to ancient times, the teddy bear, only 122 years old, is a recent invention. It has become the classic example of a *doudou* or 'lovey' and frequently functions as a transitional object, as theorized by pediatrician and psychoanalyst Donald Winnicott. For this reason, it is not surprising that many children keep their teddy bears once they reach adulthood.

Just as she brilliantly explored and unveiled the myth of Barbie, Anne Monier Vanryb has now taken on the theme of the bear, with the fortunate encouragement of Christine Macel, who was then the museum's director. With the help of Marie-Lou Canovas, assistant curator of the toy department, she has brought together an extraordinary ursine collection. We would like to thank these very generous lenders: the Steiff Museum, the Victoria & Albert Museum, the Musée du Louvre, the Bibliothèque Nationale de France, the Tomi Ungerer Museum – International Illustration Center, the Muséum d'Histoire Naturelle of Toulouse, the Musée de la Chasse et de la Nature, the Musée Carnavalet – Histoire de Paris, the Médiathèque Françoise Sagan, the Bibliothèque Mazarine, the Musée de l'Archerie et du Valois, the University of Surrey, the maisons of Père Castor, Hermès, Louis Vuitton, Moschino, Issey Miyake, Marine Serre, and Koché, the Fondation Monique Martin, the galleries of Talabardon & Gautier, Marian Goodman, Sultana, Nathalie Obadia, and Xavier Hufkens, as well as Myriam and Jacques Salomon and the artist Charlemagne Palestine. Each was kind enough to part with several pieces for our education and delight.

As well as featuring many pieces from the toy collection of the Musée des Arts Décoratifs, the exhibition has also borrowed from the library and several other departments: the Middle Ages/Renaissance, publicity and graphic design, fashion and textiles, and jewelry. This interdisciplinary spirit is at the very heart of the museum.

This exhibition would not have been possible without the support of the International Council of the Musée des Arts Décoratifs, Andrew J. Martin-Weber and Beejan Land – the fortunate owners of Charlotte –, as well as Margarete Steiff GmbH. They show, by example, that the world of the teddy bear can be sweet and generous, and they deserve the gratitude of all our visitors, young and old alike.

AUTHORS

Marie Adamski
Director of Collection Documentation at the Musée du Quai Branly – Jacques Chirac

Sophie Lemahieu
Curator at the Musée des Arts Décoratifs (Paris), department of fashion and textiles from 1947 to the present day

Anne Monier Vanryb
Curator at the Musée des Arts Décoratifs (Paris), modern and contemporary department, Collection of Toys

Elena Paillet
Chief Curator of Cultural Heritage, DRAC Bretagne and UMR 6566 Université de Rennes

Michel Pastoureau
Historian and Professor Emeritus, École Pratique des Hautes Études

Catherine Schwab
Chief Curator of Cultural Heritage, Musée d'Archéologie Nationale (Saint-Germain-en-Laye), UMR 8068 Temps

Hélène Valotteau
Library Director and Head of Heure Joyeuse youth collection, Médiathèque Françoise Sagan

11
THE BEAR IN EUROPE: FROM VENERATION TO CONFLICT
Michel Pastoureau

23
THE BEAR IN PREHISTORIC TIMES: FROM ANIMAL TO SYMBOL
Elena Paillet and Catherine Schwab

27
THE HISTORY OF THE TEDDY BEAR
Anne Monier Vanryb

55
BEARS ON PAPER
Hélène Valotteau

63
FROM BEAR TO DOUDOU
Anne Monier Vanryb

85
THE BEAR, THE FUN FAVORITE OF FASHION DESIGNERS
Sophie Lemahieu

99
THE TEDDY BEAR TODAY
Anne Monier Vanryb

117
BEAR FESTIVALS IN VALLESPIR
Marie Adamski

125
EXHIBITED WORKS

141
BIBLIOGRAPHY

Anne Monier Vanryb

Adults often like to see children's interests as predictions of their future careers. My own childhood only confirms this belief: at the age of ten, I founded the Stuffed Animal and Doll Museum on the top floor of my parents' house. Stuffed animals were true friends to me, and I had hundreds of them, like many fortunate children in the late twentieth century. Each animal was listed in a notebook with a name and description, and I also considered the thorny question of how to label them: should I use the existing tag, or add my own label? The museum regularly displayed its latest acquisitions and was supported by the generosity of my relatives and family friends who became members. The membership benefits included an occasional museum newsletter and an exclusive cocktail party at Christmastime.

Today, I have put this early experience to good use to curate the national toy collection, which holds over 15,000 items that have been held in the Musée des Arts Décoratifs since its founding. However, these toys were not assembled into a collection until the early 1970s. Now arranged in a clearly identified collection, they are part of a systematic acquisition's policy aiming to bring together, within the museum, the most representative toys from the seventeenth century up to the present day, along with rare and unusual examples.

The exhibition "My Teddy Bear" is thus the fulfillment of a true childhood dream. The enthusiasm that it has sparked has gone beyond the toy department to infect all the museum staff—a sign of the very special status of this object, the ruler of childhood bedrooms and the friend and confidant of young people. Today, no one expects young adults to throw away their old stuffed friends. The teddy bear has moved beyond its original status as a toy to become both an accepted object in the public sphere and the symbol of childhood itself. It is omnipresent and seems to play an unquestionable role; however, its identity still offers a wide range of facets to explore for anyone who takes a closer look. This is why the Musée des Arts Décoratifs has organized this exhibition, for young and old alike.

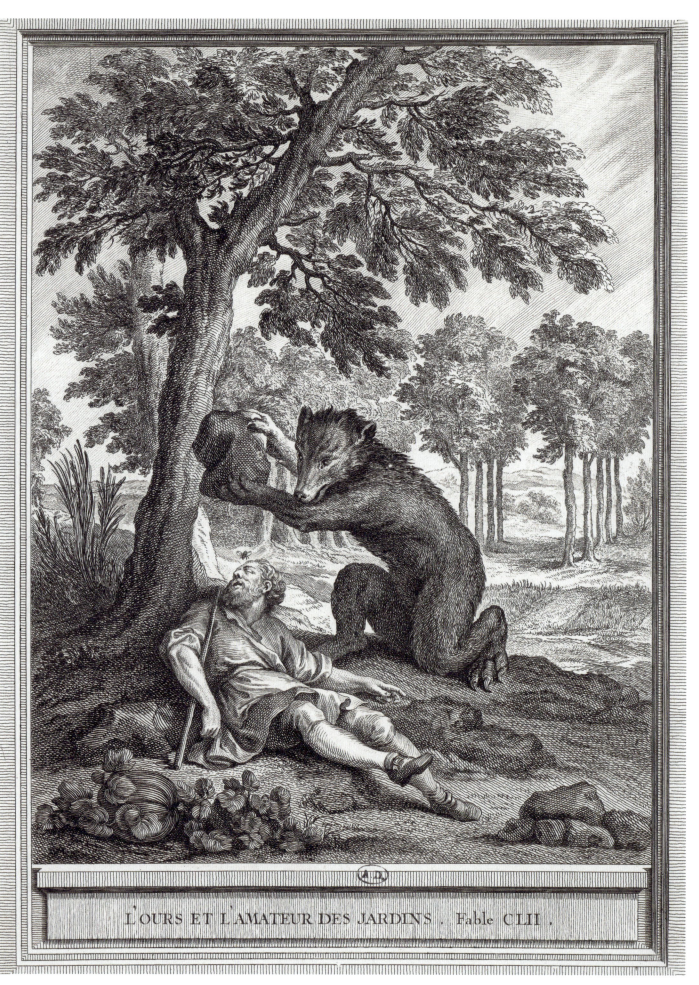

CAT. 27 Jean-Baptiste Oudry, *L'Ours et l'Amateur des jardins* (The Bear and the Lover of Gardens), in Jean de La Fontaine, *Fables choisies*, 1756. Paris, Bibliothèque du Musée des Arts Décoratifs

THE BEAR IN EUROPE: FROM VENERATION TO CONFLICT

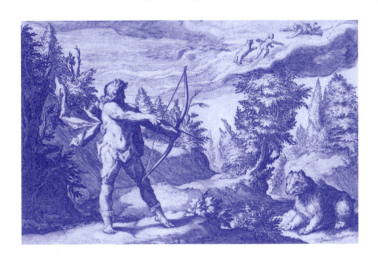

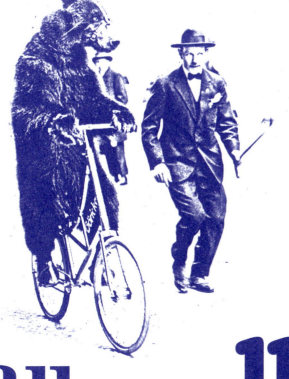

Michel Pastoureau

11

Beginning in the Neolithic era, the bear cult was the most widespread animal cult in the northern hemisphere. Its exceptionally rich mythology then spread in countless tales and legends throughout the late Middle Ages and even sometimes far into the modern era. The bear is the most important animal in longstanding oral traditions. Bears are also the animals with the most noticeable anthropomorphic qualities. As a result of this, they have a close relationship with humans, especially women—a relationship that can be violent and sometimes carnal. The stark contrast between the bear's bestiality and the woman's beauty is an age-old and recurring theme. The bear is a hairy animal, the *masle beste*, as described in Old French, and, by extension, it is connected to the figure of the wild man. But, most importantly, the bear is also the king of the animals—the strongest, biggest, and heaviest. It would take several millennia for the bear to be deposed and forced to yield its authority to another beast: the lion.

BEARS IN ANCIENT MYTHOLOGY

Greek myth offers the best transition from the prehistoric bear to the historic bear. Without being itself a divinity, the bear is the attribute of several gods, and the tales depicting bears have maintained traces of the role they played during very ancient times. In most of these myths, caves play an important and often ambivalent role. They are dark, troubling places where monsters and evil spirits live, places of ignorance, suffering, and sometimes punishment—like the cave described by Plato in *The Republic*. But they are also sanctuaries where men go to make alliances with the gods, control magical forces, and draw new energy. Many heroes are born in caves, while others are initiated, strengthened, liberated, or transformed there. Entering a cave always symbolically means moving from one state to another.

However, the Greek bear was no longer the cave bear, but the brown bear, the strongest of all wild beasts in Europe. Along with the pig, it is also considered to be the animal closest to humans—anatomically, physiologically, and symbolically. The attribute of several divinities, the bear's main role is to accompany the goddess of the hunt, Artemis, twin sister of Apollo, daughter of Zeus, goddess of moonlight and woods and mountains, and thus the protector of wild animals. Fierce and vengeful, Artemis vows to remain a virgin. She enjoys only hunting: armed with her bow, she pursues and strikes dead all those who defy her, betray her, or act against her will. Among her many victims, Orion and Acteon are the most well known. Orion was loved by the goddess, but he challenged her to a contest with the discus and tried to rape her. She had him stung by a scorpion. Acteon not only boasted of being a better hunter than Artemis, but, more importantly, he surprised her naked one day as she was bathing in a fountain. She changed him into a stag and he was devoured by his own dogs.

The tragic story of the nymph Callisto especially highlights the connection between the goddess Artemis and bears. The daughter of Lycaon, king of Arcadia, Callisto was extraordinarily beautiful but avoided men. She preferred to hunt with Artemis, and, as one of her followers, also took a vow of chastity. One day, Zeus saw Callisto and fell in love. To get close to her, he took on the appearance of Artemis and slept with her. Callisto became pregnant, and when this was discovered, Artemis was furious and vengeful. She shot an arrow at Callisto that caused her child to be born and at the same time transformed her into a bear. Callisto then wandered through the mountains in animal form while her son, Arcas, grew up and became king of Arcadia. When Arcas was out hunting one day, he came across a female bear, whom he did not recognize as his mother. He was on the verge of killing her, but, in order to avoid such a crime, Zeus changed him into a bear cub; the god then put mother and child into the heavens where they both became constellations: Ursa Major and Ursa Minor.

Artemis's name itself is constructed from the Indo-European root of most words for bear (*art-*, *arct-*, *ars-*, *ors-*, *urs-*, etc.), particularly the Greek word *arktos*. The myth of Callisto and her son, Arcas, is grafted onto this etymological background. Arcas has a name that directly evokes the wild animal, and his kingdom, the wealthy

CAT. 14 After Hendrik Goltzius, *Callisto changée en ourse* (Callisto changed into a bear), 1590. Crépy-en-Valois, Musée de l'Archerie et du Valois

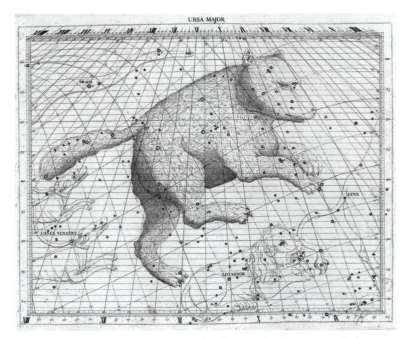

CAT. 12 John Flamsteed, "*Ursa Major*," in *Atlas Coelestes*, 1729. Paris, Bibliothèque Nationale de France

Arcadia, located in the center of the Peloponnese, is etymologically the 'land of the bears'. In his description of Greece from the second century CE, the great traveler Pausanias recounts that 'in the past' the men of Arcadia donned bear skins to go to battle when they warred with Sparta.

However, Arcadia does not have a monopoly on bears. They are found in many place names of ancient Greece, especially in mountainous regions, particularly in places where sanctuaries devoted to Artemis are located. In fact, her priestesses were once called 'little female bears' (*arktoi*). The oldest of these sanctuaries is located in Attica in Brauron (today called Vravrona, near Athens). There, from the sixth century BCE until the Hellenistic era, a strange ritual took place once every five years in the spring. Dressed in yellow and white, girls under the age of ten acted as priestesses during the major festival held in the goddess's honor. This festival ended with the sacrifice of a female bear—probably a modified form of a more ancient ritual in which the girls themselves would have been sacrificed.

But not all bears in classical mythology are connected to Artemis. Several tales tell of lost or abandoned children who are rescued by female bears and later become heroes. Such is the case of Paris, the youngest son of Priam, king of Troy. Before his birth, his mother, Hecuba, dreamed that she would give birth not to a child, but to a flaming torch that would set the entire city on fire. This dream was a premonition of the destruction of Troy. Frightened, Priam decided to get rid of the newborn and sent one of his servants to take him to the forest and kill him. But the servant took pity on the baby and abandoned him, still alive, on Mount Ida. Paris almost died of cold and hunger, but a female bear found him, gave him warmth, and nursed him. Later adopted by shepherds, the child became a magnificent young man. One day, as Paris watched his flocks on Mount Ida, Hermes came on behalf of Zeus and asked him to settle the argument of three goddesses who each claimed to be the most beautiful: Hera, Athena, and Aphrodite. When Paris chose Aphrodite, the other goddesses became his sworn enemies. Then he returned to Troy, where he was recognized and celebrated by his parents and his brothers. Shortly afterwards, he left for the Peloponnese, where he met Helen and fell madly in love with her. He won her love and kidnapped her. And that is how the Trojan War began.

Starting with Homer, countless authors have told the story of the judgment of Paris, the kidnapping of Helen, and the dramatic events that followed. However, very few have emphasized that the kidnapping of the most beautiful woman in the world was carried out not by an ordinary individual, but by a man who, for some time, had been fed and raised by a female bear, i.e., a human who still had traces of a bear-like nature from his earliest years. In European traditions, the male bear is the animal who is the most attracted to women: he kidnaps them and has carnal relations with them, leading to the birth of creatures that are half-human, half-bear. In this way, the story of Paris is related to a myth from the earliest times that tells of the mating of woman and animal, the beauty and the beast. It is the oldest written version of this myth.

Celtic mythology also describes the union of humans and animals, most often horses. For instance, King Mark of Cornwall was said to have an ancestress who slept with a horse, inheriting equine ears that he tried in vain to hide. While some kings or heroes have a very bear-like nature—such as King Arthur—this is for a different reason: they were raised by a goddess or a fairy who protected female bears. The Celtic pantheon contains many female figures who are similar to the Greek goddess Artemis. Many of them even have a name that relates them directly to Apollo's twin sister, such as the goddess Arduina, whose cult was located in the Ardennes region, which takes its name from the divinity. There is also an equivalent goddess in the Alps, Andarta, who was the protectress of both hunters and wild beasts. The great goddess Artio was a true copy of Artemis among the Celts of southern Germany and Switzerland. Artio's main attribute is a bear, as shown by a votive statuette found in 1832 in Muri, near Bern, depicting the nourishing goddess, bearer of fruits, seated across from a bear with the inscription: *DEAE ARTIONI / LICINIA SABINILLA* (to the goddess Artio [from] Licinia Sabinilla). The statuette dates to the late second century CE, an era when this Swiss region was very Romanized. But the ancient bear cults often resisted Romanization and then Christianization, enduring through the centuries.

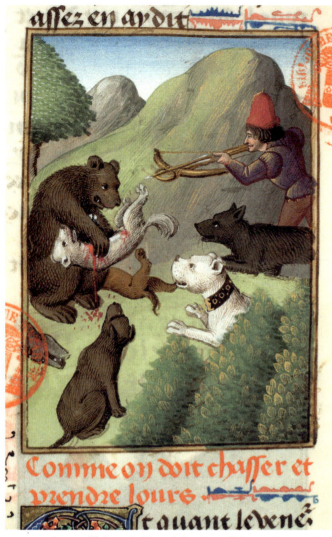

CAT. 17 Gaston Phébus, *Le Livre de la chasse* (The Hunting Book), before 1476, f° 081 v°. Paris, Bibliothèque Mazarine

The case of King Arthur, whose name is explicitly that of the bear, is different. Arthur is not a god but the most famous ruler in medieval literature. His history is partly connected to an ancient ursine myth whose traces can be found in several Celtic legends. The figure of the king is associated with that of the bear because, among the Celts—as, moreover, among the Germans, the Balts, and the Slavs— the bear is the king of all the beasts and therefore the epitome of the royal animal. He would remain so throughout a large part of Christian Europe during the early Middle Ages, and even after the year 1000, until the Church, the declared adversary of the bear, finally succeeded in installing another beast on this symbolic throne. Arthur was originally a bear-king because he was the strongest of all rulers. Once Christianized, he became simply a feudal king, and even a weak, indecisive king who must constantly seek counsel.

THE BEAR OF MEDIEVAL BESTIARIES

As the strongest of all the animals, a thief, and a rapist of women and girls, the bear could only

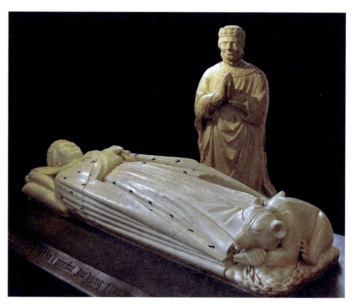

FIG. 1 Jean de Cambrai, *Funerary Monument of Jean, Duc de Berry*, first quarter of the 15th century. Bourges, Cathédrale Saint-Étienne

frighten the Christian Church. Not only does the beast have prodigious strength, but it is said to be lustful and violent. Moreover, it resembles man in its ability to stand up on its hind legs, and its sexual practices. Indeed, ever since Pliny, who most likely misinterpreted a passage by Aristotle, a large number of medieval authors affirmed that bears mated *more hominum* (like humans), face to face and stomach to stomach, unlike other quadrupeds. The male bear thus appears as a dangerous cousin to man, an animal that is all the more threatening because it is native. Hunting, admiring, and worshiping the bear constituted pagan rites attested in Christian lands until around 1000, and even later in northern Europe.

Therefore, early in its history the Church battled against a creature that it wanted to depose. Between the seventh and twelfth centuries, throughout Christendom, it promoted the lion, an animal that belonged to written culture and was thus easier to control. Whenever possible, it 'played' the lion against the bear. In order to do this, clerks, prelates, and theologians used various strategies. The most common, and perhaps the most effective, consisted in attempting to discredit the bear. Relying on the Bible, where the bear is always depicted in a negative light, and repeating the passage in a famous sermon by Saint Augustine comparing the bear to the devil (*ursus est Diabolus*), the Church Fathers and the Christian authors of the Carolingian era place the animal in Satan's bestiary, stating that the devil often took the form of a bear to threaten or torment sinners. Moreover, they denounce the many vices— brutality, spite, lust, filth, voracity, perversion, sloth—of an animal whom they associate with no fewer than four deadly sins. Bad-tempered, the bear does not allow others to approach (anger); it sleeps part of the year (sloth); omnivorous, it loves honey (gluttony); lascivious, it rapes girls (lust).

Most of the bestiaries of the feudal era repeat these various characteristics for their own purposes,

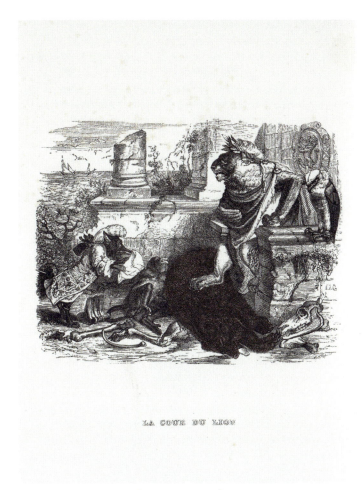

CAT. 31 *La Cour du lion* (The Lion's Court), in Jean de La Fontaine, *Fables de La Fontaine*, 1838. Paris, Bibliothèque du Musée des Arts Décoratifs

CAT. 26 Charles Le Brun (author), Dominique-Vivant Denon (engraver), *Dissertation concernant le rapport de la physionomie humaine avec celle des animaux* (Essay concerning the Relationship between Human Physiognomy and that of the Animals), 1806. Paris, Bibliothèque du Musée des Arts Décoratifs

adding others and offering many examples. However, some are more nuanced, sketching a less systematically negative portrait of the animal, especially concerning lust. In these bestiaries, this issue concerns the females more than the males. Their authors maintain that bears are obsessed with physical passion and indulge in it excessively. But it is the females who, unable to control their desire, pursue the males night and day and refuse to stop their lovemaking once it has begun. Several authors affirm that bear cubs are born after only thirty days, emerging small and misshapen, without eyes or fur and barely alive. This is attributed to the fault of the mother, who does not have the patience to wait until the end of the normal gestation period. Why is she in such a hurry to give birth? Because the male refuses to mate with her while she is pregnant. The pleasures of the flesh are more important to her than the joys of motherhood, and therefore the female bear rushes to give birth, producing cubs who are barely viable. She then hastens to rejoin the male in order to fornicate with him once more.

However, this image of the bad mother was corrected by other authors, who were more numerous and more faithful to ancient traditions. Drawing on various passages by Aristotle and Pliny, these authors explain how, by licking her failing cubs for a long time, the mother bear brings them back to life, warms them up, and restores their strength. She then keeps them with her for many months and bravely defends them against predators. The lustful female is thus turned into a good mother. Her behavior is connected to repentance, or even conversion: she becomes aware of her sins, leaves behind her vicious nature, and becomes an example worthy of imitation.

Medieval bestiaries and encyclopedias also discussed many other properties of bears, whose breath was described as fetid and dangerous to certain animals, particularly the wolf and the fox. The bear was described as having very strong limbs: with one blow of its paw, it could knock down an oak or a beech tree. Its fat was said to have the ability to make hair grow back and restore virility to impotent men. Moreover, writers asserted that the more you beat a captured bear, the fatter it became, on condition that it had first been blinded. It was also claimed that beatings caused the bear to become docile, performing domestic tasks such as carrying stones, drawing water from a well with a bucket, and turning a wheel or a millstone. Although it was omnivorous, the bear was said to avoid certain plants, especially mandrake, which would be deadly. If it consumed mandrake accidentally, the bear had

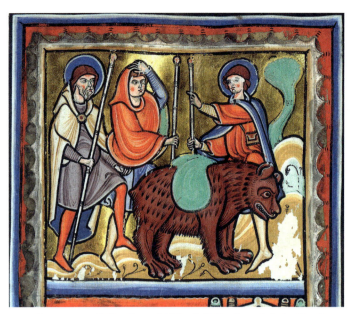

FIG. 2 Anonymous (Saint-Amand Abbey), *Saint Amand, Saint Humbert, and the Bear Going to Rome*, in *Vie de Saint Amand*, c. 1160. Valenciennes, Médiathèque Simone Veil

CAT. 19 *Costnitzer Concilium*, book of heraldry, Frankfurt-am-Main, 1575. Paris, Bibliothèque du Musée des Arts Décoratifs

to quickly eat a large quantity of ants in order to recover. In order to catch them, it stuck its paw into an anthill, left it there until it was covered with ants, and then withdrew it and eagerly licked off the insects. Hibernation gave rise to many questions. Where did the bear go? What did it do between late autumn and mid-winter? Was it really sleeping? How did it eat? Some authors stated that the bear went to hell and received instructions from the devil to spread evil over the earth.

Hagiographers created an image of the bear quite similar to that of the bestiaries. As described by Saint Augustine, the bear was seen as the devil. But saints were stronger than this beast. Many saints' lives and legends recount how a man of God, through his example, his virtues, or his power, conquered a wild and dangerous bear and forced it to obey him. Saint Amand, the apostle of Limbourg and Heynault, made a bear who had devoured his mule carry his baggage in its place. Saint Eligius, bishop of Noyon, required a bear who had eaten his ox to pull his plow. Saint Rusticus did the same, in Limousin, to a bear who had killed and carried off his two oxen attached to the funeral carriage of his disciple Saint Viance. As for the great saint Colomban, he forced a bear to make room for him in its cave so that he could take shelter from the cold. His disciple Saint Gall went even further: he became friendly with a bear who helped him to build a hermitage, the future Abbey of Saint Gall, the wealthiest abbey in the Christian world.

Demonized by bestiaries and domesticated by hagiographers, the bear was also ridiculed by performers beginning in the twelfth to thirteenth centuries. Although the Church was hostile to performing animals, it did not oppose traveling bear tamers. Muzzled and chained, the animal accompanied jugglers and acrobats from fair to fair and market to market. The royal beast, once admired and feared, was now transformed into a circus animal that danced, performed tricks, and entertained the public. Henceforth, the bear was no longer the kingly gift that it had been during the Carolingian era. Starting in the thirteenth century, bears were removed from princely menageries and even from the iconography of Noah's Ark. Only the polar bears offered by the kings of Norway and Denmark preserved a certain prestige, as rarities or curiosities.

THE BEAR IN MODERN TIMES

In the modern era, while the bear was no longer the king of the animals, various stories and traditions nevertheless continued to emphasize its relationship to human beings, particularly the attraction of male bears to girls. The tale of Antoinette Culet, victim of the monstrous passion of a bear, although it does not constitute a unique case, is, however, one of the best-documented of those that circulated in various European regions, usually in mountainous areas, under the Old Regime. Therefore it is worth recounting.

The episode took place in the Tarentaise Valley of the French Alps in the early seventeenth century. Pierre Culet, a prosperous farmer, lived with his family in Naves, a village in the diocese of Moutiers. His eldest daughter, Antoinette, aged sixteen, was unusually beautiful. Not yet married, she helped her parents with farmwork and, in the spring, would often take the sheep to graze in the mountains, quite far from the village. One evening in April 1602, during the festival of the Rogation Days, she did not return. A search party could not find her. Her family thought that perhaps she had been the victim of a wolf, but no sheep were missing. Only later would they learn the tale of her terrifying experience.

The animal in question was not a wolf but a gigantic bear. At twilight, the bear suddenly

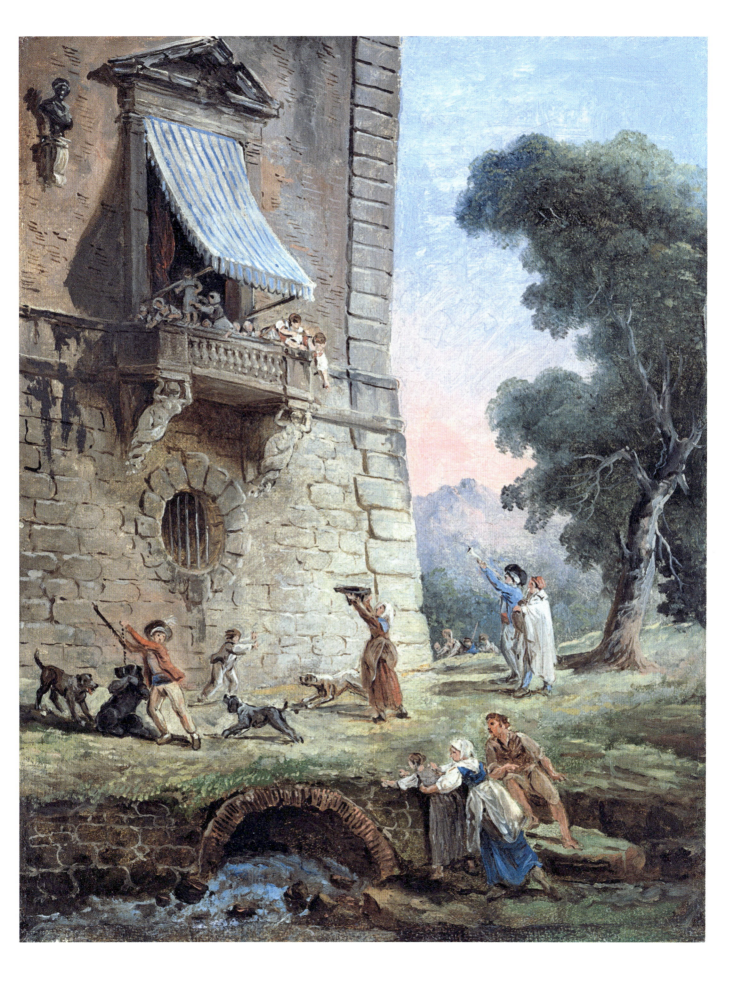

CAT. 21 Hubert Robert, *Le Montreur d'ours* (The Bear Tamer), late 18th century. Paris, private collection, courtesy Galerie Talabardon & Gautier

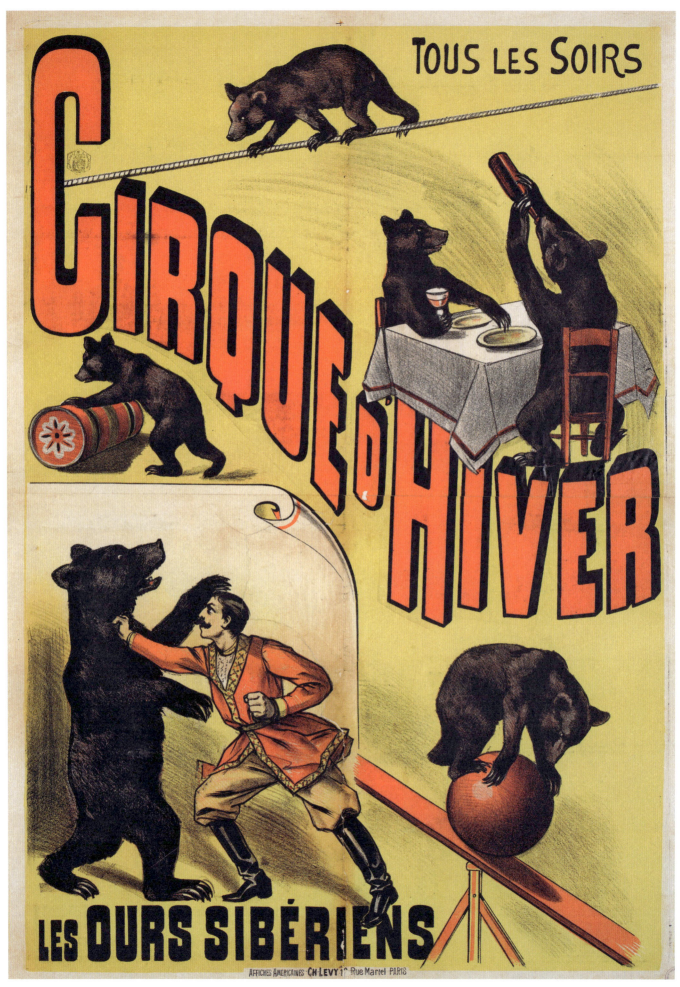

CAT. 50 Anonymous, *Tous les soirs. Cirque d'Hiver. Les ours sibériens* (Every Night. Winter Circus. Siberian Bears), poster, n.d. Paris, Musée des Arts Décoratifs

appeared and, instead of attacking the sheep, seized the pretty young shepherdess. He took her to his cave and closed off the entrance with an enormous rock. Stimulated by an unnatural sexual urge, he assaulted the girl and "took carnal pleasure" with her. When she fainted, he watched over her, held her, licked her, and displayed true affection. This monstrous love was accompanied by carnal knowledge that was even more monstrous and was repeated on an almost daily basis during the shepherdess's long captivity. The bear came to visit her at night. During the day, he left the cave and went to the surrounding villages to steal things that he thought Antoinette would need: bread, cheese, honey, fruit, and sometimes even clothes.

The girl remained his prisoner in the cave for almost three years. Then, in early 1605, three men from the village went to cut down fir trees higher up and farther off than usual. Despite the enormous rock blocking the entrance, Antoinette heard the sound of hatchets and, for the first time in a very long time, human voices. She shouted. Her cries were heard, and the woodcutters approached. She told them who she was and begged them to help her escape. One of the men went to seek help in the village. The cave entrance was opened up and the girl, whose wild appearance was dreadful, was taken back home to her father. There, once she had been washed, her hair cut, dressed, and cared for, she told her awful story in great detail. She admitted having given birth to a monstrous child that was half-human and half-bear. The father accidentally smothered the child a few weeks after its birth by hugging it too tightly. Many of the villagers found Antoinette's tale hard to believe and thought she was insane. The priest even considered bringing in the exorcist of the diocese the following day. The very night Antoinette returned home, the bear came down from the mountain and shouted in front of the Culet farm, demanding that his "little wife" be returned to him.

The entire village was terrified. The bear returned the following night, and the night after that. But on that third night, the villagers were waiting for him. The animal was shot with an arquebus, after defending itself tooth and nail and killing two men. It was the biggest bear that had ever been seen in the Tarentaise Valley. Its corpse was burned and its ashes thrown into a ravine. The young Antoinette was unable to lead a normal life and was taken to a convent in Dauphiné province.

In the duchy of Savoy, the "amorous bear" was discussed for a long time. Shortly after the event, a priest from the diocese of Moutiers, at the request of his bishop, wrote down the story of Antoinette Culet: *Le Discours effroyable d'une fille enlevée, violée et tenue plus de trois ans par un ours dans sa caverne* (The Frightening Account of a Girl who was Kidnapped, Raped, and Held Over Three Years by a Bear in his Cave), printed in Chambéry in 1620. Today this volume is a highly sought-after bibliophilic rarity.

The theme of a woman kidnapped and raped by a bear, leading to the birth of a being with prodigious strength but an antisocial nature, constitutes a 'standard tale' of which many versions exist. The most famous version, known as *Jean de l'Ours* from the name of its hero, is found in the Pyrénées and the Alps from the late Middle Ages and documented in the sixteenth and seventeenth centuries. In various forms, this tale is also seen in Scandinavia, the Slavic countries, the Caucasus, and even America. The story of the bear falling in love with the young Antoinette is simply a variant of it—a telling that may have been attached to an actual event involving a girl who became pregnant and fled her village.

In the nineteenth century, a fantastic tale by Prosper Mérimée, *Loki* (1869), tells more or less the same story: the day before her wedding, a young woman is kidnapped and raped by a bear. Quickly released, she gives birth nine months later to a child who, as he grows up, becomes stranger and stranger: Count Michel. This tale, set in the Lithuanian forest, was probably intended to frighten the ladies of the imperial court. By that time, bears had not terrorized the countryside for a long time, having been replaced by wolves. By then they were part of the world of the circus and fairs, with bear tamers having multiplied ever since the beast had disappeared from most regions.

Starting in the late eighteenth century, bear tamers criss-crossed Europe, showing the animal to populations that had never seen one. But was it still a wild animal? Engravings, followed by photographs and postcards, show us abundant images of these muzzled bears, sometimes standing up on their hind

CAT. 40 Frankl, *Ours savant faisant du vélo* (Trained Bear Riding a Bicycle), 1925. Paris, Bibliothèque Nationale de France

The Bear in Europe: From Veneration to Conflict

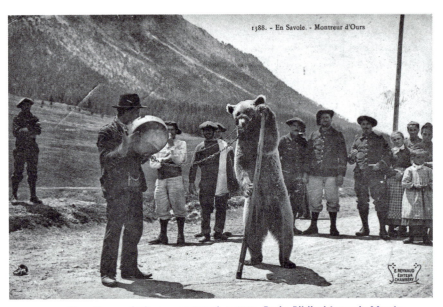

CAT. 43 Bear Tamers in Savoy, postcard, c. 1908. Paris, Bibliothèque du Musée des Arts Décoratifs

legs, accompanying a vagabond dressed in rags, or clumsily dancing on a village square before a few curious onlookers. The animals are often small and thin, with little fur. They seem timid and resigned. The bear tamers were generally from the Carpathian Mountains, where the cubs were captured and trained. They were taught to dance, to wave, to do somersaults, to curl up into a ball, to mock-fight, and to play dead. Their teeth and claws were filed down, and they had a ring in their muzzles so that they could be chained up.

In France, during the nineteenth century, bears from the mountains in Ariège were also displayed in southern towns and villages. Less mistreated than their fellows from the East, they were supposed to bring good luck and to protect from certain illnesses. Children in particular were encouraged to pat them and climb up on their backs, which was supposed to cure them of all their fears. These Pyrénées bears, shown throughout southern France, disappeared after World War I. By then, the teddy bear had come into existence and had begun to transform the way the animal was perceived.

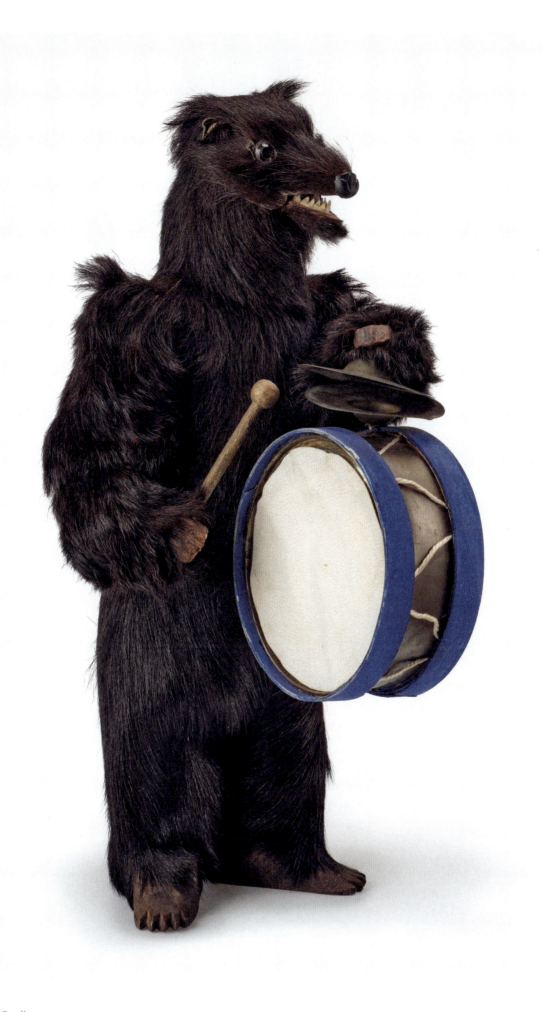

CAT. 44 Jean Roullet (manufacturer), bear playing a bass drum, France, 1880–1885. Paris, Musée des Arts Décoratifs

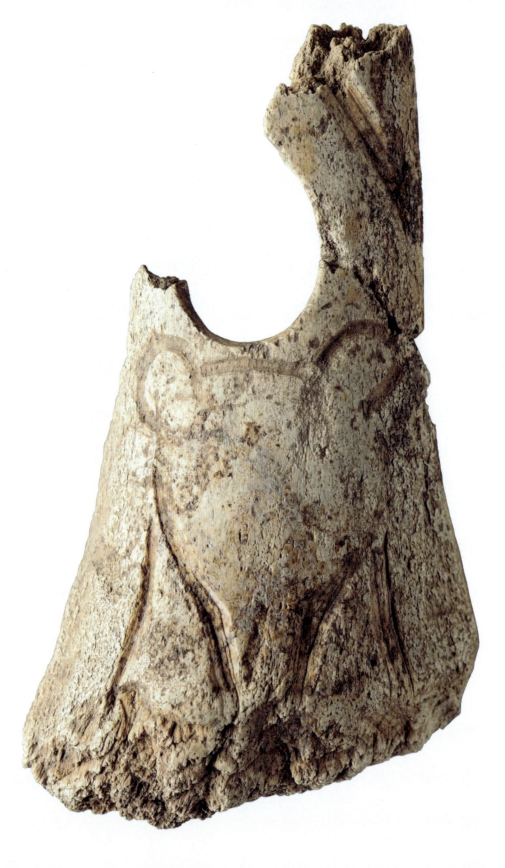

CAT. 2 Bear engraved on deer antler, cave of Ker de Massat, Ariège, 17,000 to 14,000 BP. Toulouse, Muséum d'Histoire Naturelle

Elena Paillet
Catherine Schwab

Archeological evidence from prehistoric times suggests that there was a profound relationship between humans and bears, which were once considered our 'wild cousins'. In prehistoric times, the two species frequently shared the same caves. This has been shown in Rouffignac and Cussac (Dordogne), where possible burials took place in dens that had been dug out by hibernating bears. In the cave of Aldène (Hérault), scratches made by bears were integrated into carved representations by cave artists. While hypotheses of a 'bear cult', especially among the Neanderthals, are not generally accepted today, other evidence does suggest that there was a very special connection between bears and modern humans, starting in the Late Paleolithic (around 44,000 BP). In the Chauvet cave (Ardèche), people handled bear bones and sometimes depicted bears. But these examples remain exceptional; indeed, the bear generally appears as a very isolated figure, both in the environment and in the artistic bestiary.

Today, we are aware of almost 200 representations of bears dating to the Late Paleolithic (approximately between 44,000 and 13,000 BP). Although this figure continues to evolve with research and new discoveries, it reflects a basic reality: bears remain unusual in the prehistoric bestiary, barely reaching 2 or 3% of all artworks. Indeed, in Paleolithic art, animal representations are greatly dominated by large herbivores, especially horses and bison. Bears are divided equally between portable art (art on objects that people moved around or with which they were sometimes buried) and parietal art (the art on cave walls), which was both private and monumental and quite separate from daily life.

In portable art, bear figures are mostly attributed to the Magdalenian epoch (approximately 20,500 to 13,000 BP), the period closest to our own time and the most abundant in symbolic activity. Bears appear on all kinds of media. While the perishable materials disappeared a long time ago, others have survived, either rocks or fossilized bones. Among the rocks, we very frequently find bears engraved on plaques that have no apparent function, or on stones that may have served as hammerstones for carving flint. The bear was sometimes sculpted in the round, like a miniature statuette, in stone or clay that was shaped by hand. Raw materials of animal origin are also numerous. Bones, reindeer antlers, and mammoth ivory provided diverse media for artistic expression, particularly with images of bears. While some of these media are tools shaped by prehistoric artisans and used for hunting or daily life, many others have functions that are unknown to us, making the images that appear on them even more mysterious.

In cave art, depictions range greatly across the thirty millennia in question, with a strong emphasis during the Aurignacian period (approximately 44,000 to 34,000 BP), which owes a great deal to the importance of the Chauvet cave in the Ardèche department of France. At this site, the twenty or so painted or engraved ursids

THE BEAR IN PREHISTORIC TIMES: FROM ANIMAL TO SYMBOL

are always represented in summary fashion. With simplified forms, the lines suggest a return to the animal's very essence. On the contrary, at some Magdalenian sites, such as the Grotte de la Mairie in Teyjat (Dordogne), the animals are so detailed that they evoke an almost photographic representation of reality. The bear is often isolated in cave paintings; it seems to be separate, relegated to areas that are difficult to access or to see. In Lascaux (Dordogne), the bear is even hidden, appearing in the middle of a spectacular panel with only its ears and feet emerging from behind the ventral line of the bull.

Most of the representations of bears share fundamental characteristics, true 'identification keys' for the animal. They make the species identifiable, even for us today in the twenty-first century. First of all, their outline is always massive and round. The dorsal line of the animal emerging in the distance in the tall grass of the steppes was often the first visual contact for the prehistoric hunter. The head reflects the same phenomenon: shaped like the base of a cone, this body part is often shown as round, massive, and imposing. But the ears attract our attention first. As on children's stuffed animals, they are round and proudly perched on the top of the head, making them very visible and recognizable. The ears are essential, in fact, for distinguishing the bear from its closest zoological relatives, the big cats.

On the contrary, other characteristics, such as canines or claws, are practically absent from prehistoric art.

The bear is often shown alone and is rarely associated with other species. However, the theme of bears in couples does occur on a few occasions: following each other in pairs, as on the walls of Ekain (Spain), or on a bone from Isturitz (Pyrénées-Atlantiques), and even depicted as part of a family on a smoothing tool made of bone from La Vache (Ariège). While there are a few original images, described as scenes of fishing or hunting (fishing for salmon, but also hunting for humans), relationships with other thematic elements from the bestiary are usually peaceful. Generally, in prehistoric art the bear is usually seen juxtaposed with other animals—at times even superimposed and difficult to distinguish—instead of being truly associated with them.

Images in Paleolithic art—particularly images of bears, which are rare—respond to symbolic choices: they are the reflection of a society, of its narratives and its beliefs. Through art, we perceive a few shards of this society, even if it remains unattainable.

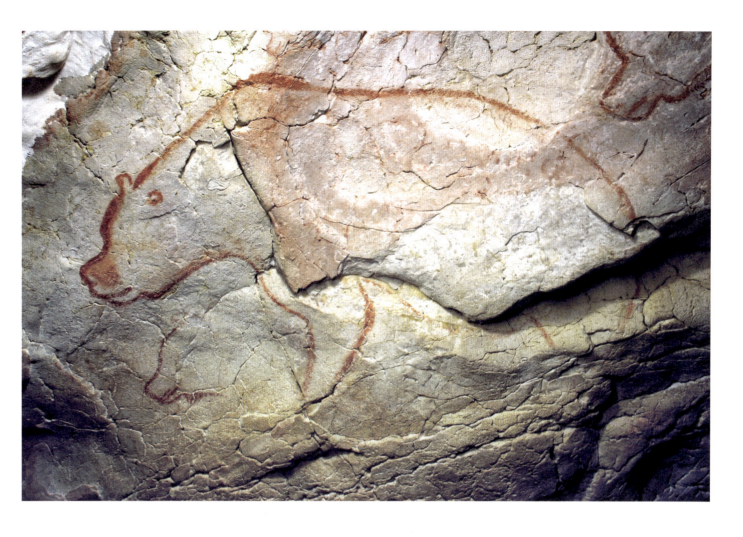

CAT. 1 Red bear,
Passage of the Bears,
37,000 to 33,000 BP, Ardèche,
Chauvet-Pont-d'Arc cave

CAT. 68 Anonymous, Bär 55 PB, photograph, 1903. Giengen an der Brenz, Margarete Steiff GmbH

THE HISTORY OF THE TEDDY BEAR

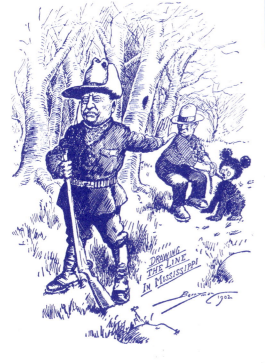

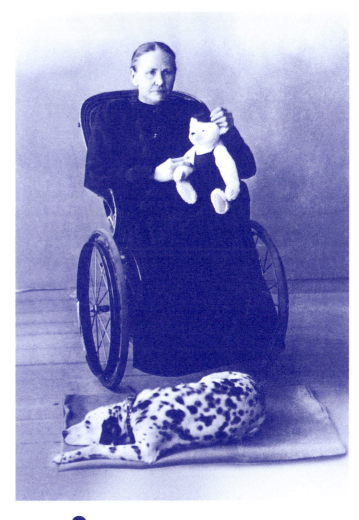

Anne Monier Vanryb

27

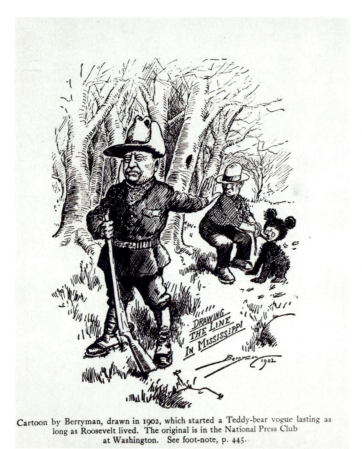

CAT. 57 Clifford Kennedy Berryman, *Drawing the Line in Mississippi*, in *The Washington Post*, November 16, 1902. Washington D.C., Archives of American Art, Smithsonian Institution

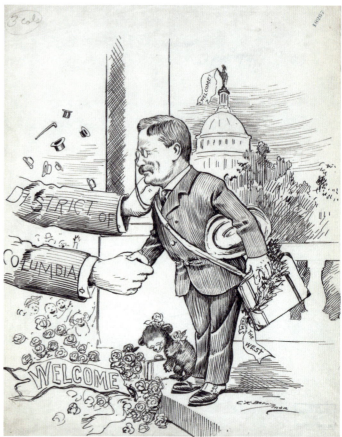

FIG. 3 Clifford Kennedy Berryman, *District of Columbia Welcoming Theodore Roosevelt, with Laurels from the West*, 1904. Washington D.C., Library of Congress

THE RECENT ORIGINS OF THE TEDDY BEAR

Toward the end of the Paleolithic, from 17,000 to 12,000 BCE, objects like miniature sticks with holes in them and discs featuring drawings were used as toys. In antiquity, dolls, carts, and sculpted animals became increasingly common. The types of toys we know today were established between the early Middle Ages and the end of the nineteenth century. This was, in large part, due to the technical advances of the nineteenth century, which allowed toys to be manufactured quickly and cheaply in industrial quantities. But one toy came later, the teddy bear, which has become a mainstay.

In fact, before the end of the nineteenth century, bears were uncommon toys. Animals made from clay and wood, in earlier eras, tended to represent everyday creatures like dogs, farm animals, and, of course, horses. But when the teddy bear made its appearance, it did so simultaneously on both sides of the Atlantic, as though the emergence of this toy were necessary and expected.

THEODORE ROOSEVELT AND THE AMERICAN LEGEND

In November of 1902, Theodore Roosevelt, the very popular American president and an ardent advocate of nature conservation, was invited to join the governor of Mississippi on a bear hunt. To avoid sending Roosevelt home empty-handed after a long day of fruitless tracking, the organizers captured a bear, tied it to a tree, and invited the president to kill it. Roosevelt categorically refused to shoot a defenseless animal.

This unusual story was picked up by newspapers, and was most notably featured in a cartoon by Clifford Kennedy Berryman, entitled "Drawing the Line in Mississippi". The bear thus became a kind of unofficial Roosevelt mascot (CAT. 57), and the hero of many Berryman cartoons illustrating episodes in the president's life (FIG. 3).

Roosevelt's attitude is difficult to interpret in a modern-day context. He spared the bear not out of pity or humanity but because the situation did not align with his personal ethics: shooting a tethered animal was not fair play. The kind of nature conservation that Roosevelt practiced was different from the environmental protection of our modern era, and did not exclude hunting. The early twentieth century marked the end of a major shift in the way humans perceived nature. Though previously perceived as wild and at times threatening, inspiring wariness, nature was now seen as romantic, idyllic, and innocent.[1] It was against this backdrop that Roosevelt's unusual gesture, seen as proof of his kindness, became part of the myth surrounding him.[2]

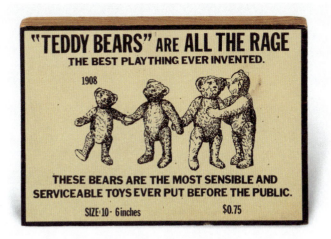

CAT. 58 Advertising panel for Ideal Toy teddy bears, United States, c. 1908. Paris, Les Arts Décoratifs

Roosevelt had not been elected for his first term; as the vice-president, he had replaced President William McKinley after his assassination. In August of 1904, Roosevelt was triumphantly elected for another term.

Rose and Morris Michtom, owners of a Brooklyn candy shop, were inspired by the media coverage and made a stuffed toy that they sent to Roosevelt and then sold, with his permission, under the name "Teddy's Bear" (as Teddy was a common nickname for Theodore). The teddy bear was a big success and, in 1906, it was featured in *Playthings*, the trade magazine for toys, where it was officially named "teddy bear".[3] Today, none of the original bears are known to exist. The following year, the Michtoms teamed up with the Butler Brothers, a wholesale company, to create the Ideal Novelty and Toy Company, which manufactured and marketed bears made of mohair (CAT. 62).

THE STEIFF SAGA

In 1902, the same year "Teddy's Bear" appeared, a German toy brand called Steiff launched a revolutionary new product: a mohair bear with articulated joints.

The company had started as a sewing workshop founded in 1877 in Giengen an der Brenz by Margarete Steiff, a young woman who had become paralyzed after contracting polio as a child (FIG. 4). Margarete had a strong character and strove to gain autonomy and independence, despite her handicap. She set up a felt workshop in her parents' home, equipped with the city's first sewing machine. In 1880, Steiff was inspired to make a small felt elephant after seeing a pattern

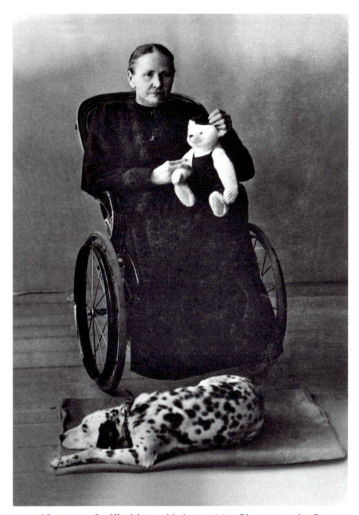

FIG. 4 Margarete Steiff with a teddy bear, 1908. Giengen an der Brenz, Margarete Steiff GmbH

published in the December 1879 issue of the newspaper *Die Modenwelt* (CAT. 80). Though they were originally intended to be pincushions, the elephants she made for her family and friends were quite popular with children, who soon turned them into toys. She began to market them, selling eight in 1880, eighteen in 1881, and eleven in 1882.[4] Production, albeit still modest, was set up and, in 1883, a price list published by "Filz-Versandt-Geschäfts von Gretchen Steiff" (a mail-order company for felt goods owned by Gretchen—short for Margarete—Steiff) described sturdy, safe children's toys, elephants with colorful blankets. In the 1880s, Margarete Steiff and her employees manufactured a large number of felt animals, which Margarete's brother Fritz sold to Stuttgart stores and markets. Fritz Steiff also designed wood and metal structures to keep the elephants upright, as they were initially wobbly.[5] In 1889, the company moved to a larger building that included an apartment for Margarete and a store featuring the words *Filz Spielwaren Fabrik* (Felt Toy Factory). The first Steiff catalog was published in 1892, and included elephants, monkeys, donkeys, horses, camels, pigs, mice, dogs, cats, rabbits, giraffes, and birds. Four-legged bears were mentioned, but without any pictures. The following year, the "Margarete Steiff, Filz-Spielwarenfabrik

1. Mike Jeffries, "Out of the Wild Wood and into Our Beds: The Evolutionary History of Teddy Bears and the Natural Selection of Deadly Cuteness," in *The Bear: Culture, Nature, Heritage*, ed. Owen T. Nevin, Ian Convery, and Peter Davis. Martlesham: Boydell & Brewer, 2019, p. 24.
2. Sarah Kaplan, "The True Tangled Tale of the Teddy Bear: Theodore Roosevelt and the Resurgence of a Threatened Species," *The Washington Post*, March 11, 2016.
3. Leyla Maniera, *Christie's Century of Teddy Bears*. New York: Watson-Guptill Publications, 2001, p. 33.
4. Jürgen and Marianne Cieslik, *Button in Ear: The History of the Teddy Bear and His Friends*. Jülich: Marianne Cieslik Verlag, 1989, pp. 11–13.
5. Ibid., p. 14.

The History of the Teddy Bear

Giengen a.d. Brenz" was registered as a company. It employed four seamstresses and ten home workers, and a sales representative would soon join them.[6]

In 1897, Fritz Steiff's son Richard joined the company after studying at the Stuttgart School of Applied Arts. An inventor at heart, he wanted to help Steiff innovate. This led him to explore making movable limbs for the animals. Was he inspired by dolls? At the time, doll manufacturing was in full swing in Germany, and Steiff also sold several types of doll.[7] In any case, he set his focus on bears and monkeys—animals that could move like humans. He returned to the sketches he had made during his visits to the zoo, as a student (CAT. 70), to refine the posture and expressions of his prototypes. Thus, at the end of 1902, the first animals with mohair fur were born, stuffed with wood wool, with strings connecting movable limbs to the body. There was the Aff 60 PB monkey, and, especially, the first teddy bear, Bär 55 PB—55 for the size, in centimeters, P for *Plüsch* or plush, and B for *beweglich* or movable (CAT. 68). Margarete Steiff was not convinced, fearing that the use of mohair would make the toys too expensive.[8] She was initially proven right by the cold reception that the bears received at the Steiff showroom in New York City. According to Paul Steiff, Richard's brother who had gone to the United States to promote the brand, the bears were too big, too heavy and too hard to attract children.[9] However, they were noticed at the Leipzig Fair in March of 1903 by Hermann Berg, the buyer for a New York toy store called Geo. Borgfeldt and Co., who was looking for something new (CAT. 69). He purchased the one hundred models on exhibit and ordered 3,000 more. Yet the fate of these Bär 55 PB models is unclear, as none of them have survived to this day. Was the cargo lost at sea? Or upon arrival in the

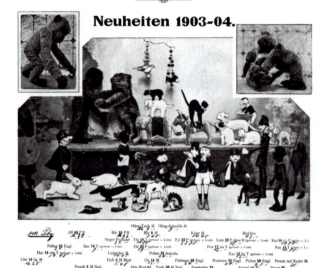

CAT. 69 Steiff (manufacturer), catalog of new items 1903–1904. Giengen an der Brenz, Margarete Steiff GmbH

United States? Was it never delivered? Unfortunately, the Steiff archives shed no light on this mystery.

Today, the oldest teddy bear in existence is the smaller, lighter-colored Bär 35 PB, from 1904 (FIG. 5), which was reworked by Richard Steiff so that it would move more smoothly. Indeed, this combination of materials, the standing position, and the articulated limbs made this stuffed bear very original and attractive, and set it apart from existing furry or four-legged bears. The product was exhibited at the St. Louis Fair, where it won over Americans looking for teddy bears, and 12,000 units were sold.[10]

By the end of 1904, Bär 28 PB had arrived. It had small, round ears, a long, shaved snout with a wax nose with sculpted nostrils, long, narrow feet, and movable limbs that used a new system made of metal rods (FIG. 6). Yet Margarete Steiff and her nephews remained dissatisfied with the bear's appearance. In 1905, Richard Steiff suggested a bear that was less wild and more tender, almost melancholic, with a rounder head

CAT. 70 Richard Steiff, *Bear Drawings*, early 20th century. Giengen an der Brenz, Margarete Steiff GmbH

6 Ibid., p. 15.
7 Ibid., p. 28.
8 Maniera, op. cit., p. 25.
9 Cieslik, op. cit., p. 28.
10 Ibid., p. 34.

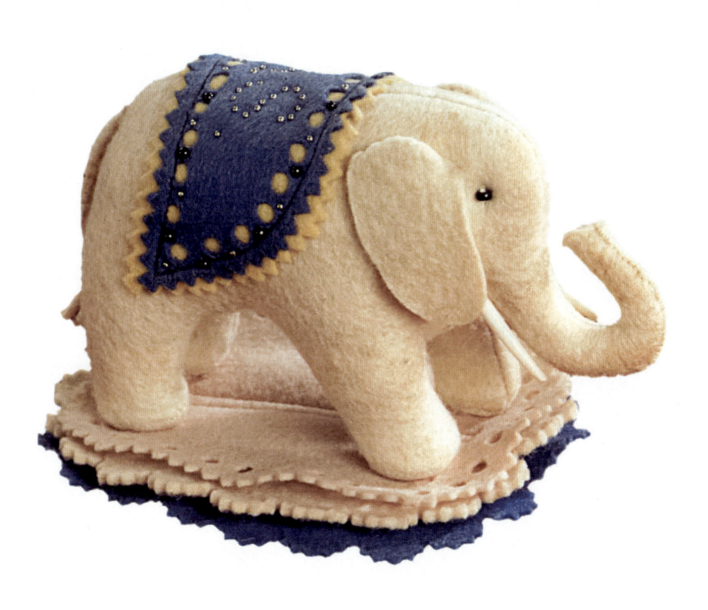

CAT. 80 Steiff (manufacturer), *Elephant*, Germany, 1888. Giengen an der Brenz, Margarete Steiff GmbH

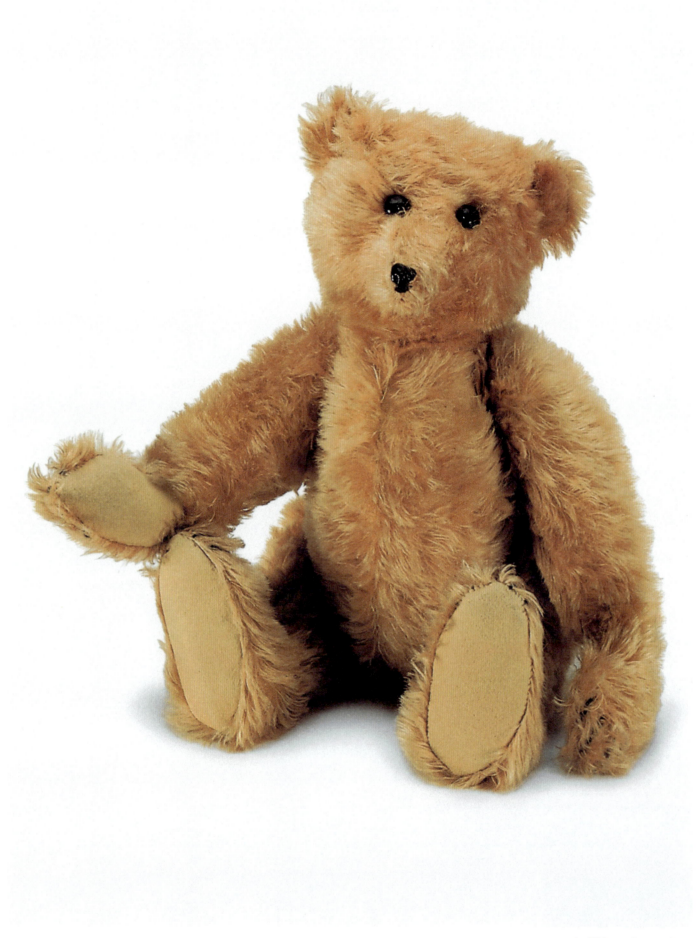

FIG.5 Steiff (manufacturer), Bär 35 PB, Germany, 1904. Giengen an der Brenz, Margarete Steiff GmbH

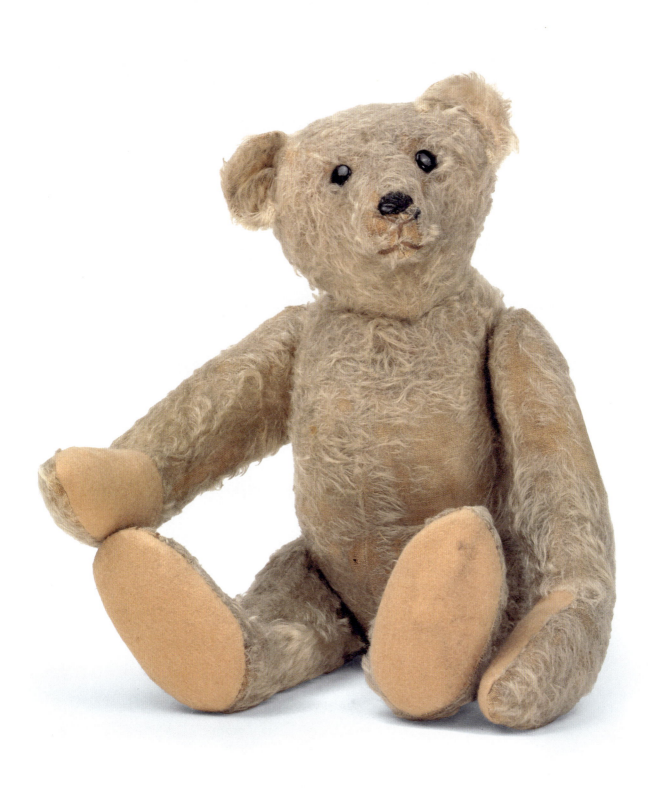

CAT. 87 Steiff (manufacturer), Bärle 5335, Germany, 1905. Giengen an der Brenz, Margarete Steiff GmbH

The History of the Teddy Bear

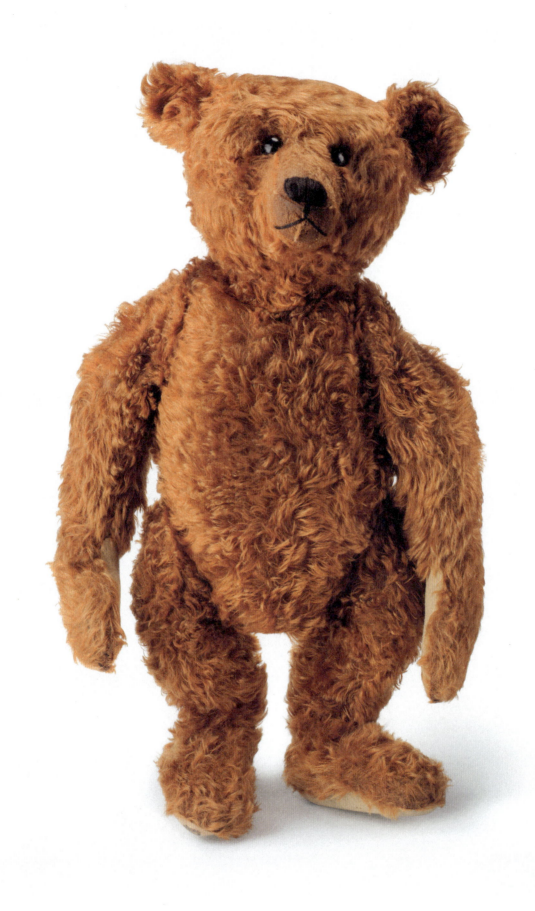

CAT. 89 Steiff (manufacturer), teddy bear, Germany, c. 1910–1912. Paris, Musée des Arts Décoratifs

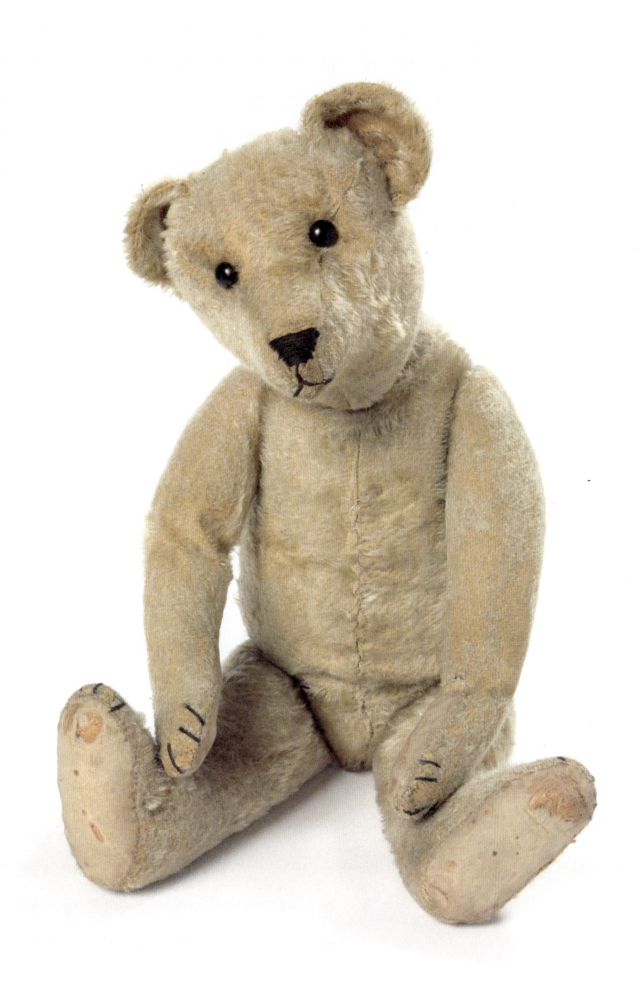

CAT. 62 Ideal Toy Corp (manufacturer), teddy bear, United States, c. 1910. London, Victoria and Albert Museum

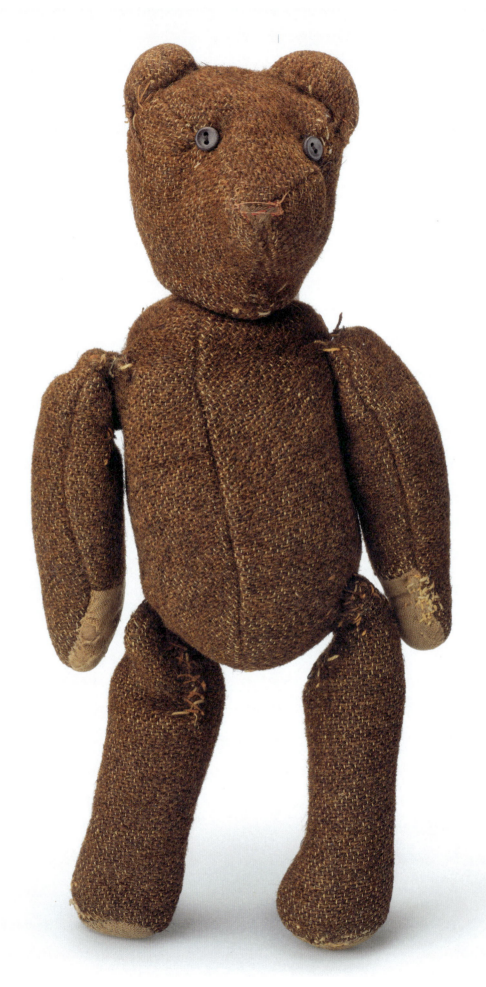

CAT. 145 Anonymous, artisanal homemade production, *Martin*, France, 1916. Paris, Musée des Arts Décoratifs

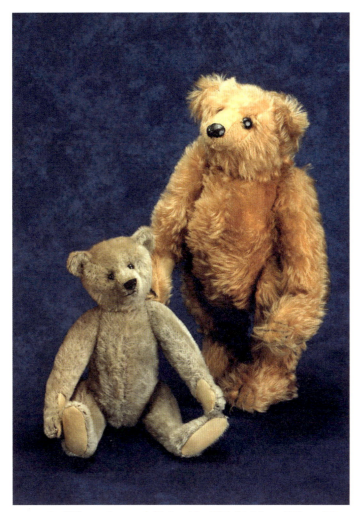

FIG. 6 Steiff (manufacturer), Richard Steiff Teddybär and Bär 28 PB, Germany, 1904. Giengen an der Brenz, Margaret Steiff GmbH

To stand out from competitors, Steiff patented its trademark metal "button in the ear", which had been used since 1904 and is still in use today. In fact, Germany had long been a major hub for manufacturing and exporting toys. Manufacturers quickly entered this successful market. This included Bing, in 1907, which was one of the world's largest toy companies, with 3,000 employees.[13] In Sonneberg, where a number of small firms, relying on a network of home workers, were already making soft toys, new companies like Educa and the Hermann brothers were reorganizing their production to offer high-quality teddy bears for export. In a volatile job market, workers moved from one factory to another with their ideas, skills, and knowledge, contributing to the exceptional vitality of the German toy market.[14] To maintain dominance, Steiff innovated and, in 1909, offered a new golden fur, followed by a colored bear in 1913, a hot-water bottle bear in 1911, and so on.[15] Starting in 1908, Steiff bears also growled, the result of a variety of mechanisms that were a common feature in the first half of the twentieth century but have since disappeared.

THE INSTANT SUCCESS OF TEDDY BEARS

For German brands, the American market was of the utmost importance. Initially dismissed by the press as a passing fad,[16] the teddy bear quickly became established,[17] both in toy stores and in the cultural landscape (CAT. 58, CAT. 61), even surpassing dolls.[18]

While American production was gradually taking shape, these German brands remained the benchmark in the industry. Ideal Toy boasted that it was selling exact replicas of foreign models at half the price.[19] Like Steiff bears, Ideal bears featured a hump at the top of their backs and boot-button eyes, but could be distinguished by their triangular heads with broad foreheads and wide-set ears. The pads on their paws were somewhat pointed, and their arms were long and curved, with a plump body (CAT. 62). In the late 1910s, a number of short-lived American brands emerged to feed this growing market: Bruin, Aetna, Hecla, and others. The coincidence may seem surprising, but the teddy bear really was simultaneously born in the United States and in Germany. The success of Roosevelt's story fueled demand for German bears, in a virtuous cycle that stimulated the toy's popularity.

The teddy bear also thrived beyond Germany and the USA. In France, where the toy was never called a teddy bear, *l'ours en peluche* would always keep the name of the first Steiff bears, as well as ties to the plush material, called *peluche* in French. As early as 1907, it was featured in the catalogs of Parisian department stores, the preferred places to purchase toys (CAT. 106, CAT. 108).[20] In France, too, the toy

and a less pointed muzzle. It was stuffed with straw and wood wool, but also with kapok, a vegetable fiber obtained from tropical trees, making the bear lighter. But the true innovation was in the joints, which were now made of cardboard discs inserted on both sides of the limbs and linked together. These new bears, named PAB (A for *angeschiebt* or 'with discs'), were available in white, dark brown and light brown. Margarete Steiff was delighted and renamed them *Bärle*, an affectionate nickname meaning 'little bear' (CAT. 87).

Steiff had achieved success, and the factory had to expand several times, adding modern, bright, glass buildings to make it easier for the seamstresses to work. In 1907, with 400 employees and 1,800 home workers, the factory produced 1,700,000 toys, including 973,999 *Teddybären* (CAT. 89).[11] This name, derived from English, was adopted as early as 1906, to make it easier to connect with the American market.[12]

11 Pauline Cockrill, *The Teddy Bear Encyclopedia*. London: Dorling Kindersley, 1993, p. 38.
12 Maniera, op. cit., p. 44.
13 Ibid., p. 92.
14 Ibid., p. 52.
15 Cockrill, op. cit., p. 22.
16 "The Teddy Bear Craze in New York," *The San Francisco Sunday Call*, November 18, 1906; "Fad of the Teddy Bear," *The Cairo Bulletin*, January 10, 1907.
17 "Teddy Bear to Stay," *The Evening Star*, March 13, 1909; "News From Toyland," *The Daily Missoulian*, December 20, 1910.
18 *The Sun*, November 4, 1906, p. 6.
19 Maniera, op. cit., p. 33.
20 See the gift catalogs: *À la Samaritaine Paris, Étrennes, Jouets*, 1908; *Au Bon Marché, Étrennes, Jouets*, 1908; *Maison Bail, Jouets, Jeux*, 1908.

The History of the Teddy Bear 37

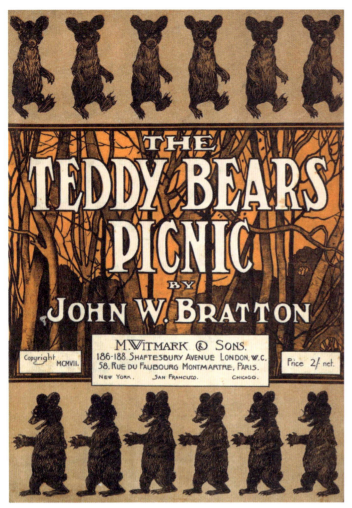

CAT. 61 John Walter Bratton, *The Teddy Bears' Picnic*, 1907. Paris, Bibliothèque du Musée des Arts Décoratifs

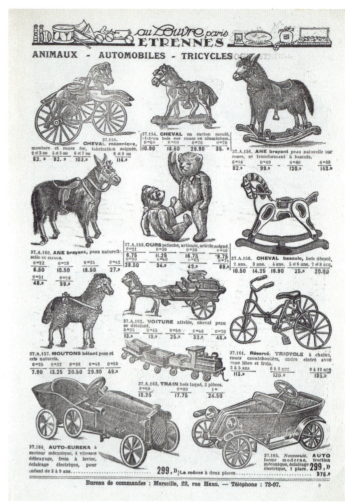

CAT. 106 *Au Louvre. Jouets, 1925-26* (At the Louvre. Toys, 1925-26), sales catalog, 1925. Paris, Bibliothèque du Musée des Arts Décoratifs

was soon a success, as reflected in articles in the general press[21] and in women's magazines.[22]

France was also a major toy manufacturer, specializing in luxury dolls with porcelain faces and lavish sets of clothing and accessories. But there was no history of manufacturing stuffed animals in France. With their fur- and fabric-covered mechanical toys, Roullet-Decamps and Fernand Martin offered a very different type of toy (CAT. 44). It is likely that the first teddy bears to be sold in France were imported from Germany, but department stores were in the habit of erasing the names of manufacturers to increase their own prestige, which makes it challenging to identify the bears. Steiff, however, did operate in the French market and, in 1911, created Steiff Frères.

In the UK, where the teddy bear craze was even more widespread, local production soon took off. One paragraph in the whimsical news section of the August 14, 1911, edition of *Liberty* reported that teddy bears were so popular, and so big, that during school breaks, they cluttered up train compartments andsometimes even occupied seats. In response to complaints, some companies took action: "Teddy is going to be treated as a dog and, from London to Margate, he'll have to pay a shilling for the transport of his fluffy, cumbersome person."

Some factories converted their operations to keep up with the trend. Thus, in 1906, J. K. Farnell, a silk goods trader and manufacturer since 1840, created a teddy bear with a pointed muzzle, long limbs, and a humped back. The eyes were made from boot buttons, like all the others, but the company soon opted for glass instead. W. J. Terry, a fur trading company founded in 1890, made fur toys, and in 1913 the company created a bear that was quite similar to those of its competitor. Chad Valley, a former printing firm, launched its own bear in 1915.[23] Dean's Rag Book Co. Ltd. manufactured bears printed on fabric, which you could cut, sew, and stuff yourself.

In just ten years or so, teddy bears had become extremely popular toys. But this did not mean the toy was affordable; families without the means to buy them could opt for home-made bears (CAT. 145). Sturdiness and safety were strong selling points, and in France the teddy bear

21 *Le Figaro*, December 27, 1906; *Comoedia*, December 23, 1908.
22 *Femina*, December 15, 1912.
23 Maniera, op. cit., p. 59.

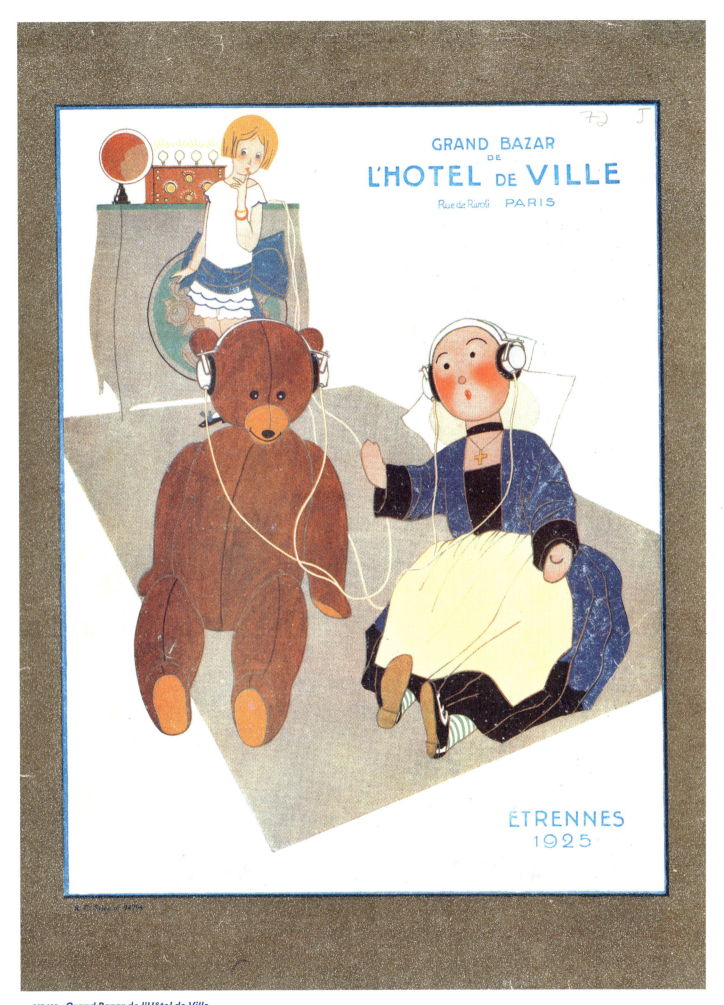

CAT. 108 *Grand Bazar de l'Hôtel de Ville. Étrennes 1925* (Grand Bazar de l'Hôtel de Ville. Gifts 1925), sales catalog, 1924. Paris, Bibliothèque du Musée des Arts Décoratifs

The History of the Teddy Bear

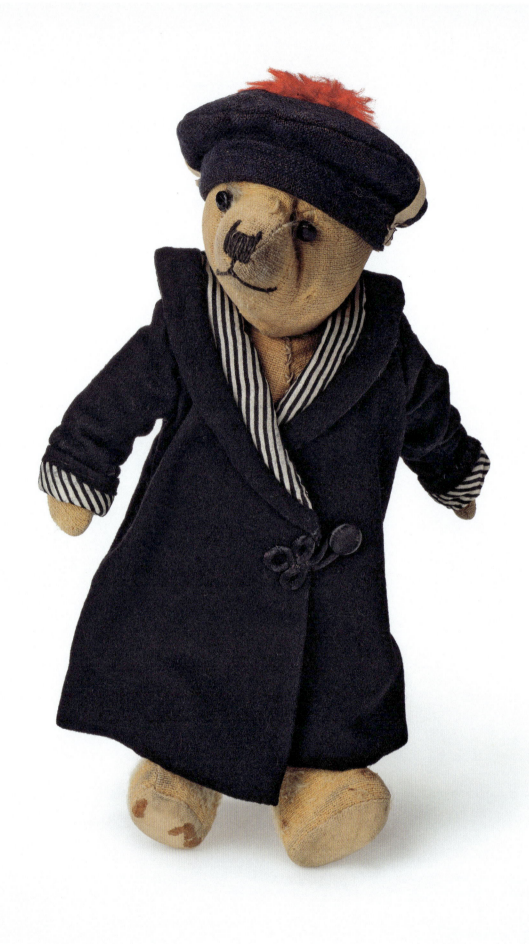

CAT. 148 *Bimpo*, c. 1932. Paris, Musée des Arts Décoratifs

CAT. 114 Child playing with a teddy bear, postcard, 1925.
Paris, Bibliothèque du Musée des Arts Décoratifs

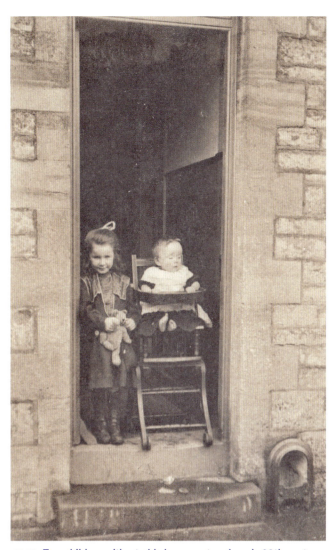

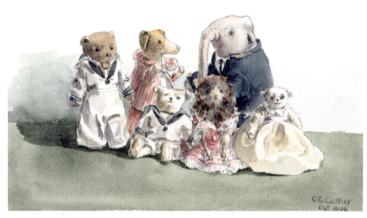

CAT. 110 Two children with a teddy bear, postcard, early 20th century.
Paris, Bibliothèque du Musée des Arts Décoratifs

FIG. 7 Célia Cattley, watercolor from toy album of the Cattley family, 1908.
London, Victoria and Albert Museum

was seen as an ideal gift for the youngest children.[24] Beyond these practical advantages, the teddy bear rapidly found a special place in the world of toys. The sheer abundance of postcards and studio photographs depicting children with teddy bears makes it clear that these stuffed animals were special companions (CAT. 110, CAT. 114), either because children wanted to have their picture taken with their bear, or because the photographer offered one to keep them busy or to soothe them.

This success is not hard to understand, as the teddy bear meets the need for a soft toy that can be used by any child. At a time when dolls were strictly marketed for girls, it provided an alternative for boys—and for girls, too, as dolls were still fragile and harder to cuddle than bears. The theory that the teddy bear was a doll for boys is supported by the existence of dressed teddy bears (CAT. 148).[25] Playing with dolls, however, had the very specific function of teaching little girls about their future role as mothers and wives, through imitating the care provided in motherhood. In the early twentieth century, dolls evolved in this direction, to allow for increasingly maternal gestures. They became babies to be cradled in one's arms, and eventually could even be bathed, due to the use of celluloid. The teddy bear, due to its ursine nature, escaped this realm of imitation and presented another type of play, one based on companionship and cuddling, which girls and boys could both enjoy. In London, for example, in the late 1900s, the three girls and two boys of the Cattley family looked after a whole menagerie of stuffed animals, including nine bears, which they dressed, brushed, and pampered (FIG. 7). As demonstrated by Winnie-the-Pooh, teddy bears were considered to be more like friends with whom children could discover the world, rather than offspring to be raised.

This unprecedented bond with a toy was fostered by the emergence of a new perspective on childhood, and a new place for children in society. Following demographic growth and the development of a vision of the family linked to the rise of the bourgeoisie and the spread of Enlightenment ideas

24 See *Jouets, étrennes 1913, pendant tout le mois de décembre,* [Noël 1912–étrennes 1913], sales catalog, Paris, Grands Magasins du Louvre, 1912; *L'École nouvelle. Les intérêts de l'école et du personnel,* 17th year, no. 15, January 10, 1914, p. 174; Dr. Marguerite Bonnin, "Les jouets, leur utilité dans l'éducation de l'enfant," *Parigiana,* December 25, 1909.
25 Pauline Cockrill, op. cit., p. 9.

The History of the Teddy Bear

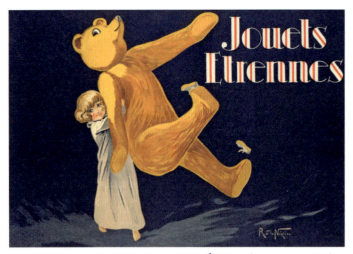

CAT. 109 Raymond de La Nézière, *Jouets Étrennes* (New Year's Toys), poster, c. 1925. Paris, Musée des Arts Décoratifs

on education, by the late nineteenth century childhood had emerged as a special age, with its own specificities to be respected in education, care, and leisure. In fact, it was in 1900 that Ellen Key, the influential Swedish philosopher and teacher, wrote *The Century of the Child*.

BEARS AND TEDDY BEARS

Michel Pastoureau's research, like the stories collected by folklorists,[26] underscores the close ties between bears and humans, developed over thirty thousand years of cohabitation and frequent encounters.[27] In our culture, the bear holds a place that no other animal can challenge.

The most significant characteristic of the bear is the ease with which it can be anthropomorphized, given the traits it shares with humans: it stands upright, is plantigrade, and an omnivore. Following our counterpart as we spread across the planet, we found favorable conditions for our species—food, habitat, etc. Many stories have been told about bears and women mating or living as a household (*Jean de l'Ours* or the ursine ancestors of the kings of Denmark and Sweden[28]), or about young children raised by bears, and these tales render bears and humans almost interchangeable.[29] The sexual dimension is also important, as no other animal's sexuality has been so carefully dissected.[30]

Our biological proximity to the bear has allowed us to create empathetic relationships and to project human feelings onto it, reinforced by its sociability with our species.[31] Over the years, the bear has danced, jumped, and performed tricks for us. Whether we look at folktales and legends depicting bonds of kinship, filial relationships and alliances, or examine bears' natural behaviors, everything underscores the permeability of the boundary between us.[32] The bear thus exists as a bridge between our specifically human nature and our animal side,[33] a link between nature and ourselves, but also between us and the divine. It is an object of worship[34] for Arctic and sub-Arctic peoples,[35] as well as for groups in northern Eurasia (like the Sami) or the Ainu of Hokkaido.

Political battles were fought with toys when Billy Possum, the stuffed toy opossum mascot made to represent William Taft, Roosevelt's successor in the White House, was launched in 1909. Hoping to replicate the success of the Teddy bear, toy manufacturers actively promoted Billy,[36] to no avail. The Teddy bear was not just any toy, because the bear was not just any animal. It simply could not be dethroned by an opossum, just as none of the other animals made by Steiff at the end of the nineteenth century would ever achieve the same dazzling success.

AN ENDURING SUCCESS

The First World War altered the playing field: German toys could no longer be exported, and English mohair could not be imported into Germany. After the war, Steiff faced economic difficulties and found it necessary to reinvent its materials. While European toy manufacturers were already selling a few teddy bears, they had to stop sourcing products from Germany. In France, major campaigns were launched to showcase French toys, including exhibitions at the Musée des Arts Décoratifs.

As early as 1909, Marcel Pintel, the head of a factory that had existed since 1890 and had been galvanized by Steiff's success, was considering the possibility of producing stuffed toys in France—first dolls, then animals. In 1911, Pintel was listed in the toy manufacturers' directory as a manufacturer of toys made of cloth, plush, felt, and velvet, though it had still been a manufacturer of metal toys in the year prior. The first Pintel bears, however, were not teddy bears as we know them, but mechanical bears, covered in felt or plush fabric. It wasn't until 1919 that the first Pintel [37] bear was born, with slender, elegant limbs, a long, pointed and prominent muzzle, and a serious expression **(CAT. 139)**. Pintel dominated the French teddy bear market, and the company's stand at the International Exhibition of Modern Decorative and Industrial Arts in 1925 was dominated by a teddy bear.

26 Roger Maudhuy, *Mythes et légendes de l'ours*. Ciboure: Pimientos, 2012.
27 Owen T. Nevin, Ian Convery, and John Kitchin, "Knowing Individual Bears," in *The Bear: Culture, Nature, Heritage*, ed. Owen T. Nevin, Ian Convery, and Peter Davis, op. cit., p. 80.
28 Owen T. Nevin, Ian Convery, Peter Davis, John Kitchin, and Melanie Clapham, "Introduction: What Is a Bear?" in *The Bear: Culture, Nature, Heritage*, ed. Owen T. Nevin, Ian Convery, and Peter Davis, op. cit., p. 5.
29 See Michel Pastoureau, "L'ours européen. Histoire d'un animal vénéré puis maudit," *supra*, pp. 11–21.
30 Sophie Bobbé, *L'ours et le loup. Essai d'anthropologie symbolique*. Paris: Éditions de la Maison des sciences de l'homme, 2002, p. 6.
31 Ibid., pp. 19 and 26.
32 Ibid., p. 29.
33 Nevin, Convery, and Kitchin, op. cit., p. 80.
34 Jeff Meldrum, "Bears, Wildmen, Yeti and Sasquatch," in *The Bear: Culture, Nature, Heritage*, ed. Owen T. Nevin, Ian Convery, and Peter Davis, op. cit., p. 55.
35 Kristinn Schram and Jón Jónsson, "Visitations: The Social and Cultural History of Polar Bear Narratives in Iceland and the North Atlantic," in *The Bear: Culture, Nature, Heritage*, ed. Owen T. Nevin, Ian Convery, and Peter Davis, op. cit., p. 147.
36 Jeffries, op. cit., p. 25.
37 "Fadap et Pintel, 50 ans d'ours français," *La Vie du jouet*, October 2001, p. 28.

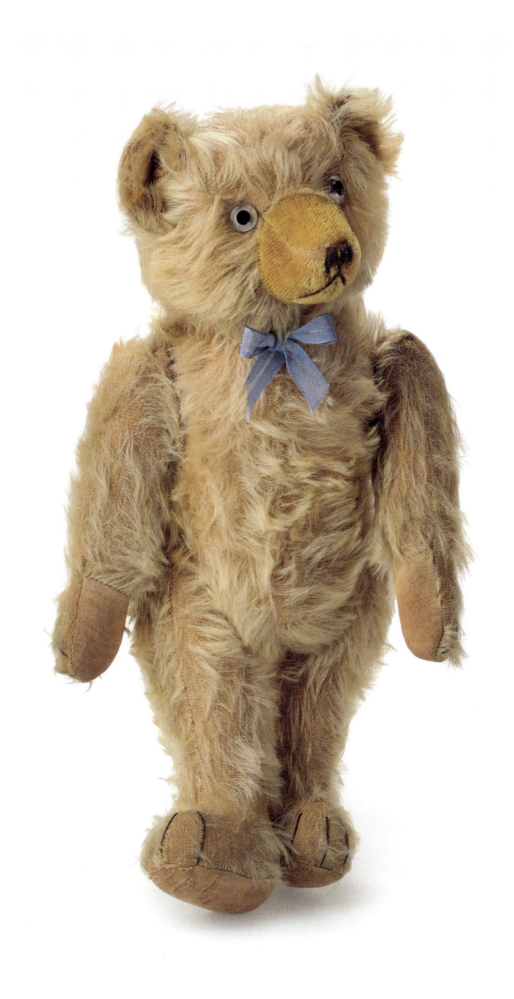

CAT. 139 Pintel (manufacturer), *Growler*, France, c. 1935. Paris, Musée des Arts Décoratifs

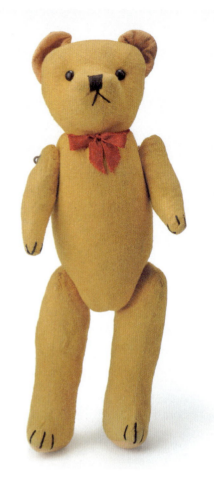
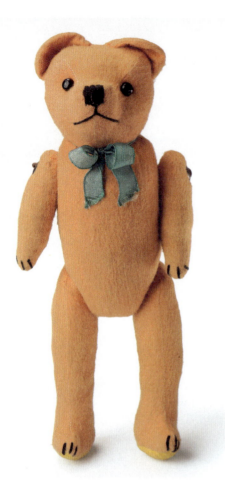
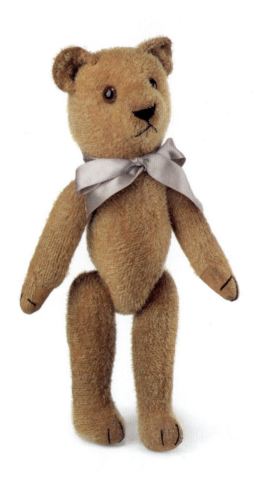

CAT. 134, 135, 136, 137
Articulated bears, France,
c. 1935. Paris,
Musée des Arts Décoratifs

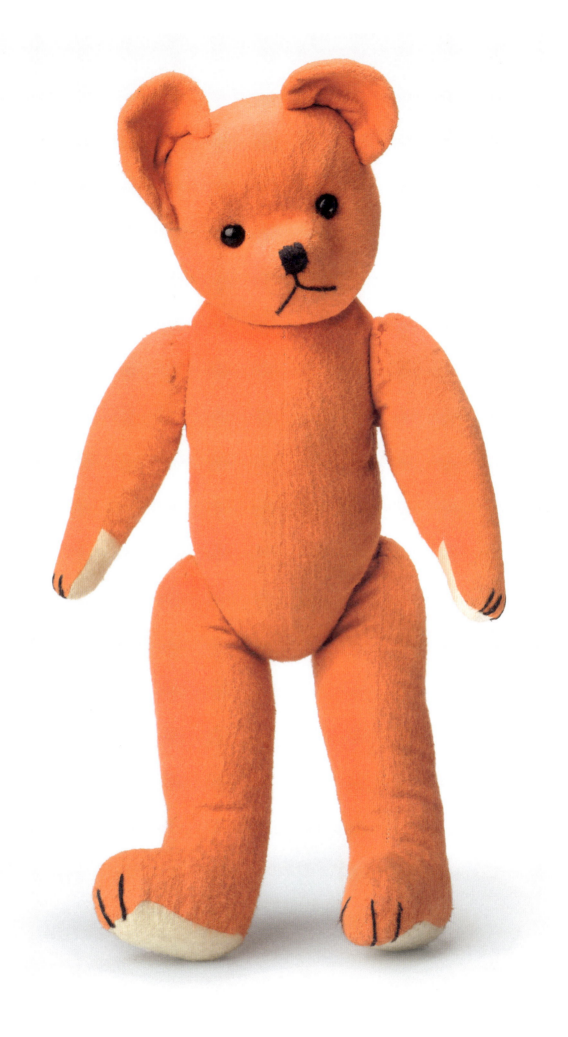

The History of the Teddy Bear 45

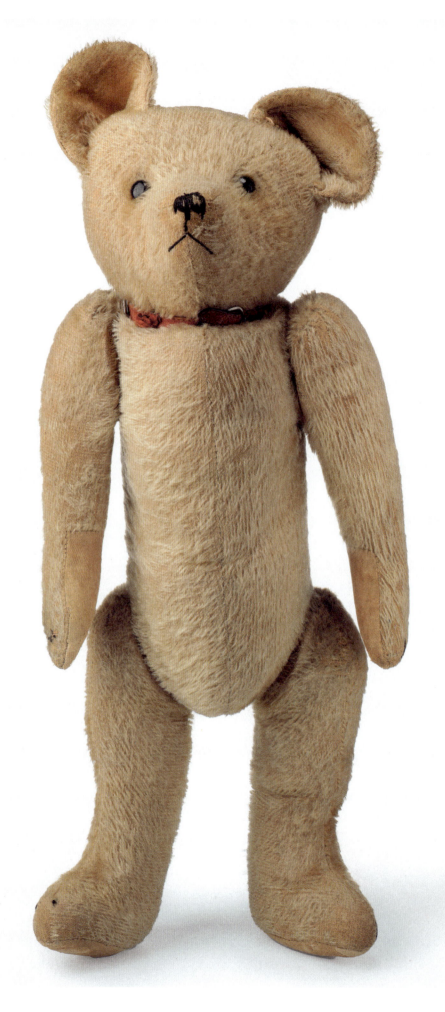

CAT. 141 Fadap (manufacturer), teddy bear, France, 1932–1934. Paris, Musée des Arts Décoratifs

The company's Paris factory employed over a hundred people, 80% of whom were women. Pintel exported products to the United States and published bilingual catalogs, while tensions ran high over the issue of German imports, and as the German industry recovered from the devaluation of the Deutschmark in 1923.

The French production process took shape in the 1920s, through the founding of companies like the Fabrication Artistique d'Animaux en Peluche, also called Fadap, and Thiennot.[38] The French bears were less sophisticated and did not benefit from the German manufacturers' many years of experience (CATS. 134 TO 137). The mohair fur was short and could be prickly,[39] the metal joints could be visible from the outside, the ears, instead of being sewn on, were set into holes in the head, and the eyes were sewn onto the face.[40] With designers and workers often changing factories, the French bears of this era all have a family resemblance. Like Pintel bears, Fadap bears featured a long body, a slender head, and a neck practically fused to the body, but the snout was elongated, made with shaved mohair fur and, especially, had a snubbed nose, which was a distinguishing feature (CAT. 141).

In the women's supplement to *L'Écho de Paris*, on January 3, 1922, a nurse gave advice about toys, criticizing teddy bears and other stuffed animals for acting as dust traps. Still, she acknowledged, children could not be deprived of one of their favorite toys: the teddy bear had quickly become an enduring fixture.

More companies continued to spring up, including Merrythought in the UK, in 1930 (CAT. 144), Alfa Paris, in 1934, and Les Jouets Bourrés, in the late 1930s. In the USA, this long-term success led to the mass production of average-quality bears by companies that have since been forgotten. American teddy bears from the 1910s were copies of Steiff models, while those from the post-World War I era were known as 'stick bears' because of their slender limbs and unsophisticated features.[41]

38 Maniera, op. cit., p. 111.
39 Cockrill, op. cit., p. 48.
40 Maniera, op. cit., p. 110.
41 Cockrill, op. cit., p. 46.
42 Maniera, op. cit., p. 111.
43 Jeffries, op. cit., p. 27.

A few decades after it was created, the bear evolved and underwent its first significant changes. While the nose, mouth, and claws were still hand-embroidered, the boot-button eyes, made of compressed wood pulp, were replaced with glass eyes like those used by taxidermists. Wood wool was replaced with kapok, which had previously been used to stuff jackets and cushions. The kapok was lighter and softer, resulting in rounder bodies like those of the Steiff bears. The color palette grew, moving away from the colors of real bear fur (CAT. 150). Two-toned mohair was used by Steiff, and French manufacturers, especially Fadap, used rayon in a range of hues.[42] The German brand Schuco offered miniatures, sometimes in brightly colored mohair, halfway between toy and gadget, which could be used as lipstick or perfume cases: the teddy bear had evolved into a range of accessories (CAT. 151).

In 1930, Steiff began an interesting shift that would continue after the end of the Second World War, offering more childlike teddy bears. These models were far removed from the first ones, which had pointed muzzles and realistic humps on the back—still close to wildlife.[43] Early models included Dicky, with his broad smile (CAT. 100), and the very popular Teddy Baby (CAT. 99), whose open mouth looks as if he is laughing. This is when the teddy bear became cute.

The History of the Teddy Bear

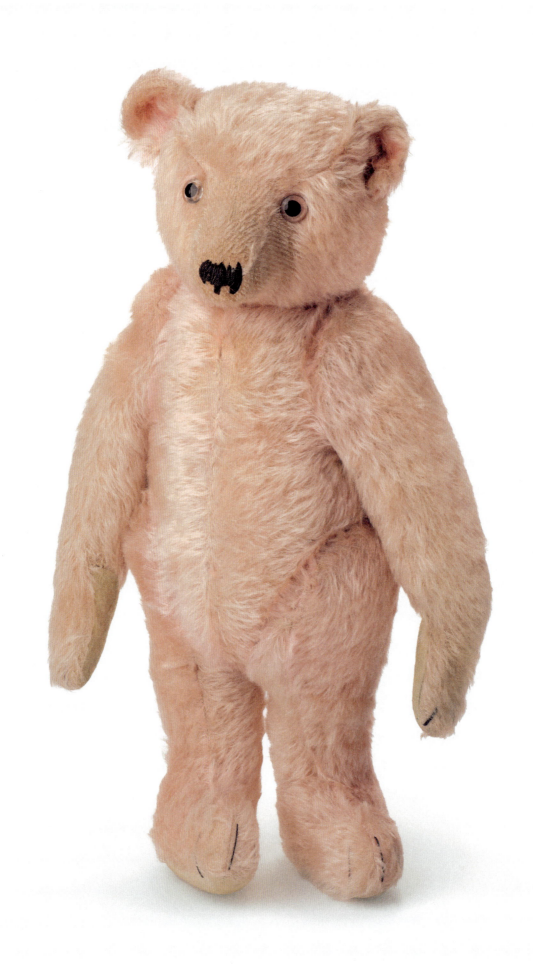

CAT. 150 Pintel (manufacturer), pink bear, France, c. 1925 or 1935. Paris, Musée des Arts Décoratifs

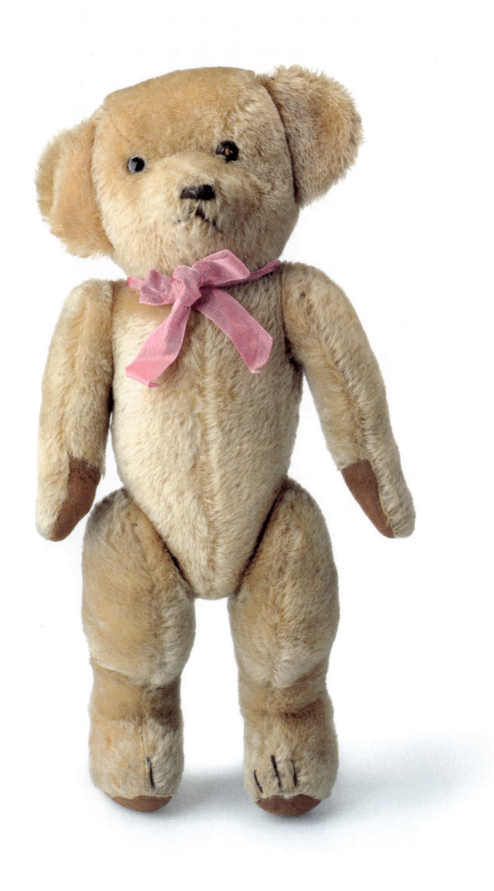

CAT. 144 Merrythought (manufacturer), bear with pink ribbon, UK, c. 1935. Paris, Musée des Arts Décoratifs

CAT. 151 Steiff (manufacturer), handbag, Germany, 1927. Giengen an der Brenz, Margarete Steiff GmbH

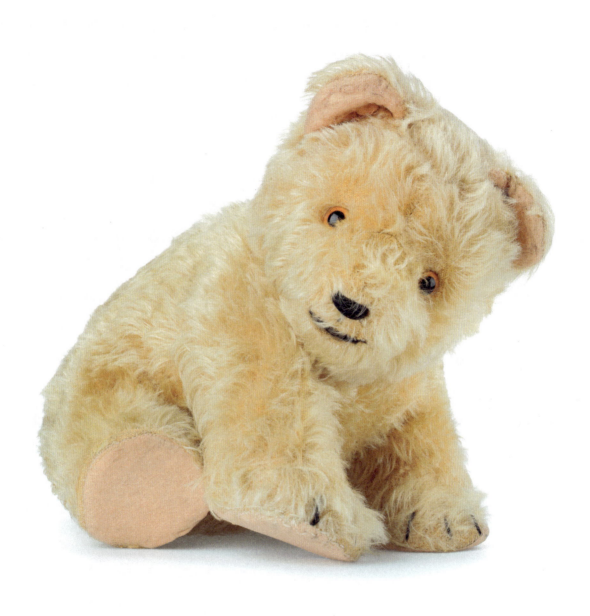

CAT. 123 Teddy bear, Germany or UK, 1927. Paris, Musée des Arts Décoratifs

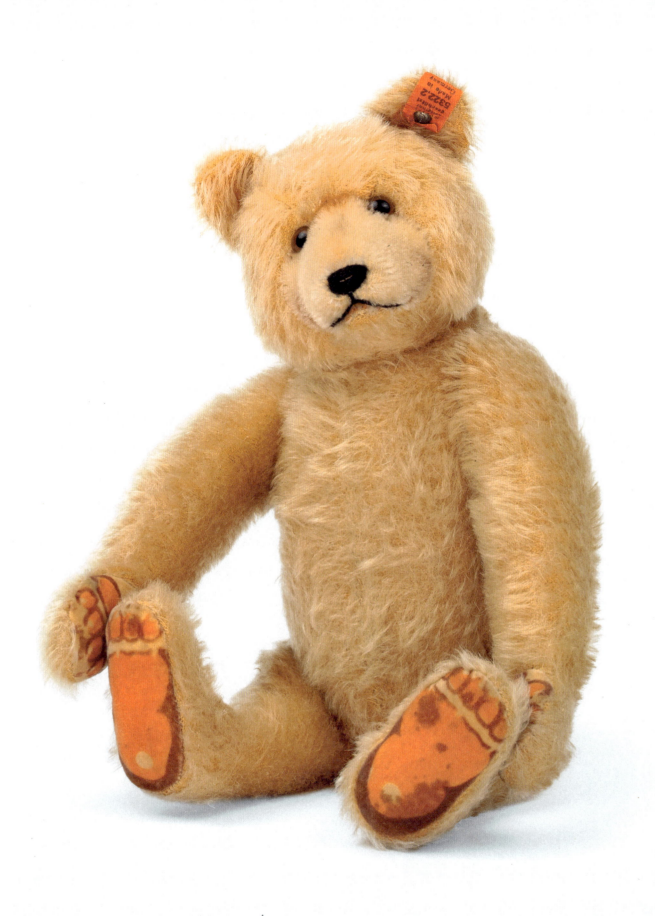

CAT. 100 Steiff (manufacturer), *Dicky*, Germany, 1930. Giengen an der Brenz, Margarete Steiff GmbH

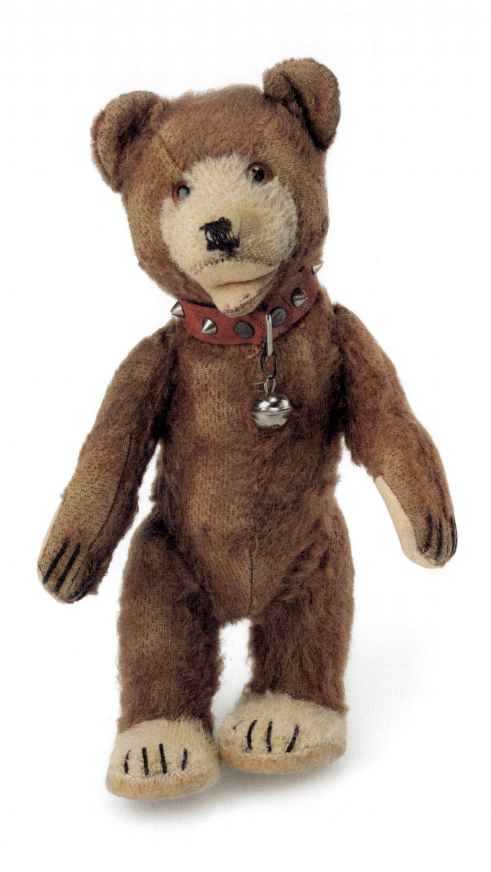

CAT. 99 Steiff (manufacturer), *Teddy Baby*, Germany, c. 1930. Paris, Musée des Arts Décoratifs

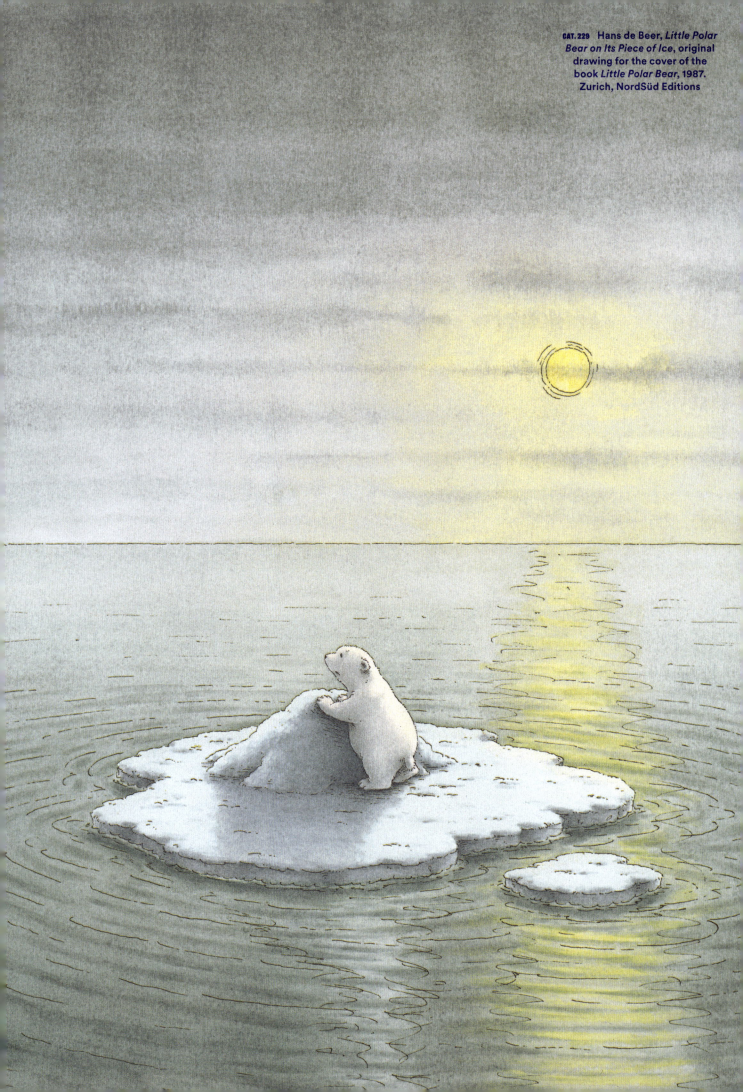

CAT. 229 Hans de Beer, *Little Polar Bear on Its Piece of Ice*, original drawing for the cover of the book *Little Polar Bear*, 1987. Zurich, NordSüd Editions

Hélène Valotteau

Michka, Otto, Ernest, Nounouk, Plume, Winnie, Paddington, Bourru, Bernie, Pompon, Petit Pote, Calinours, Little Brown Bear. Whether they are the heroes of a single short story or a series of long adventures, these bears have all accompanied children for generations, well before they turned up in movies or on TV. Some remain anonymous, or are just called 'Bear', like the character drawn by Junko Nakamura as the symbol of the publishing house MeMo.
Some of these bears have real fur that can be touched, as in *Little Fur Family* by Margaret Wise Brown and Garth Williams (1946). Others exist only on paper, but their furry coats still demand to be cuddled. These children's books are themselves like beloved stuffed animals, who are there for our childhood joys and sadnesses. Rooted in our memories, they soften the image of the gigantic, ferocious, hairy bears who are the 'villains' of children's tales. Whether the books are about real bears or stuffed animals that come to life, and whatever their color, the best-known ones are male bears. However, there are some female bears that are very significant in children's literature. This is true of the female bear symbolizing the highest honor given every year by the children's book fair in Montreuil, the Salon du Livre et de la Presse Jeunesse: the Grande Ourse. In 2023, the prize was awarded to Beatrice Alemagna for her body of work.[1] We should also recall the female bears who come in threes—the "Trois Ourses" of the non-profit organization founded by Annie Mirabel, Élisabeth Lortic, and Odile Belkeddar. These symbolic figures, accompanied by several male and female bears and cubs, have advocated for thirty years for the artistic education of children with a focus on books. Their legacy continues and helps keep the fictional bears of our childhood safe and sound within us all.

[1] *Oméga et l'Ourse*, written by Guillaume Guéraud and illustrated by Beatrice Alemagna, was published by Panama in 2008.

BEARS ON PAPER 55

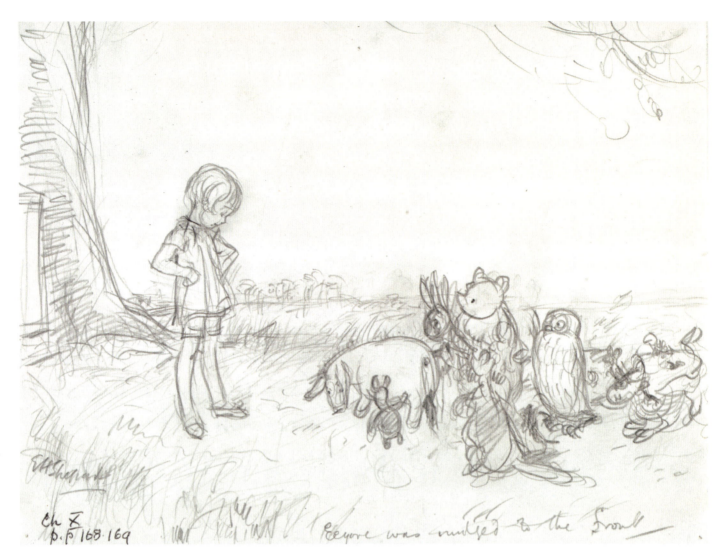

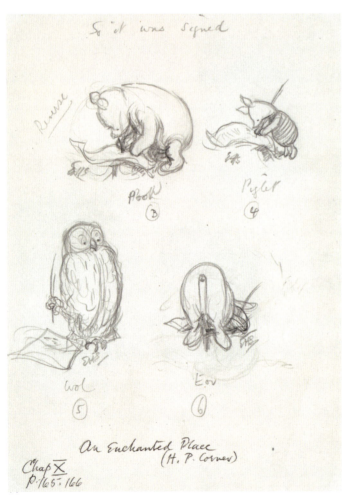

CAT. 176 E. H. Shepard, "Eeyore was nudged to the front," *The House at Pooh Corner*, 1928. London, Victoria and Albert Museum

CAT. 187 E. H. Shepard, "So it was signed," *The House at Pooh Corner*, 1928. London, Victoria and Albert Museum

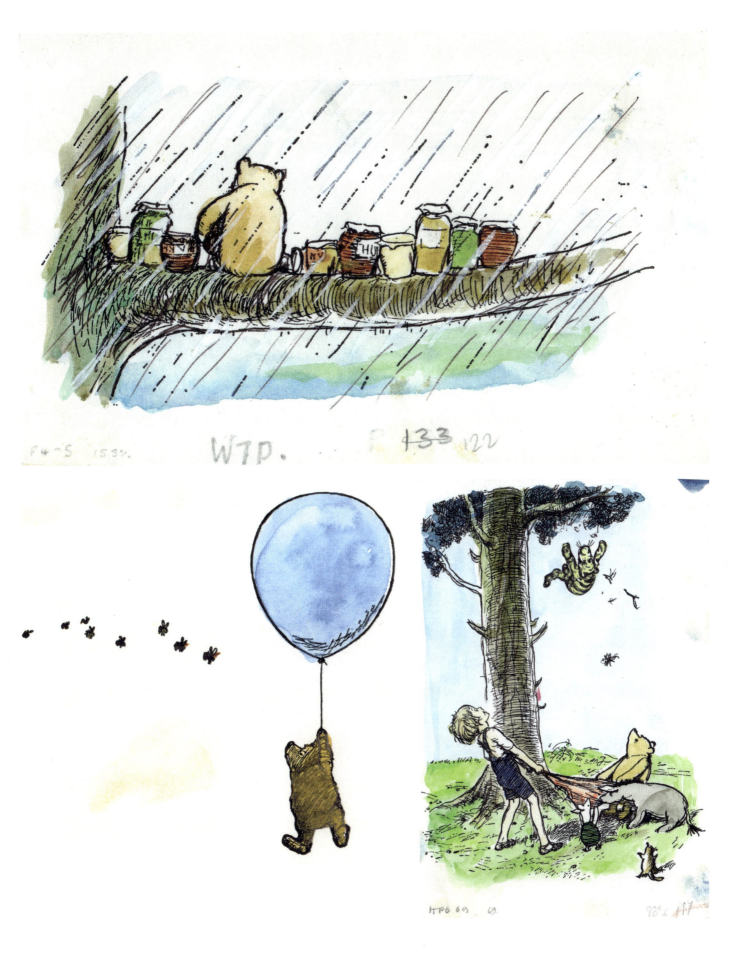

CAT. 174 E. H. Shepard, *Winnie-the-Pooh Sitting on Branch in the Rain with Honey Pots*, 1970. Guildford, Egmont UK Collection, University of Surrey

CAT. 173 E. H. Shepard, *Winnie-the-Pooh Floating under a Balloon with Bees*, 1970. Guildford, Egmont UK Collection, University of Surrey

CAT. 186 E. H. Shepard, *Tigger Falling out of a Tree, with Christopher Robin, Piglet, Eeyore, Winnie-the-Pooh and Roo Waiting to Catch Him*, 1970. Guildford, Egmont UK Collection, University of Surrey

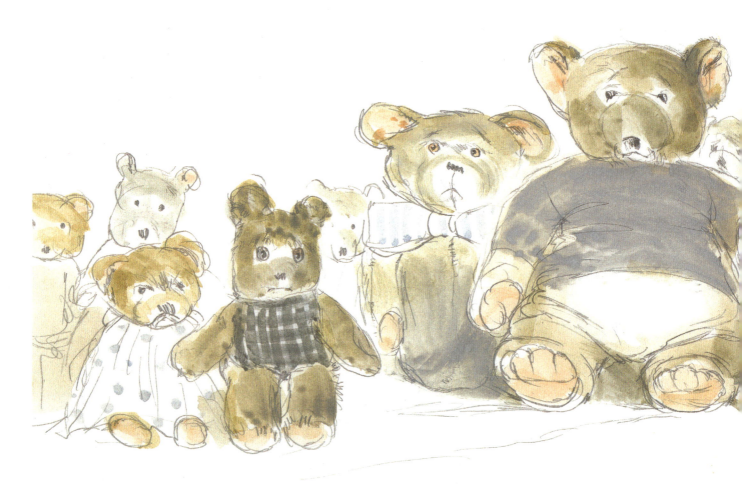

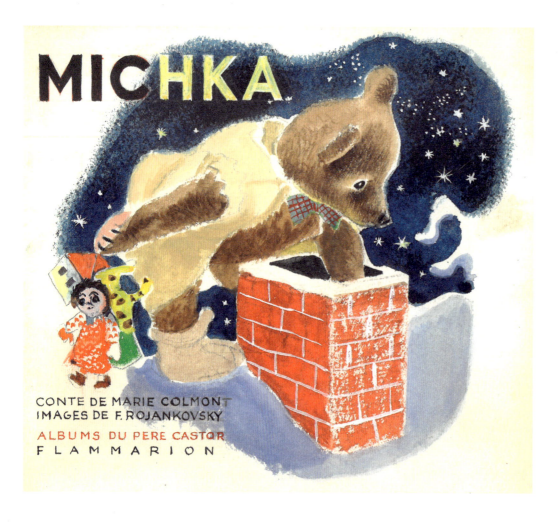

CAT. 214 Gabrielle Vincent, *Au bonheur des ours* (To the Happiness of Bears), original drawing, 1993. Charleroi, Fondation Monique Martin/Gabrielle Vincent

CAT. 189 Feodor Rojankovsky, *Michka*, draft not selected for cover, 1941. Meuzac, Maison du Père Castor

RIGHT PAGE CAT. 215 Gabrielle Vincent, *La Naissance de Célestine* (The Birth of Célestine), original drawing, 1993. Charleroi, Fondation Monique Martin/Gabrielle Vincent

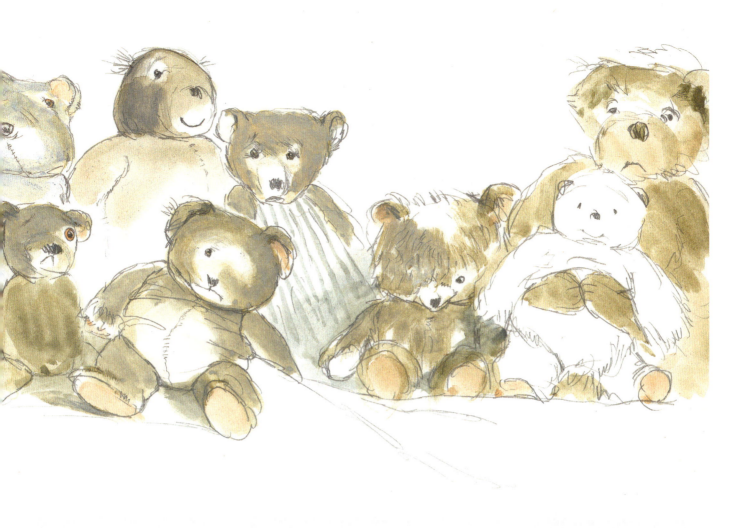

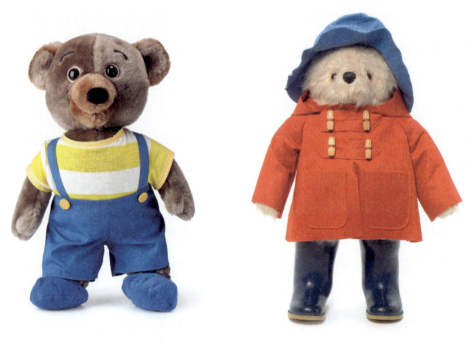

CAT. 211 Danièle Bour, *Petit Ours Brun joue à la dînette* (Little Brown Bear is having a tea party), 1999. Paris, Les Arts Décoratifs

CAT. 242 Danièle Bour (designer), Boulgom (manufacturer), *Petit Ours Brun* (Little Brown Bear), France, c. 1989. Paris, Musée des Arts Décoratifs

CAT. 193 Gabrielle Design Bears, *Paddington*, UK, 1974. Paris, Musée des Arts Décoratifs

RIGHT PAGE CAT. 197 Margaret Wise Brown (author), Garth Williams (illustrator), *Little Fur Family*, 1946. Paris, Ville de Paris/fonds patrimonial Heure Joyeuse

LITTLE FUR FAMILY

BOOK BY MARGARET WISE BROWN
PICTURES BY GARTH WILLIAMS

CAT. 272 Fisher-Price (manufacturer), *Teddy Betsy Bear*, United States (design), Korea (manufacture), 1986. Paris, Musée des Arts Décoratifs

FROM BEAR TO *DOUDOU*

Anne Monier Vanryb

63

CAT. 284 Benoît Piéron, *Peluche psychopompe VIII* (Stuffed Animal Psychopomp VIII), 2022. Paris, courtesy of Benoît Piéron & Sultana

CAT. 288 Julien Béziat, original illustration for *Le Mange-Doudous* (The *Doudou*-Eater), Paris, l'école des loisirs, 2013. Bordeaux, collection of Julien Béziat

THE OBSESSION WITH THE DOUDOU OR BELOVED STUFFED ANIMAL

The anxiety of losing this beloved 'stuffie' hangs over parents like the sword of Damocles, leading them to develop very elaborate strategies to avoid such a 'tragedy'. It has a name and place in family photos, although it is never washed, except after long negotiations. It is the child's chosen one, confidant, and best friend, who is there for all their secrets and joys, but also all their fears and tantrums.

The *doudou* is not like other toys. In *Le Mange-Doudous* by Julien Béziat[1] (CAT. 288), a monster appears in a child's room and begins eating all his stuffed animals. But he cannot eat the *doudou*, the favorite one, who is too full of tears and drool, symbolic of the child's feelings and memories. So this stuffed animal is saved precisely because it is not clean—a source of frequent disagreement between parents and children. The sense of smell is especially dominant in children from the early stages of their fetal development. This is something that adults forget, and they tend to see the *doudou*, a true repository of reassuring odors that have been patiently assembled, as a disgusting rag.

Parents are involved in the relationship between the child and the *doudou*, offering approval or disapproval. If they respect the fact that the *doudou* is a child's first possession separate from their body, if they understand the child's need to find it day after day just as they left it, without any changes except those made by the child themself, the *doudou* can fully play its role in the child's development.

This item inspires irrational behavior, especially in case of loss, an event that can have dramatic consequences. If the *doudou* is lost, an announcement may be made with a photo, description, and sometimes a reward (like the restaurant owner who offered a year of free hamburgers to anyone who could find his daughter's teddy bear),[2] with the daily regional press serving to spread the word.[3] The reverse can also happen when newspapers or shopping centers[4] seek the owner of a *doudou* that has been found, and the police may even become involved![5] Adults who are not the parents in question are, thus, also aware of the extreme importance of this object and the need to find it. At the end of an article about maintenance workers on French highways, *La Nouvelle République* reminds traveling families of what should be done if an item is lost on the road:

> In the special case of a *doudou* (how could a child enjoy the trip without their *doudou*?), it is possible that maintenance workers can send it in a package to the operations center closest to your vacation site so that it can be recovered as quickly as possible.[6]

The Vinci Autoroutes company has published instructions in case of a *doudou* lost on the highway,[7] and has created a social media hashtag, #doudouperdu. Knowing this procedure can prevent parents from stopping on the hard shoulder of the road to recover a stuffed animal that has been thrown through an open car window.[8] The company describes its approach as a solid support system established by its social media team. Widespread use of the internet naturally makes it easier to search for lost *doudous*, with special websites devoted to this subject.[9] However, it can be observed that most of these sites emphasize links to other sites offering similar *doudous*, either new or used, for sale. Using social networks, especially with local connections, increases the chances of finding the lost item.

New technologies can be involved, with some stuffed animal manufacturers allowing parents to register the item with a unique number to help find it if it is lost. The Pamplemousse Peluches

1. Julien Béziat, *Le Mange-Doudous*. Paris: L'École des loisirs, 2013.
2. "Pau: des burgers contre un doudou retrouvé, et de généreux bienfaiteurs," *Sud Ouest*, May 23, 2023.
3. "Dijon: un doudou a été égaré, l'avez-vous trouvé?" *Le Bien public*, October 16, 2016; "Le doudou fugueur de Lucien a été retrouvé ce mardi à Limoges," *Le Populaire*, September 27, 2022.
4. "Vittel: un doudou perdu recherche sa famille désespérément," *Vosges Matin*, December 18, 2020; "Saint-Jean-d'Angély: avis de recherche pour un doudou perdu," *Sud Ouest*, August 6, 2020; "Toulouse: à qui appartient le doudou girafe?" *La Dépêche*, January 21, 2022.
5. "Doudou perdu à Colmar: la police lance un appel à témoins," *Dernières nouvelles d'Alsace*, April 21, 2021; "La police de Meurthe-et-Moselle lance une alerte 'doudou perdu,'" *L'Ardennais*, July 16, 2019.
6. "Les anges gardiens de l'autoroute," *La Nouvelle République*, July 1, 2014.
7. "Autoroute, mode d'emploi. Que faire si vous perdez un doudou durant votre trajet?" at Vinci-autoroutes.com.
8. Christophe Janssen, "L'objet transitionnel dans un contexte de fragilisation des liens," *L'École des parents*, 2016/6, special addition to no. 621.
9. For example, *Doudoù*, URL: www.doud-ou.com.

From Bear to *Doudou* 65

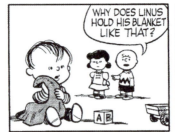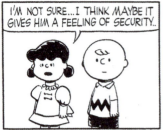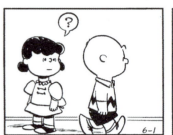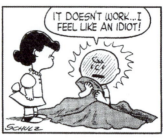

CAT. 244 Charles M. Schulz, "Linus and his blanket," *Peanuts*, June 1, 1954

company offers an even simpler solution by giving its stuffed animals QR codes. Ultimately, if the search is a failure, the parents must choose between two developmental approaches: protect the child by using ploys such as buying an identical stuffed animal, or helping the child to overcome the loss of separation.

WINNICOTT'S TRANSITIONAL OBJECT

But is it actually that easy to replace a treasured stuffed animal? The care that is taken of this object emphasizes its psychological importance. For Donald Winnicott, the most influential child psychiatrist of the second half of the twentieth century, the *doudou* is what he calls a 'transitional object'. In a lecture from 1951, "Transitional Objects and Transitional Phenomena: A Study of the First Not-Me Possession,"[10] which was published in the collection *Playing and Reality* in 1971, Winnicott explains that the human being's primary mission is to accept reality, i.e., to manage the tension that exists between our internal reality and external reality, between subjectivity and perceptions. In order to help individuals do this, there is an intermediate zone involving transitional phenomena such as art, religion, and, first of all, play. Play is thus a necessary imaginary zone for the child to create a relationship to the world. In order to play, children need physical objects that are part of external reality. Often the first ones are the thumb or fist, followed by soft objects such as a stuffed animal or a piece of blanket, and finally dolls and hard toys. The transitional object is the one that the child, at this stage of development, finds and invests with significance. It is *created* by the child. Its significance will then gradually fade as the child's cultural interests are developed. The artist Benoît Piéron, who spent his childhood in hospital rooms, produces items including *doudous* that are bats in pastel colors made of soft fabric from old hospital sheets. His practice allows him to express the voice of the others who were not fortunate enough to survive, but also to speak for those who must stay in hospital. Intended to establish a link between the living and the dead, his *peluches psychopompes* (stuffed animal psychopomps) exist in the gray area of illness and are transitional objects in several ways (CAT. 284).

What makes the *doudou* special is not its appearance, its mechanics, its educational qualities, or any other criteria generally used to judge other toys. The connection that the child makes with the object is the most important thing. Replacing a lost *doudou* with a new equivalent item does not reactivate this relationship. The fear of losing it or the demands of cleanliness may lead parents to use several identical *doudous* kept in the various places where the child stays, but this seems to contradict Winnicott's theory of an object that the child has invested with significance. However, alternating several *doudous* for the child to cuddle or keep in bed, which all absorb familiar smells, seems to work, allowing for emergency *doudous* or for leaving several *doudous* in different places. While buying and storing an object that looks the same does not correspond to Winnicott's theory, the simultaneous use of identical *doudous* can allow for dividing transitional object value among several copies of the same item. In all these cases, in attempts to balance psychiatric orthodoxy and reality, parents devote considerable time and energy to the issue of the *doudou*!

Unlike what might be expected, the transitional function of the *doudou* does not refer to the transition between the home and other places, serving to remind the child of family and home. The object is transitional because it allows the child to grasp the difference between themselves and the rest of the world. It is around the time of weaning, towards the age of six months, when children understand that they are beings separate from their mother and, therefore, that their mother can go away, that the transitional object becomes important (CAT. 285). It is quite unlikely that children had *doudous* before the nineteenth century, when their separation with the world of adults was not firmly established, and when childhood was not a time of learning and play, but often already a time of work. In societies where the child is physically surrounded by a large family and is carried and nursed by the mother for a long time, the need for a *doudou* is not felt. By the time Winnicott emphasized its importance, women's role was no longer restricted to motherhood, the family was no longer multi-

[10] "Transitional Objects and Transitional Phenomena: A Study of the First Not-Me Possession," in *Playing and Reality*. London: Tavistock, 1971. Reprinted: New York: Routledge, 1989.

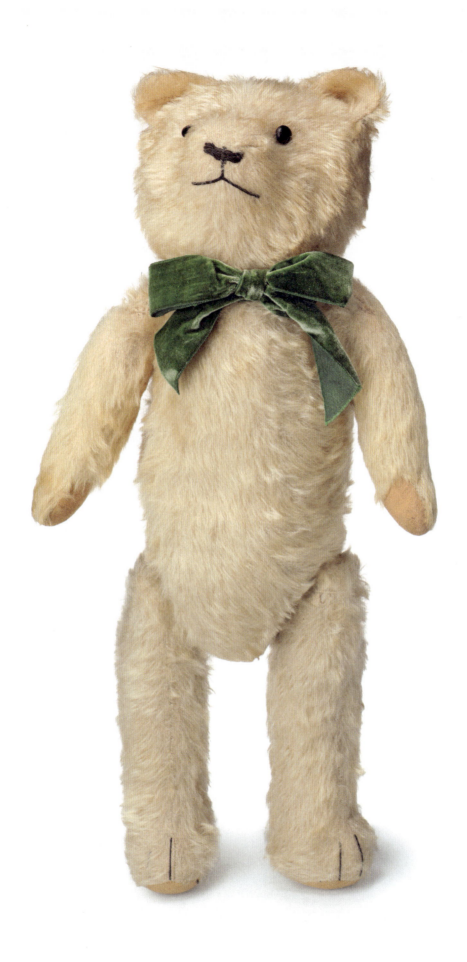

CAT. 250 White bear, 1950. Paris, Musée des Arts Décoratifs

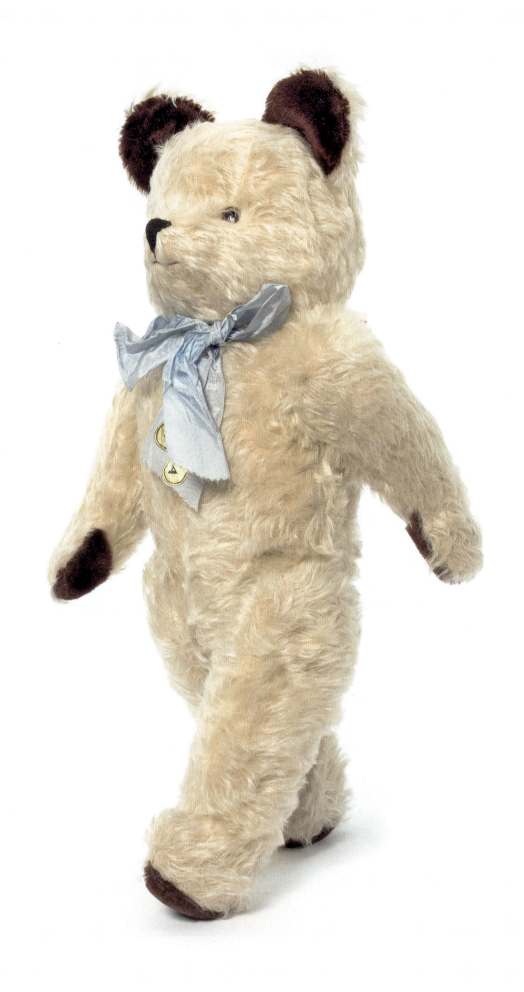

CAT. 251 Les Jouets Enchantés (manufacturer), *Michka*, France, c. 1950–1955. Paris, Musée des Arts Décoratifs

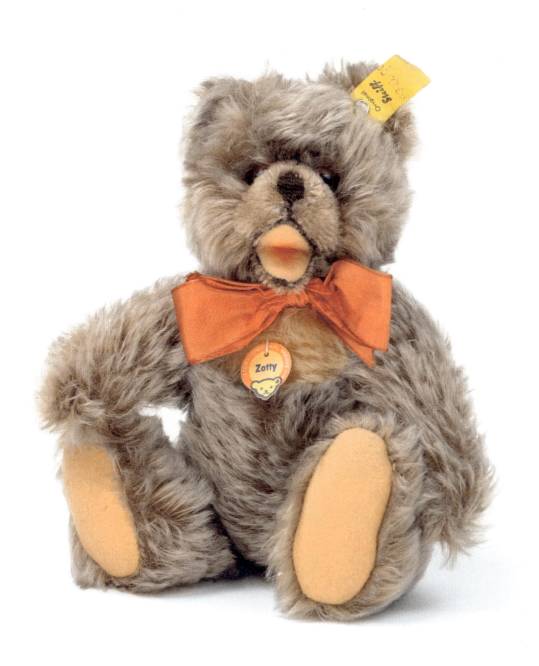

CAT. 255 Steiff (manufacturer), *Zotty*, Germany, 1952. Giengen an der Brenz, Margarete Steiff GmbH

From Bear to *Doudou*

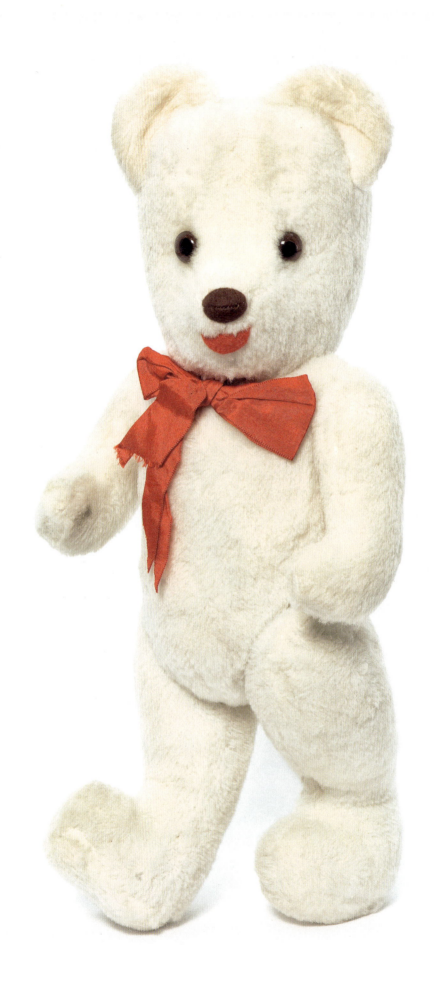

CAT. 260 Le Jouet Bourré (manufacturer), white bear, France, c. 1955–1960.
Paris, Musée des Arts Décoratifs

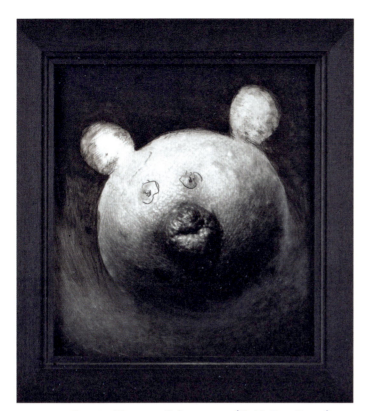

CAT. 285 Annette Messager, *Sein nounours* (Teddy Bear Breast), "Mes trophées" (My Trophies) series, 2015. Paris, courtesy of the artist and Marian Goodman Gallery

generational but nuclear, and the caretaking of small children had radically changed. While the transitional phenomenon is a necessary stage, embodying it in a toy is typical of our contemporary Western society.

WHAT MAKES A TEDDY BEAR COMFORTING?

The French word *doudou*, which cannot be dated with certainty, is unique. While the use of *lovey* is increasing, the English language emphasizes the function of the object, with terms like *comforter*, *comfort object*, and *security blanket* (CAT. 244), like the German *Kuscheltier,* literally 'cuddle animal'. Spanish and Italian separate the stuffed animal and the blanket, reducing the object to fabric and cloth. And many languages simply do not have a word for this concept.

While the first teddy bears were companions for children much more than other toys were—as can be seen in period photographs—it is nevertheless difficult to imagine a large mohair bear, stuffed with straw and kapok fiber, playing the role of a transitional object that must be squeezed, sucked on, etc. In the early 1950s, teddy bears were still very similar to those from before the war, both in their materials and their construction (CAT. 250). However, changes can be seen in their expressions, which became more smiling and friendly. When Steiff was searching for new momentum after the Second World War, the company created Zotty, a bear with a childlike look, tousled hair, and a red felt mouth that was wide open as if laughing (CAT. 255).

A study in the very serious *Journal of Positive Psychology* has attempted to identify the characteristics that make a stuffed bear comforting.[11] While many studies emphasize its helpful role in managing emotions, as well as its place in the development of the child's emotional and cognitive abilities, few focus on the physical and sensory characteristics that make this role possible. With scientific rigor and methodology, the authors of this study examine the effects of the physical differences of various stuffed bears on the perception of the participants, attempting to discern whether the emotional connection between a bear and its owner outweighs aesthetic considerations.

A questionnaire was given to some of the attendees of the Nuit Européenne des Chercheurs (European Researchers' Night), a multi-city event highlighting the impact of science and research on daily life. Participants answered questions about the appearance of eight standard bears, as well as their own bear (for those who had brought one along). After comparing the results, the researchers gave a score to each bear. They concluded that the leading variables, such as the softness of the fur or the size of the body and the head, were more tactile than aesthetic. What counts is the pleasure experienced when handling the toys, and large bears are especially appreciated. The color, posture, and accessories are of little importance, as are the facial expressions—a finding that contradicted the researchers' hypothesis. They found that a smile and childlike features do not make a bear more attractive. The hypothesis regarding the importance of the emotional bond was verified; this indeed makes a bear unique and incomparable.

THE DEVELOPMENT OF THE TEDDY BEAR

The teddy bears of the 1960s evolved through the growing use of synthetic materials: nylon plush and synthetic foam filling allowed for lighter, more flexible, and softer objects (CAT. 260). However, the most revolutionary innovation came from the English brand Wendy Boston, which marketed the first washable bear in 1954 (CAT. 263). Without joints, with securely attached eyes, and stuffed with foam, this bear, which appeared in a British TV advertisement squeezed between the rollers of a sponge mop, met with great success. In the 1970s, the joints of which the first teddy bear manufacturers were so proud, the special feature of their designs, were abandoned, as many washable bears took on the flattened look of Wendy Boston bears (CAT. 264). While attached plastic eyes became the standard for safety reasons,[12]

11 Anne-Sophie Tribot, Nathalie Blanc, Thierry Brassac, François Guilhaumon, Nicolas Casajus, and Nicolas Mouquet, "What Makes a Teddy Bear Comforting? A participatory study reveals the prevalence of sensory characteristics and emotional bonds in the perception of comforting teddy bears," *Journal of Positive Psychology*, vol. XIX, no. 2, pp. 379-392, online.

12 Pauline Cockrill, *The Teddy Bear Encyclopedia*. London: Dorling Kindersley, 1993, p. 12.

From Bear to *Doudou*

CAT. 281 *Doudou ours* (Bear doudou), 2010s. Paris, Musée des Arts Décoratifs

the noses reflected more variety, with some being stitched and others in molded plastic.

The 1980s restored volume to the teddy bear and offered companions combining softness, practicality, and roundness. While some radically departed from the animal's physical appearance (CAT. 265, CAT. 278), others maintained contact with its shapes and colors (CAT. 270), although these were approached with the idea of affection and especially softness: the fur was fuzzy and the bodies were soft. These toys were designed for snuggling (CAT. 266, CAT. 267). Some bears of this era were directly connected to this theme of snuggling, for instance, hugging another bear (CAT. 274, CAT. 276) or wearing pajamas to evoke sleep (CAT. 272).

Dictionaries do not allow us to date the appearance of the term *nounours* (teddy bear) any more than that of the word *doudou*, but this affectionate diminutive, also constructed of a repeated syllable, would become widespread to designate stuffed bears. The year 1962 saw the arrival of the television show "Bonne Nuit les Petits" (Good Night, Little Ones) and its hero Nounours (who was first called Gros Ours or Big Bear), as well as the French brand Nounours.

In today's competitive, worldwide toy market, which is highly dependent on advertising, manufacturers must produce increasingly attractive designs to lure consumers. Konrad Lorenz[13] postulated that childlike features (such as a round head that is large compared to the body, a large forehead, and big eyes) are perceived as attractive and stimulate feelings of affection and protectiveness.[14] His work became the foundation for the aesthetics of cuteness, a frequent strategy of toy manufacturers. In fact, these bears are often purchased by adults, who must be convinced as much as, if not more than, children: once the bears are sold, it matters little to the manufacturer or the shop owner if they sit neglected in the corner of a child's bedroom. Thus, the stuffed bear has become more and more distant from the wild bear, finally resembling a bear cub, or even a human baby.[15] A British zoologist very seriously considers the stuffed bear a taxon to be studied, just like any other species of the animal kingdom, and examines how adults select teddy bears for their children. He compares the adaptation strategy of stuffed bears to that of parasitism for a living species, as the stuffed animals persuade us to buy them so that we will then take care of them. He shows that we are helplessly manipulated by something that goes beyond just simple cuteness.[16] This is perhaps what led neurosurgeon Daniel McNeely to yield to the request of one of his young patients and sew up his damaged stuffed animal after having operated on the child, in a video that went viral.[17]

While the shape and colors of the toy have little importance for the baby seeking a transitional object, they can turn out to be decisive for the adult who purchases it. In this way, a market for *doudous* has been created, reducing the animals to their simplest expression, i.e., a square of fuzzy fabric with an animal's head at the top (CAT. 281). Especially practical for parents, such an object would surely not have received Winnicott's approval, as the child's search for a *doudou* and the act of investing it with significance are necessary in order to transform it into a transitional object. By offering a child an object that is already considered a *doudou*, adults get involved in a task in which they should not play a determinative role.

The comforting aspect of stuffed animals does not weaken over the years, and stuffed bears may also be very useful to adults, bringing them psychological relief[18] or almost totemic protection, as if this banal, ordinary object were endowed with the abilities of a higher order. This evocative power is explored by Annette

[13] Konrad Lorenz, "Die angerborenen Formen möglicher Erfahrung," *Zeitschrift Für Tierpsychologie*, vol. V, no. 2, 1943, pp. 235–409; *Studies in Animal and Human Behaviour*, vol. I, Cambridge (MA): Harvard University Press, 1970.
[14] Anne-Sophie Tribot et al., "What Makes a Teddy Bear Comforting?" op. cit., p. 3.
[15] Mike Jeffries, "Out of the Wild Wood and into our Beds: The Evolutionary History of Teddy Bears and the Natural Selection of Deadly Cuteness," in Owen T. Nevin, Ian Convery, and Peter Davis (eds.), *The Bear: Culture, Nature, Heritage*. Martlesham (UK): Boydell & Brewer, 2019, p. 23.
[16] Ibid., p. 30.
[17] "Surgeon Operates on Boy, Then Sews up his Teddy Bear," CTV News, October 3, 2018, online at Youtube.fr.
[18] Anne-Sophie Tribot et al., "What Makes a Teddy Bear Comforting?" op. cit., p. 2.

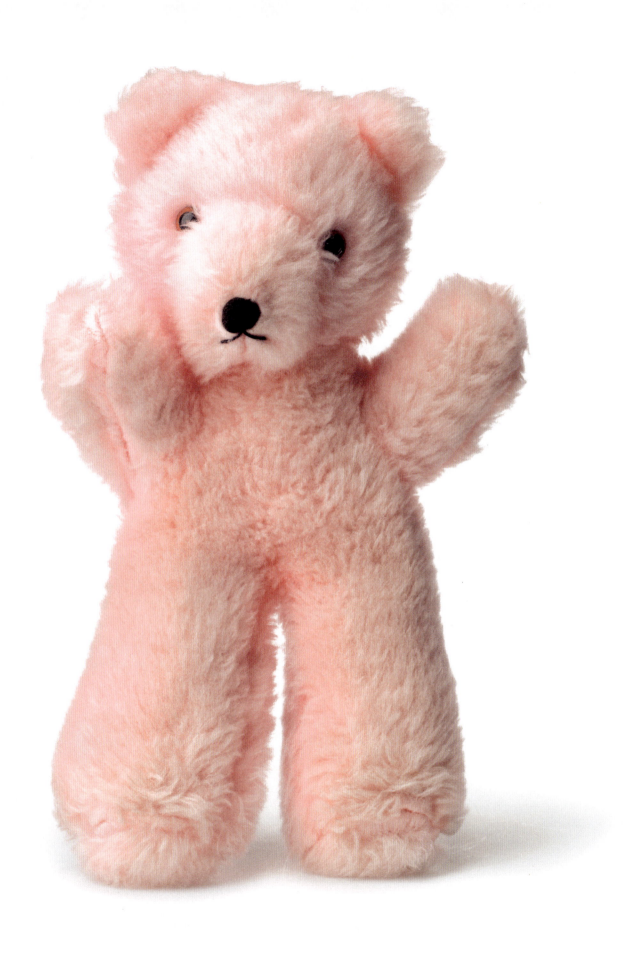

CAT. 263 Wendy Boston Playsafe Toys (manufacturer), *Wendy Boston*, UK, 1950s. Paris, Les Arts Décoratifs

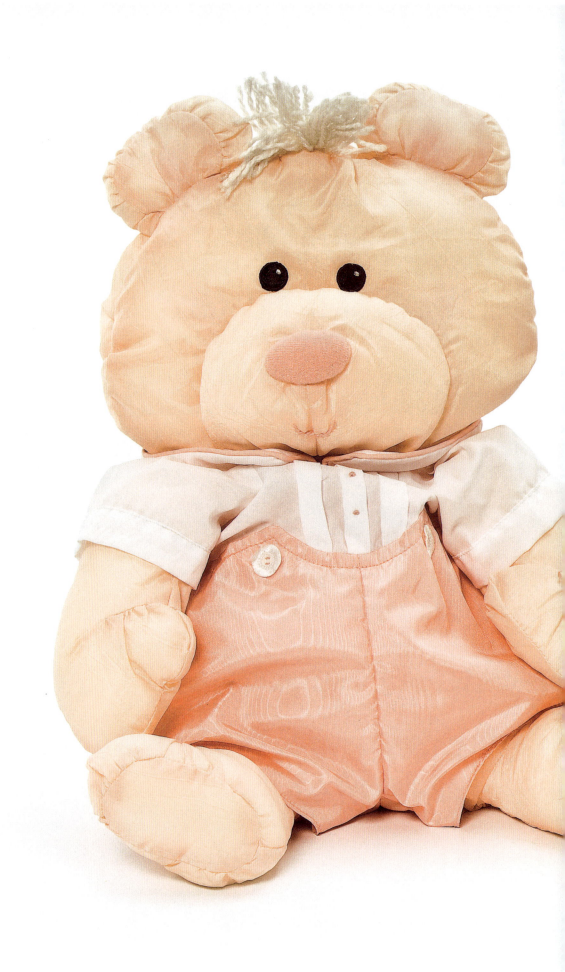

CAT. 265 Fisher-Price (manufacturer), *Puffalump Bears*, United States (design), 1986. Paris, Musée des Arts Décoratifs

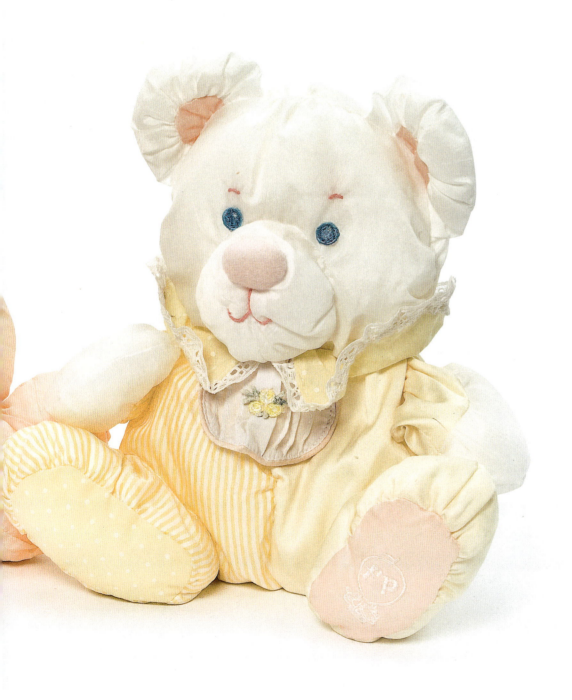

From Bear to *Doudou*

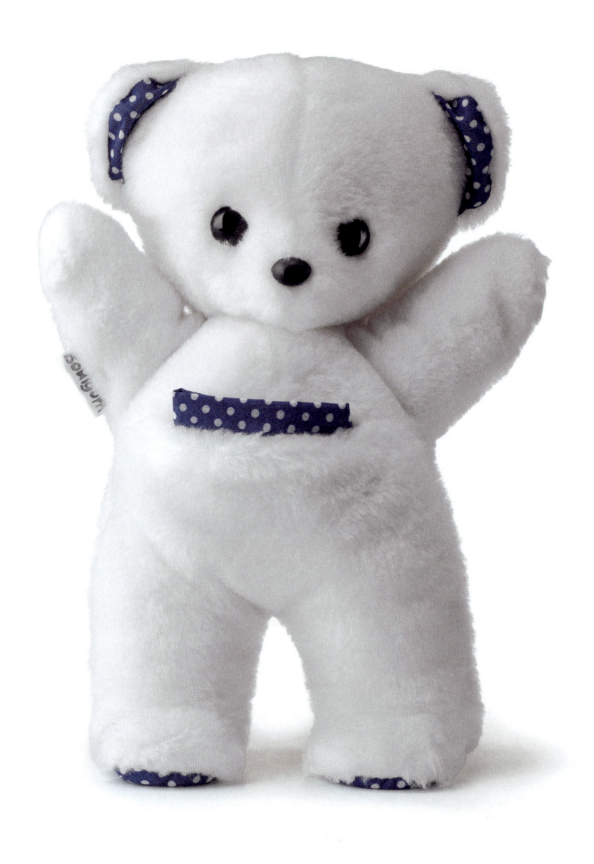

CAT. 264 Boulgom (manufacturer), *Doudoux*, France, 1979. Paris, Musée des Arts Décoratifs

Messager in her many artworks using stuffed animals (CAT. 286).

The artist Carole Benzaken draws and paints on a scroll that she has been using since her time as a student at the Ecole des Beaux-Arts in Paris, like an artistic *doudou*. After painting her teddy bear on it, she also decided to depict him on a tondo, recalling the circular paintings of the Renaissance (CAT. 287), a treatment that is worthy of the importance of her subject.

The statements of ordinary people interviewed at a street market, as well as those of Jacques Chirac and Lionel Jospin who were clearly moved as they answered questions about their teddy bears in a news story by the French television channel Antenne 2 from Christmas Day 1982, are a poignant reminder: a *doudou* is never forgotten. Even when it is no longer anything but a memory, it is still with the adult, like a kind of meta-*doudou*.

CAT. 286 Annette Messager, *Peluche protectrice* (Protective Stuffed Animal), 2023. Courtesy of the artist and Marian Goodman Gallery

CAT. 287 Carole Benzaken, *Doudou*, 2023. Paris/Brussels, Galerie Nathalie Obadia

From Bear to *Doudou*

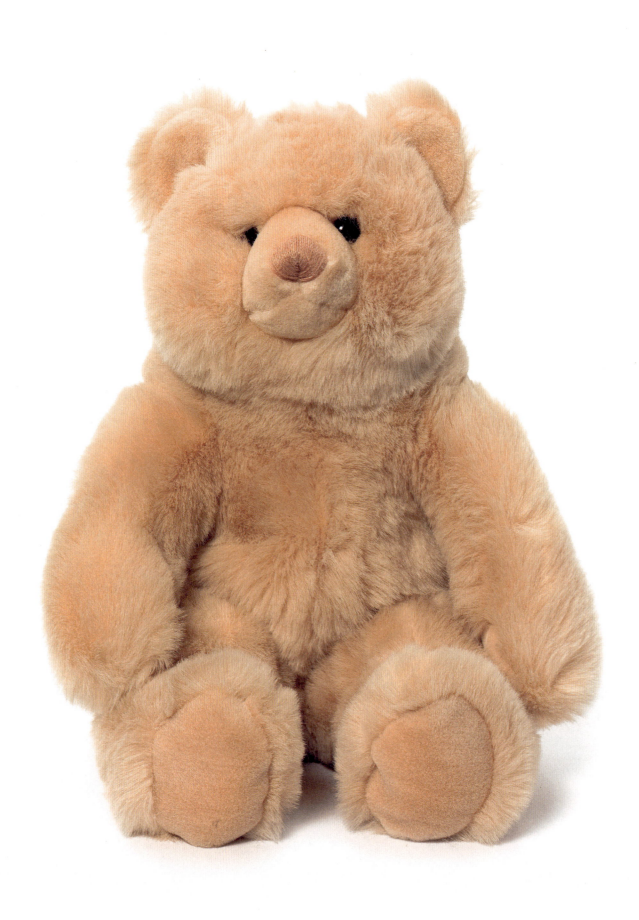

CAT. 267 Gund (manufacturer), *Cosy Bear*, United States (design), Korea (manufacture), 1985. Paris, Musée des Arts Décoratifs

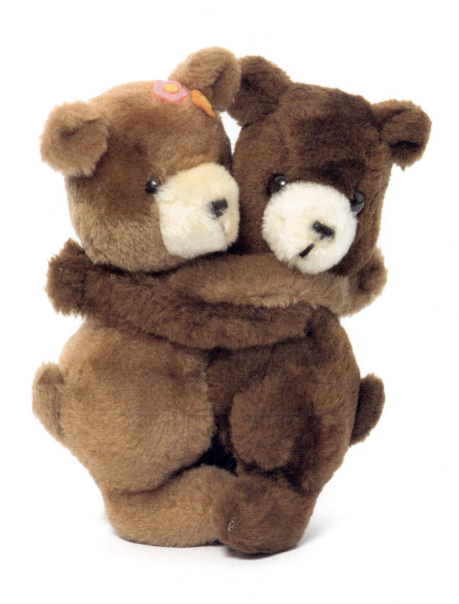

CAT. 274 Dakin (manufacturer), *Huggy Bears*, United States (design), Korea (manufacture), 1980. Paris, Musée des Arts Décoratifs

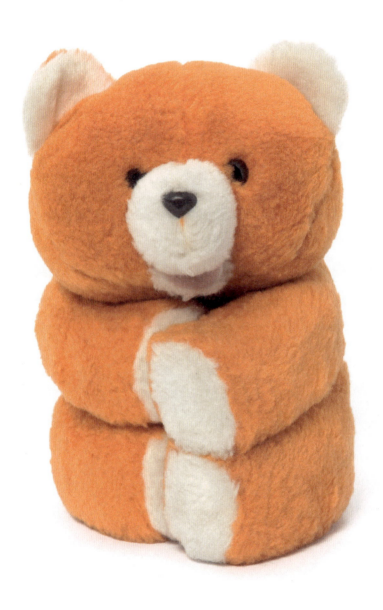

CAT. 276 Ajena (manufacturer), *Groupi*, France, 1978. Paris, Musée des Arts Décoratifs

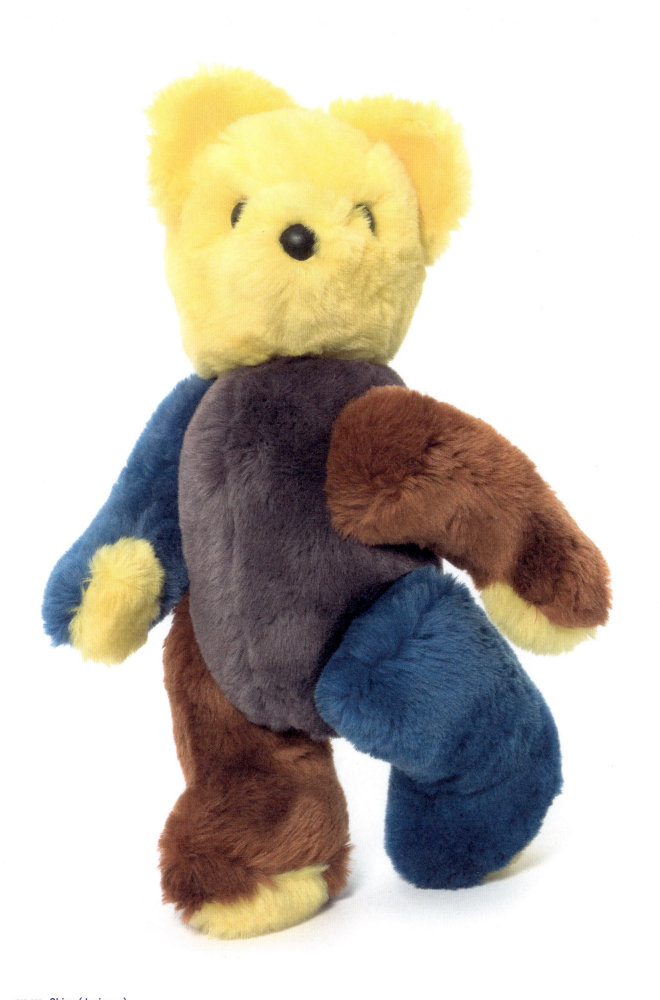

CAT. 278 Skine (designer), teddy bear, France, 1984. Paris, Musée des Arts Décoratifs

From Bear to *Doudou*

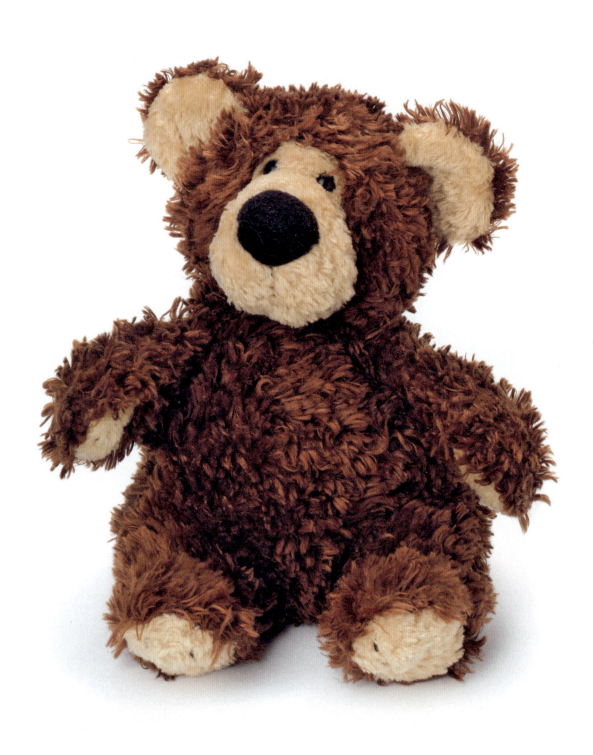

CAT. 270 Trudi (manufacturer), *Monsieur Nours*, Italy (design), China (manufacture), 2010. Paris, Musée des Arts Décoratifs

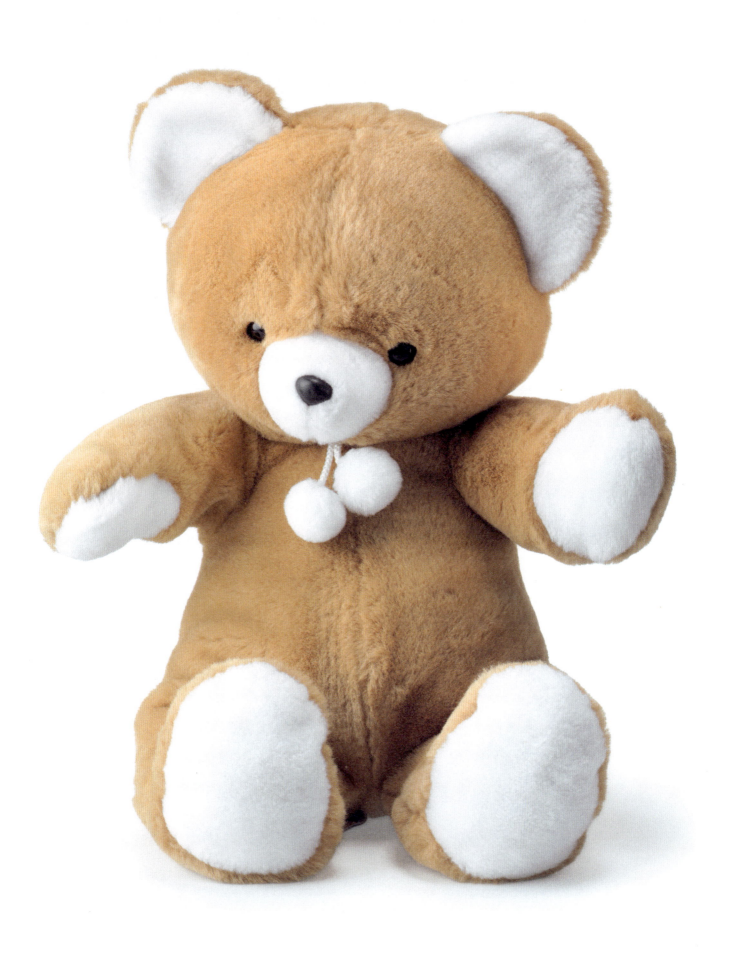

CAT. 266 Nounours (designer), *Peluche-ours*, France, 1988.
Paris, Musée des Arts Décoratifs

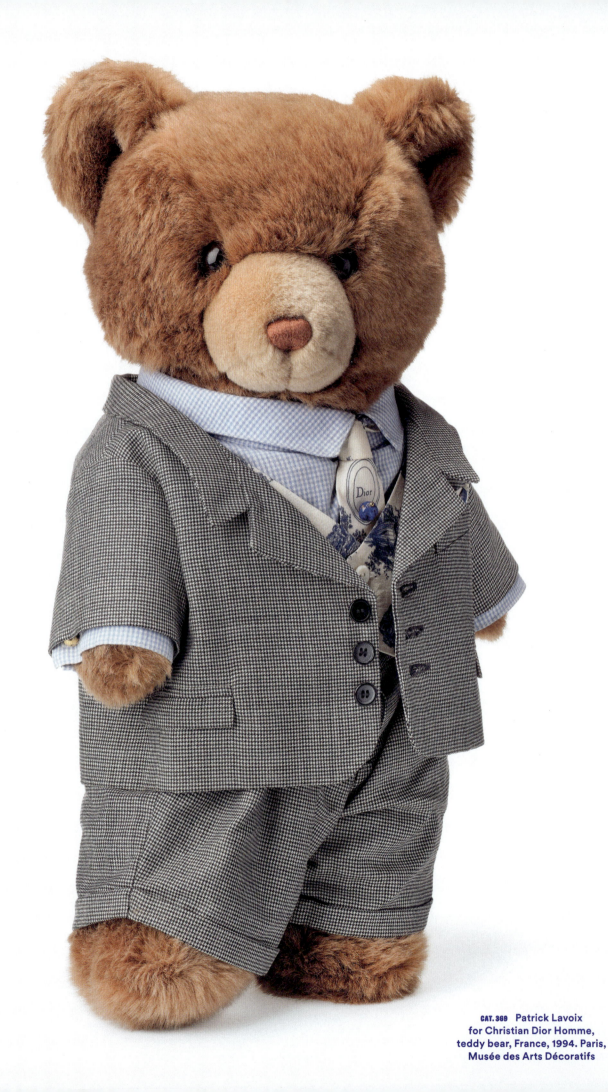

CAT. 369 Patrick Lavoix for Christian Dior Homme, teddy bear, France, 1994. Paris, Musée des Arts Décoratifs

Sophie Lemahieu

A fashion show of teddy bears? In 1994, that was what the Musée des Arts Décoratifs proposed, and many fashion designers responded enthusiastically. And for good reason: the teddy bear was very present in the fashion imagination around the turn of the twenty-first century.

As an early childhood friend, the bear has been the subject of creative inspiration, like Nana, Jean Paul Gaultier's stuffed bear. At age seven, the designer dressed her as a Folies-Bergère dancer, put makeup on her, and bleached her. He shaped his own myth around the bear whom he called his 'first muse' and to whom he had already given conical breasts.

The bear also entered designers' collections, evoking their sweetest childhood memories. Playing with the idea of the teddy bear as a child's mirror image, Karl Lagerfeld designed one in his likeness, with black glasses and a suit and tie. In Sonia Rykiel's designs, the teddy bear is a logical addition to the maternity clothes and children's wear that were present from the start of her career; it was soon picked up by several other brands. Elsewhere, it takes on the function of a 'lovey' and a decisive piece in the aesthetics of a look. Vivienne Westwood's jewelry bears can be pinned to clothing or worn around the neck like a fun and comforting good-luck charm. Virgil Abloh designed real stuffed animals that were attached to Louis Vuitton jackets from the spring-summer 2021 collection. The bear even became the mascot of Ralph Lauren who, inspired by his brother's toy collection, dressed bears in the brand's representative styles and also took a different approach by putting teddy bear motifs on sweaters and t-shirts.

As a pop culture phenomenon, the teddy bear also gave rise to various humorous twists. In his autumn-winter 1988 collection, Franco Moschino used the bear to decorate the décolleté of a simple black dress, adding a hat that was entirely made of bears. In a darker turn, Jeremy Scott, who became artistic director of the same company, created a bear-shaped perfume bottle whose head screws off, while Demna Gvasalia put a bear in a BDSM harness in 2022—a provocative move that sparked outrage. Jean-Charles de Castelbajac gathered large numbers of teddy bears and turned them into activists when he sewed them together to produce the *Nounours* jacket (winter 1988)—a manifesto against fur in fashion.

THE BEAR, THE FUN FAVORITE OF FASHION DESIGNERS

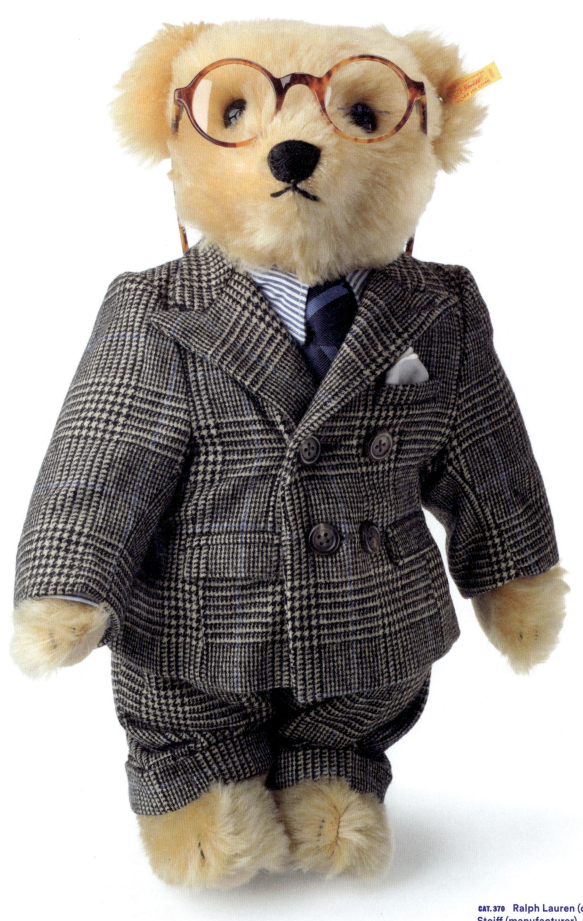

CAT. 370 Ralph Lauren (designer), Steiff (manufacturer), *Chairman Bear II*, Germany (Giengen an der Brenz), 1994. Paris, Musée des Arts Décoratifs

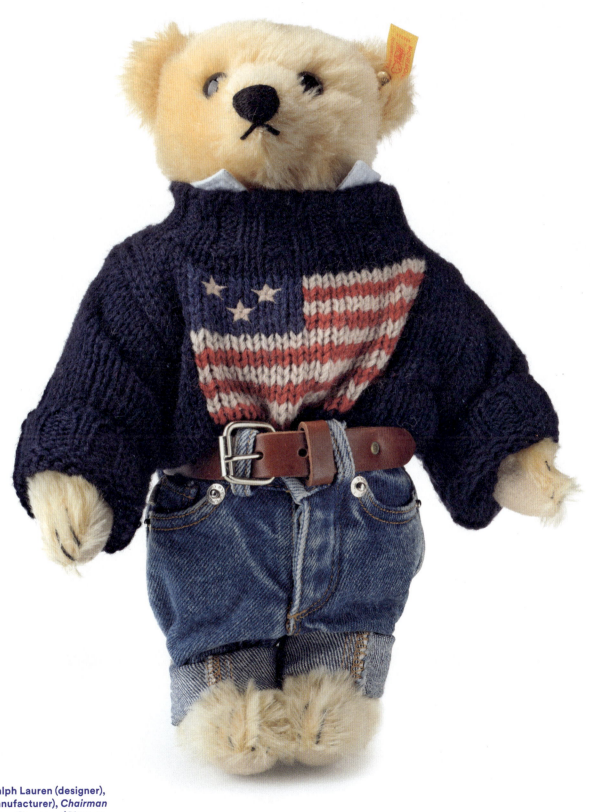

CAT. 371 Ralph Lauren (designer), Steiff (manufacturer), *Chairman Bear II, Son*, Germany (Giengen an der Brenz), 1994. Paris, Musée des Arts Décoratifs

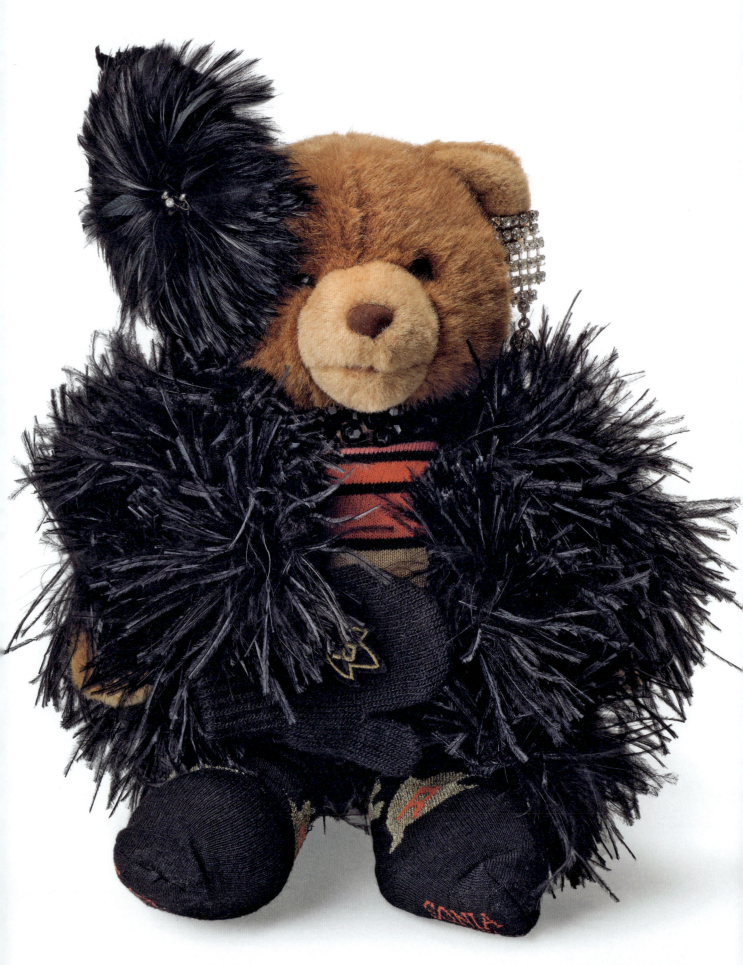

CAT. 373 Sonia Rykiel, teddy bear, Paris, 1994. Paris, Musée des Arts Décoratifs

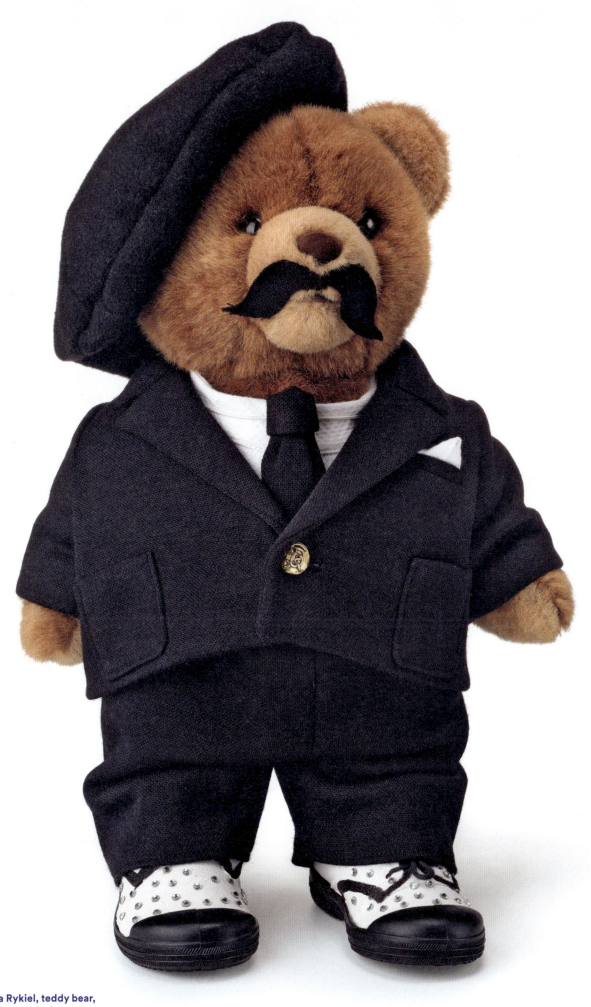

CAT. 374 Sonia Rykiel, teddy bear, Paris, 1994. Paris, Musée des Arts Décoratifs

89

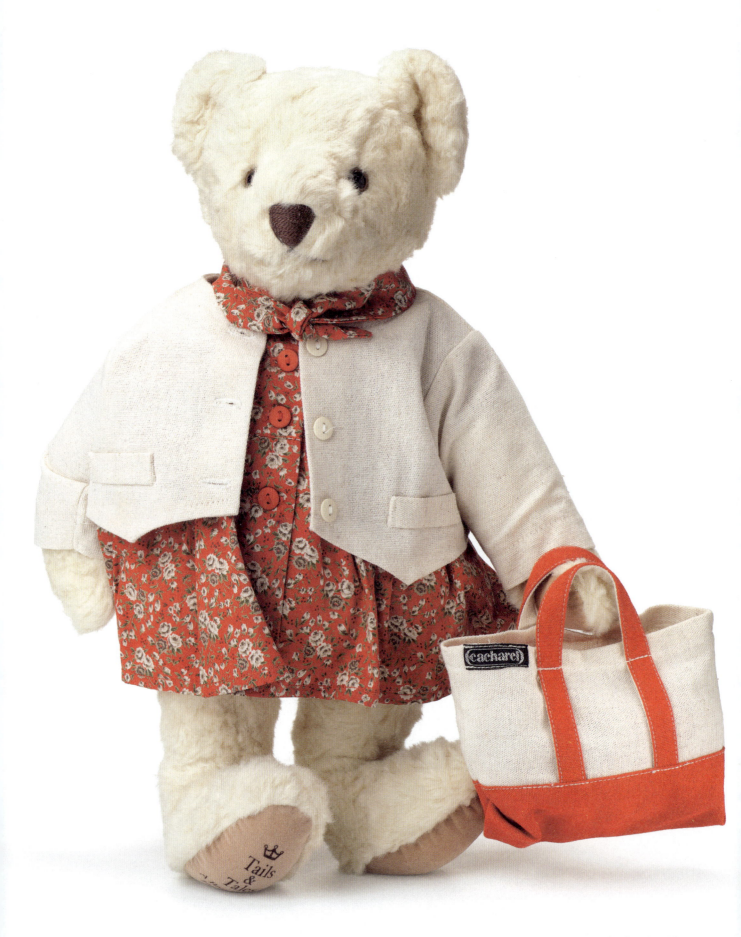

CAT. 375 Cacharel, teddy bear, Nîmes, 1994. Paris, Musée des Arts Décoratifs

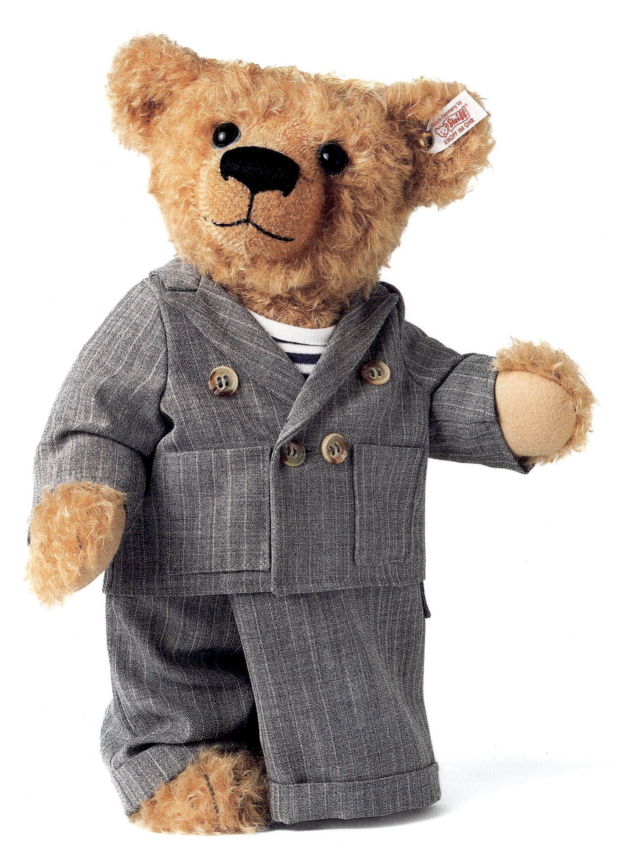

CAT. 384 Steiff (manufacturer), *Ours en peluche Jean Paul Gaultier, l'Ours terrible de la mode* (Jean Paul Gaultier Teddy Bear, Fashion's Terrible Bear), Germany, 2005. Giengen an der Brenz, Margarete Steiff GmbH

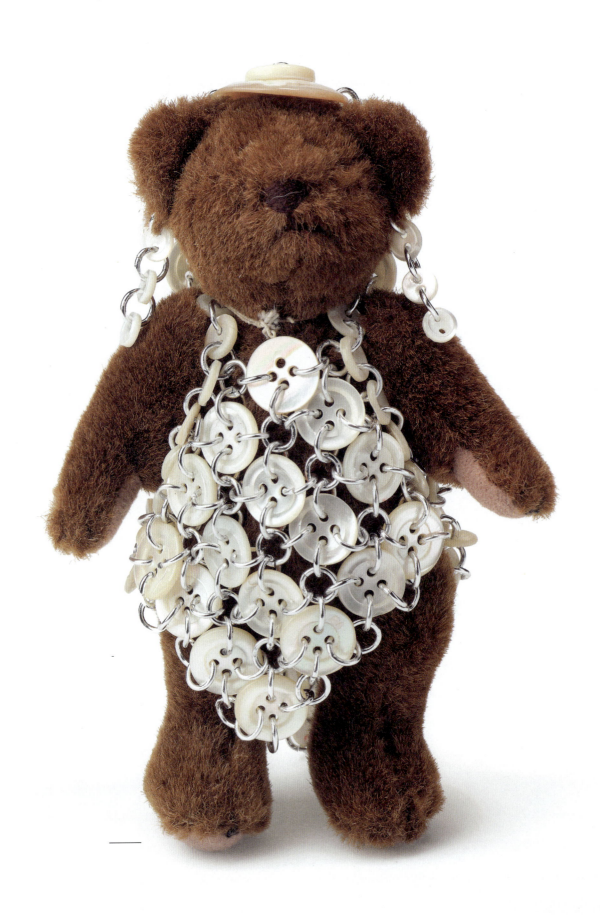

CAT. 368 Paco Rabanne, teddy bear, France, c. 1990. Paris, Musée des Arts Décoratifs

CAT. 378 Hermès (design), Steiff (manufacturer), teddy bear dressed by Hermès, France and Germany, 1992. Paris, Conservatoire des Créations Hermès

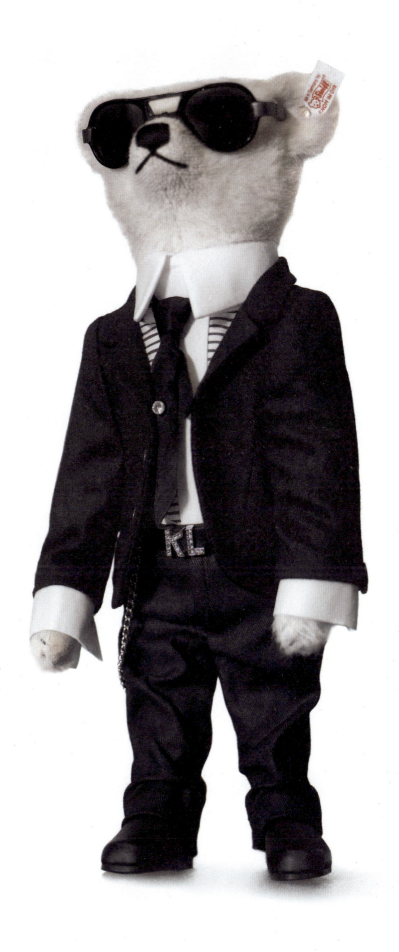

CAT. 379 Steiff (manufacturer), Karl Lagerfeld teddy bear, Germany, 2009. Giengen an der Brenz, Margarete Steiff GmbH

LEFT PAGE CAT. 361 Studio Harcourt, *The Divine Charlotte in a Dior Dress*, photograph, Paris, 2021. New York, Andrew Martin Weber and Beejan Land Collection

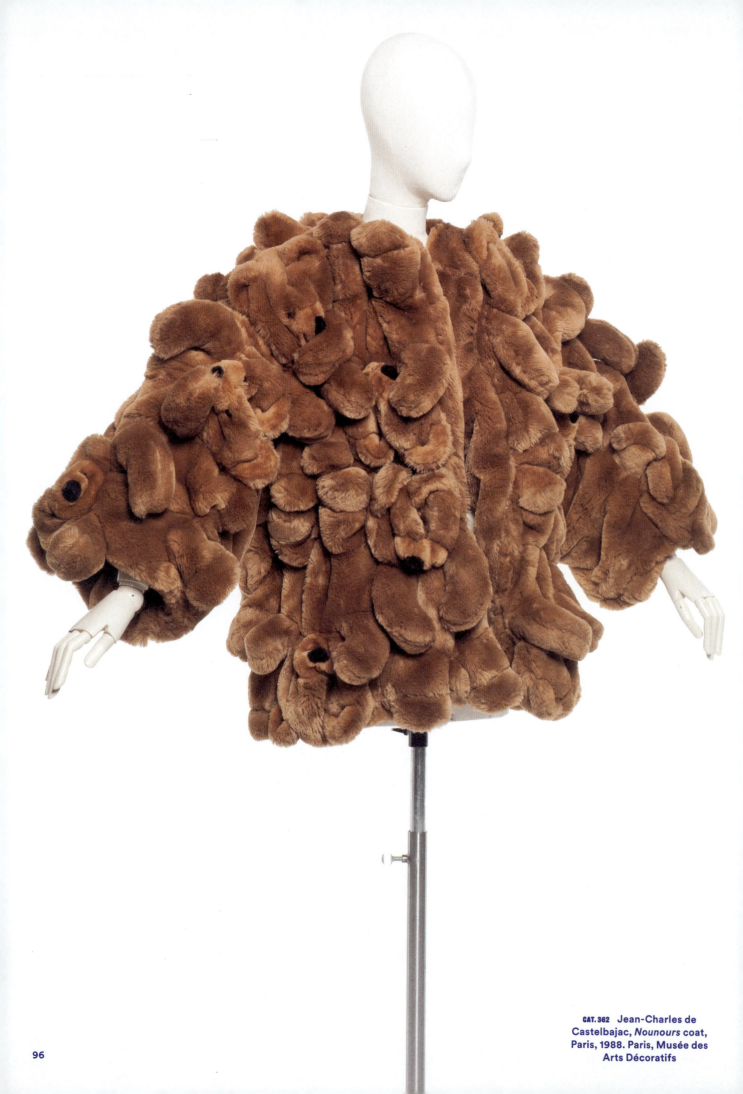

CAT. 362 Jean-Charles de Castelbajac, *Nounours* coat, Paris, 1988. Paris, Musée des Arts Décoratifs

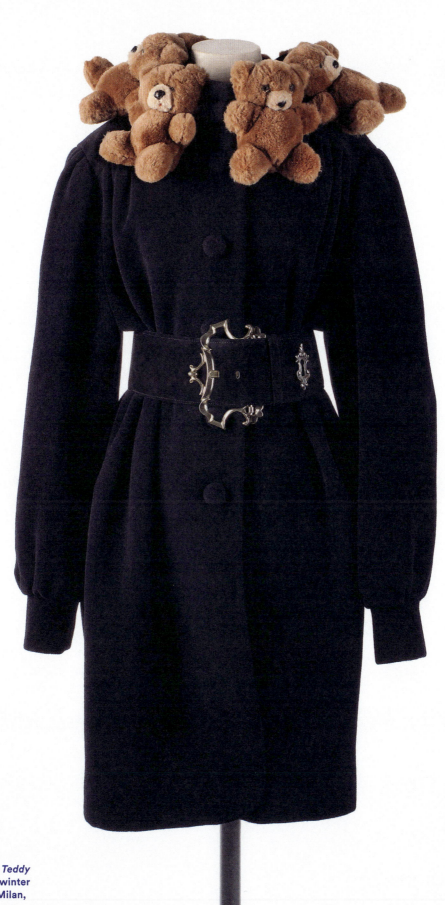

CAT. 363 Moschino, *Black Teddy Bear Coat and Belt*, fall-winter 1988–1989 collection. Milan, Moschino

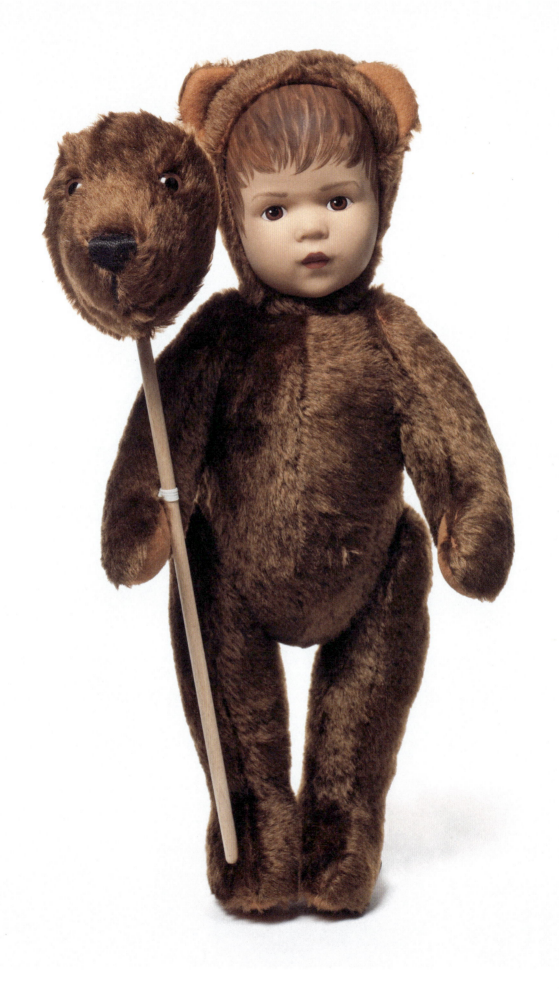

CAT. 308 Sigikid (manufacturer), bear doll, Germany, 1993. Paris, Musée des Arts Décoratifs

THE TEDDY BEAR TODAY

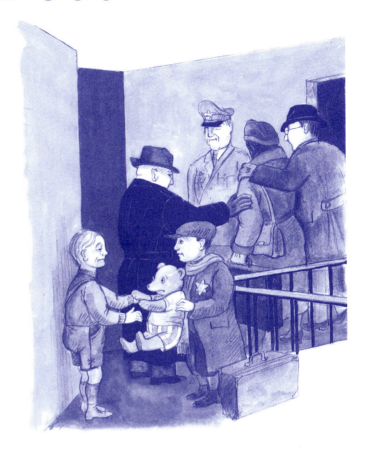

Anne Monier Vanryb

99

CAT. 292 Ulala Imai, *Care*, 2024.
Belgium, courtesy of the artist
and Xavier Hufkens

CAT. 303 Lieutenant Jim Hoeft, *A teddy bear lies amidst Rubble in Gori after the recent conflict between Georgia and Russia*, photograph, Gori (Georgia), 2008. U.S. Navy Archives

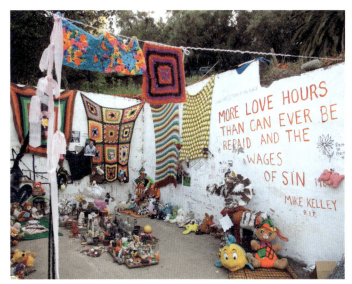

CAT. 304 Memorial for Mike Kelley, Highland Park, Los Angeles, 2012. Los Angeles, Mike Kelley Foundation for the Arts

FIG. 8 Teddy bears and toys representing children kidnapped during the war in Ukraine during an event organized in Brussels for the NGO Avaaz, Brussels, 2023

The teddy bear, the king of twentieth-century toys, is experiencing an interesting time in its history. Today it competes with other stuffed animals, especially rabbits, and children are turning away from their toys earlier and earlier—around the age of nine or ten—to take up video games and other digital entertainment. But, meanwhile, more and more adults are keeping their bears. A 2012 study by the British hotel chain Travelodge revealed that 35% of the stuffed animals forgotten in hotel rooms belonged to adults, with 51% of British people still owning a childhood stuffed animal.[1] The Build-A-Bear company estimates that over half of Americans own a stuffed animal, and 40% of those interviewed said that they sleep with it.[2] The teddy bear has thus moved beyond its status as a toy.

1 "Over a Third of British Adults still Sleep with a Teddy Bear," *Travelodge*, July 2010, online.
2 Marissa Eifert, "National Teddy Bear Day Survey Finds More Than Half of Adult Americans Still Have Their Teddy Bear from Childhood," Ir.buildabear.com, September 5, 2017, online.

A POWERFUL SYMBOL

As we have seen, humans and bears have a close relationship that seems to be particularly based on a certain feeling of identity. This closeness can also be seen in the child/cub pair, which is strengthened by mother bears' care for their young, like a human mother with her baby. The stuffed bear cub, a friend for children from the time of its invention, has thus undergone a shift in significance, taking on the role of the child's double or even functioning as a kind of representative (CAT. 308) to express the seriousness of a situation. War images showing a teddy bear in the rubble of a destroyed city (CAT. 303) never lose their power, for they pair the symbol of childhood and gentle affection with the consequences of violence. On February 23, 2023, one year after the Russian invasion of Ukraine, the NGO Avaaz put hundreds of stuffed bears on a square in Brussels to represent Ukrainian children taken to Russia by force since the beginning of the conflict (FIG. 8). In this way, these toys are used to express the reality of the conflict and its dangers to children.

Stuffed animals are often placed as tributes at the scene of road accidents or any site where a child or adult has died. They are intimately linked to memory and remembrance (CAT. 292). In this respect, the spontaneous tribute to Mike Kelley after his death is very revelatory. In his prolific and multifaceted work, Kelley often used stuffed animals, as in *Ahh... Youth!*, a self-portrait surrounded by a series of photographs of his stuffed animals, one of which was used for the album cover of *Dirty* by Sonic Youth. These photos appear in the artist's installations to question the notion of affection or the rituals of gift-giving and exchange. Very soon after the announcement of Mike Kelley's death, an anonymous Facebook page invited his fans to gather in a Los Angeles parking lot near his studio to mourn him with candles, ears of dried corn, and stuffed animals, to recreate

The Teddy Bear Today

his 1987 artwork *MORE LOVE HOURS THAN CAN EVER BE REPAID AND THE WAGES OF SIN*. This homage to the artist and his work merges with a collective expression of grief (CAT. 304).

HELPING CHILDREN

The teddy bear can be a medium to reach young children and touch their emotions. In *Otto: The Autobiography of a Teddy Bear* by Tomi Ungerer, the bear recounts his experiences of the Holocaust and the Second World War—first his happy times with David and his best friend Oskar, then the war and the bombings he witnessed with Oskar, after David and his family were taken away by men wearing black leather jackets and uniforms, and finally his journey to the United States, where he travels with an American soldier. Teddy bears are often used to discuss the Second World War: although the difficult subject matter and the sorrowful stories remain, the bear can act as an emotional buffer (CAT. 295).

In Tomi Ungerer's story, Otto is the friend of David and Oskar, and his difficult experiences

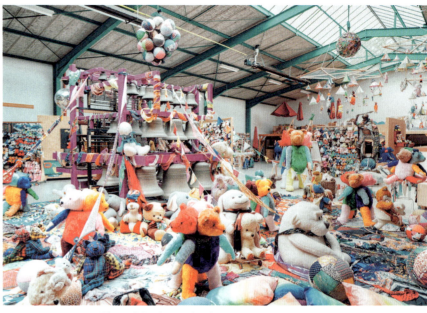

FIG. 9 Illias Teirlinck, studio of Charlemagne Palestine, 2018. Brussels

echo those of the two characters. Teddy bears can act as the mirrors of children and represent them, for instance, in messages about protecting children, such as national awareness campaigns about shaken baby syndrome or highway safety (CAT. 305). In a video made by the association Innocence en Danger, an adult reads a story to a sleeping child and then abuses the child sexually. At the end of the video, the camera focuses on a teddy bear in tears, a mute and helpless witness of the assault, in order to encourage families to identify and stop child molestation.

The bear can also be a double to help children picture themselves in complicated or painful situations. During the Covid-19 pandemic, a stuffed animal with a mask by La Pelucherie was used to help children become accustomed to wearing a mask (CAT. 309), echoing the stuffed bears of the Second World War who wore gas masks (CAT. 310). In the Hôpital de mon Doudou, a special area in the pediatric department set up by the association PharmaVie, the bear cub Toudou undergoes the same treatments as the children do (MRI, radiation, surgery, etc.), in order to help them prepare for their medical procedures. A study in the journal *Pediatric Radiology* reported the results of this initiative: the children were less anxious and the medical images were of better quality, without the young patients needing to be sedated.[3] Toudou is both a double and a source of comfort. In the trucks of first responders (CAT. 311) or alongside Red Cross workers (CAT. 313), teddy bears comfort wounded children, and an organization called Good Bears of the World (CAT. 314) exists with the sole purpose of giving teddy bears to children who are suffering. A similar initiative was carried out by French schoolchildren who spontaneously collected

CAT. 305 Secretary of State in charge of children and families, Mme Bovary agency (design), poster for the National campaign to raise awareness of shaken baby syndrome, November 2021

[3] Baptiste Morel, Frédéric Andersson, Muriel Samalbide, Gauthier Binninger, Élodie Carpentier, Dominique Sirinelli, and Jean-Philippe Cottier, "Impact on Child and Parent Anxiety Level of a Teddy Bear-Scale Mock Magnetic Resonance Scanner," *Pediatric Radiology*, January 2020, vol. L, no. 1, pp. 116–120.

CAT. 295 Tomi Ungerer, *Otto (Untitled)*, 1999. Strasbourg, Musée Tomi Ungerer – Centre International de l'Illustration

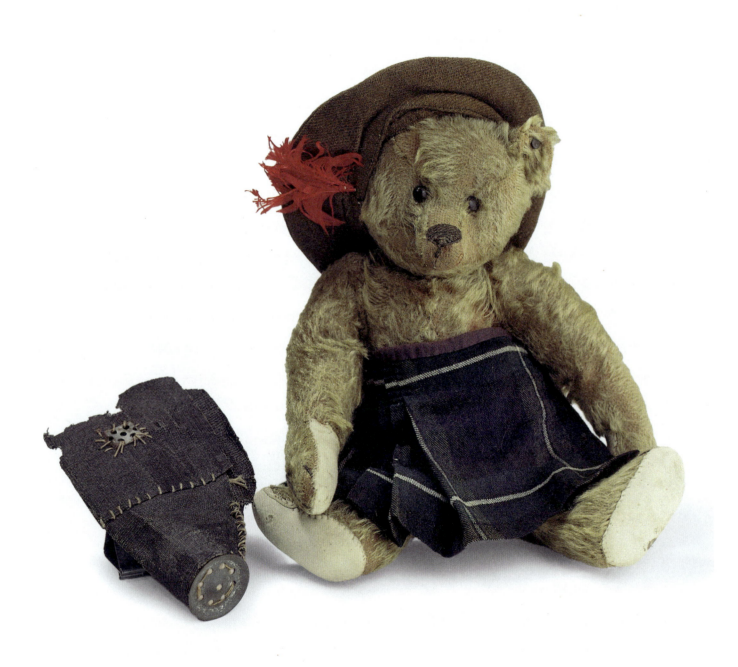

CAT. 310 Steiff (manufacturer), *Ted*, Germany, 1905–1907. London, Victoria and Albert Museum

TOP LEFT CAT. 311 National Federation of French Firefighters (designer), O60 (manufacturer), *Pompy*, France (design), China (manufacture), 2015. Paris, Les Arts Décoratifs

BOTTOM LEFT CAT. 309 La Pelucherie (manufacturer), *Mon Albert Invincible* (My Invincible Albert), France (design), Italy (manufacture), 2020. Paris, Musée des Arts Décoratifs

TOP RIGHT CAT. 314 Good Bears of the World (designer), Muffin Enterprises (distributor), *Goody*, United States (design), China (manufacture), 2022. Paris, Les Arts Décoratifs

BOTTOM RIGHT CAT. 313 Laure Godini, from a pattern by the Australian Red Cross, *Trauma Teddy*, Paris, 2024. Paris, private collection

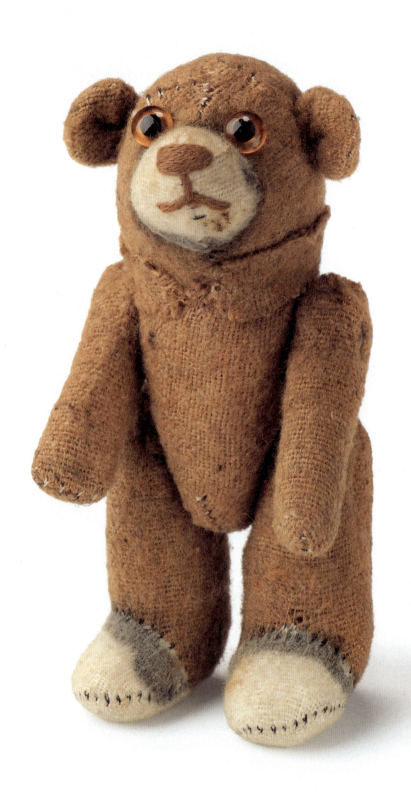

CAT. 401 Anonymous, teddy bear made by soldiers in the trenches during World War I, 1914–1918. Paris, Vanryb Collection

stuffed animals for Ukrainian children caught up in the turmoil of war.[4]

ADULT COLLECTORS AND TEDDY BEARS

In the twentieth century, adults who kept their stuffed animals were rare, and were perceived as eccentrics. Most adults are moved by the memory of their teddy bear, but speak about it in the past tense. The disappearance of a favorite stuffed animal that is lost or thrown out can be experienced as traumatic. For Charlemagne Palestine, who was born in the same Brooklyn neighborhood where the American inventors of the teddy bear had their shop, the major house cleaning carried out by his mother when he was ten or eleven years old became the basis of his entire artistic practice. He gathers abandoned stuffed animals and today has over 18,000 of them in his studio/orphanage. He puts them into on-site installations, creating immersive, acoustic works with no sappy sentimentalism. In Charlemagne Palestine's art, stuffed animals are divinities who, by communicating with us, grant us access to the magical world of their origin. This shamanic aspect is accompanied by music composed by the artist, who sang in the synagogue throughout his childhood (FIG. 9).

In similar fashion, those adults who dared to be seen with a stuffed animal during the twentieth century were often artists. The English poet John Betjeman never gave up Archibald Ormsby-Gore, the bear that accompanied him to Oxford, to the war front, and then throughout all stages of his life (CAT. 399). Archibald is not the only teddy bear who went to war: during the First World War, the English company J.K. Farnell marketed mohair bears in the colors of the British flag that could be given to soldiers as good-luck charms. Miniature-sized, they could be carried in a jacket pocket, where only their little muzzles and their small eyes (intentionally placed high on their faces) would peek out. In the trenches, some soldiers made teddy bears with the materials that were available, such as military fabric, maintaining this characteristic look (CAT. 401).

Archibald inspired Evelyn Waugh to create Aloysius, the teddy bear that never leaves Sebastian Flyte in the first part of his novel *Brideshead Revisited*. The young Sebastian hides his sadness and his alcoholism with his eccentric behavior, and Aloysius can be seen as a source of comfort, but also as a sign of his inability to leave his childhood behind. In 1981, the novel, published in 1945, was turned into a very popular television series that has since become a cult favorite[5] (CAT. 396). It is said to have led to a revival of interest in teddy bears, as seen in the appearance of a wave of collectors of vintage teddy bears in the 1980s. The historic brands that were still in existence, such as Steiff and Merrythought, responded to the trend by marketing replicas or contemporary reinterpretations of their first teddy bears using the same manufacturing techniques as in the early twentieth century. 'Teddy bear artists' appeared, modernizing their traditional characteristics to create valuable limited-edition series[6] (CAT. 343).

CAT. 399 John Betjeman, Archibald Ormsby-Gore, and Jumbo on the set of *Summoned by Bells*, photograph by Jonathan Stedall, UK, 1976

CAT. 396 Jeremy Irons, Anthony Andrews, and the bear *Delicatessen* in the series *Brideshead Revisited*, 1981

4 Bérangère Lepetit, "Guerre en Ukraine: la riposte des enfants français qui collectent des doudous en soutien aux jeunes réfugiés," *Le Parisien*, April 28, 2022.

5 "30 Years Later, Revisiting 'Brideshead'," *The New York Times*, December 30, 2011.

6 Leyla Maniera, *Christie's Century of Teddy Bears*, New York: Watson-Guptill Publications, 2001, pp. 152–153

CAT. 341 Philippe Labourel, The *Nounours des Gobelins* (The Teddy Bears of Les Gobelins) in front of the shop of their creator, Paris, 2018

CAT. 398 Poster for the movie *Ted*, 2012. Paris, Bibliothèque du Musée des Arts Décoratifs

TEDDY BEARS TODAY

In the 1990s, hybrid objects appeared, partway between toys and collector's items, such as Beanie Babies, which gave rise to a true speculative fever. Sold as toys, but reaching very high resale prices depending on the rarity of the model, these teddy bears for children, adolescents, and young adults were an early sign of marketing to *kidults*, adults who do not want to grow up, a social phenomenon that has become an economic market.[7] Today, Build-A-Bear sells some stuffed animals exclusively to adults in a 'bear den' that is open to those aged eighteen and older. The bears feature Velcro cocktails and wine glasses and they wear t-shirts that read *It's wine o'clock somewhere* (CAT. 391). Like many others, the brand also offers bears for Valentine's Day, a holiday that is not intended for children, but for adult couples (CAT. 394).

Raised in the midst of toys, young adults of today are no longer inclined to abandon the companions of their childhood. The previously cited study in the *Journal of Positive Psychology* offers evidence supporting this, finding that having a powerful emotional connection to a teddy bear offers benefits in terms of sleep or mental health.[8] This new tolerance for the teddy bear allows it to take its place in the public space and in daily life, as shown by successful initiatives such as "Les Nounours des Gobelins" (The Teddy Bears of Les Gobelins), a fun strategy to encourage Parisians to shop locally by placing giant teddy bears first in the Gobelins neighborhood and then on the terraces of several Paris cafés (CAT. 341). Similarly, it is no longer rare to see adults on the street with teddy bear accessories, such as bags, key chains, and knit caps.

*Inanimate objects,
do you have a soul
Attached to our own
and the power to love?*[9]

Although stuffed animals did not exist at the time, these lines by Lamartine seem to be addressed to them in their uniqueness. We feel moved when we see a teddy bear; we feel heartbroken when we find an abandoned stuffed

[7] Corinne Maillet, *Le Marketing adolescent. Comment les marques s'adressent à l'enfant qui sommeille en nous*. Paris: Pearson France, 2005.
[8] Anne-Sophie Tribot, Nathalie Blanc, Thierry Brassac, François Guilhaumon, Nicolas Casajus, and Nicolas Mouquet, "What Makes a Teddy Bear Comforting? A participatory study reveals the prevalence of sensory characteristics and emotional bonds in the perception of comforting teddy bears," *Journal of Positive Psychology*, vol. XIX, no. 2, pp. 379–392, online.
[9] Alphonse de Lamartine, "Milly ou la Terre natale," *Harmonies poétiques et religieuses*. Paris: Gosselin, 1830.

CAT. 343 Stella Bolland (designer), *Rory*, UK, 1993. Paris, Les Arts Décoratifs

CAT. 394 *Ours pour la Saint-Valentin* (Valentine's Day Bear), China (manufacture), 2020s. Paris, Les Arts Décoratifs

CAT. 391 Build-A-Bear, *Maggie*, United States (design), Vietnam and China (manufacture), 2024. Paris, Les Arts Décoratifs

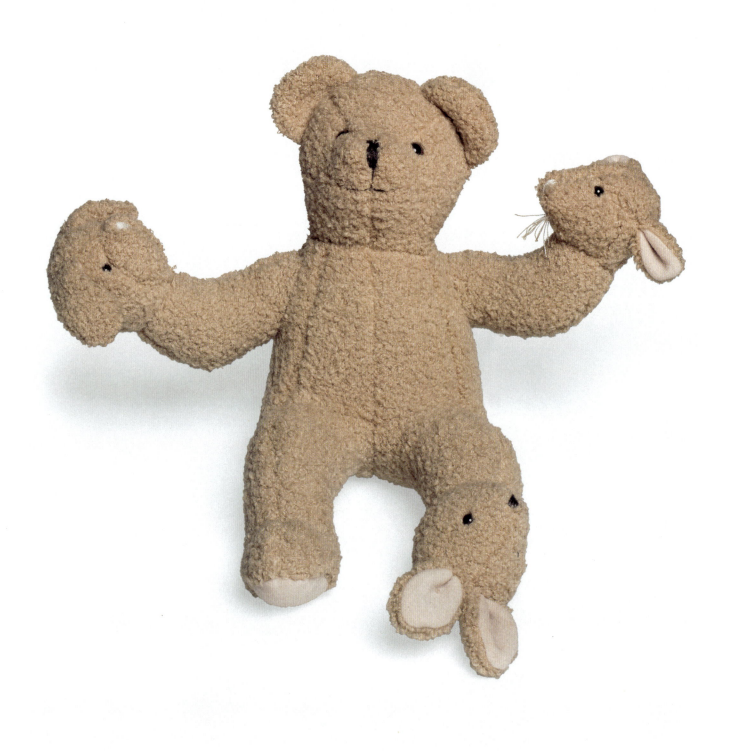

CAT. 358 Philippe Starck (designer), Moulin Roty (manufacturer), *Teddy Bear Band*, France, 1996. Paris, Musée des Arts Décoratifs

FIG. 10 Manufacture of a teddy bear at Pamplemousse Peluches, 2024

THE BEAR TOMORROW

Once a practically godlike, ferocious king of the animal kingdom, the bear—especially the polar bear—has become the symbol of climate change and threats to nature[10] (FIG. 11). Unfortunately, its stuffed counterpart has something to do with this. Mass-produced in a global market and sold very cheaply, stuffed toys also become themselves the victims of overconsumption. The multiple plastic materials used for their manufacture and the very strict safety standards for toys make them very difficult to recycle. If the stuffed animal is not lucky enough to be kept, it often languishes in waste sorting centers before ending up in the incinerator[11].

Some European manufacturers try to produce teddy bears ethically and sustainably, such as La Pelucherie or Big Stuffed, especially in France, with Pamplemousse Peluches, Adada, or Les Petites Maries. Les Petites Maries revived the manufacturing workshop of the Blanchet brand, which was the last company to make its stuffed animals entirely in France when it closed in 2014. Today, French stuffed animal companies are making a comeback by using quality materials to responsibly produce resistant and durable toys that can last and be loved for many years and then passed down to others, thus avoiding a tragic end.

In fact, teddy bear manufacturing methods have changed very little since the first attempts by Margarete and Richard Steiff: the pieces of the bear are cut according to a pattern, either by hand or machine. In a quality stuffed animal, all the pieces will have their fur aligned in the same direction, an important detail when touching it. The pieces are then carefully stitched together inside out, using a special technique for pushing back the fur so that it does not get caught in the stitching (FIG. 10). Once it is turned right side out, the bear is stuffed, and then the opening is sewn up by hand. Any innovations to this traditional process can come from improved machines, but especially from new ideas for materials, such as the Teddies for Tomorrow line by Steiff, which are made of hemp, pineapple leather, linen, or paper.

As their natural habitat has been reduced and threatened, bears have had to find new sources of food, which has brought them close to human settlements, thus blurring the separation between our two worlds. Programs reintroducing bears to promote the species' survival, in the Pyrénées for example, are the subject of heated debates,

animal. In 1972, two veterinarians were already discussing the particular kinds of teddy bear ills in *Some Observations of the Diseases of Brunus Edwardii*, a hoax published in *The Veterinary Record* describing teddy bear diseases.

In Lviv, before the Russian invasion of Ukraine, residents in a neighborhood of the old city began to gather abandoned stuffed animals in the courtyard of a building that was typical of the local architecture. The movement grew, and *The Yard of Lost Toys* became a tourist attraction, but also a kind of sanctuary, a tribute to the magic element of these objects.

Other stuffed animals have a more pleasant destiny: in Japan, Unagi Travel, an unusual travel agency, will take your stuffed animal on a trip to Tokyo, Kyoto, or Okinawa with other fuzzy friends, sending you photos to show what a wonderful time it is having!

Does giving a toy this much importance mean respecting your inner child or refusing to grow up? The cinema has dealt with this issue in *Christopher Robin* (2018), which tells the story of the reunion of Winnie the Pooh and Christopher Robin, who has been overwhelmed by the trials and tribulations of adulthood. In *Ted* (2012), the main character, John, is lucky enough to have grown up with Ted, a teddy bear that has come to life. But when it is time to propose to his girlfriend or to obtain a promotion, the troublesome Ted prevents him from taking on his adult responsibilities (CAT. 395). Behind its juvenile humor, the movie offers a happy ending and emphasizes that everything is a question of balance.

10 Henry McGhie, "Museum Polar Bears and Climate Change," in Owen T. Nevin, Ian Convery, and Peter Davis (eds.), *The Bear: Culture, Nature, Heritage*. Martlesham (UK): Boydell & Brewer, 2019, p. 120.

11 Flore Berlinge, *Recyclage. Le grand enfumage*, Paris, Rue de l'échiquier, 2020; Dominique Chapuis, "Le recyclage et la réparation des nouveaux jouets à un tournant", *Les Échos*, March 10 2020

The Teddy Bear Today

ILL. 11 John Cuneo, "The Polar Opposite,"
cover of the *The New Yorker* magazine, March 8, 2021.
Paris, Bibliothèque du Musée des Arts Décoratifs

with stuffed bears as intermediaries: in June 2020, teddy bears were placed in front of the prefecture of the Ariège department in France after a bear was killed, and, in 2017, a video parody featured masked bears armed with plastic guns responding to a video of a group of armed men in balaclavas demanding the resumption of bear hunting in France. In 2023, almost thirty years after the reintroduction of three Slovenian bears in the Pyrénées, the bear population in this mountain range reached eighty-three. In 2024, they did not all go into hibernation due to the mild temperatures.

Our relationship to the bear is more ambivalent than we might think considering our long coexistence and our linked fates. It is up to us to make sure that in a few decades time, the teddy bear will not be the only memory left of this species (CAT. 419).

CAT. 419 Steiff (manufacturer), *Knut l'Ourson* (Knut the baby polar bear), Germany, 2007. Paris, Vanryb Collection

Marie Adamski

Toward the end of winter, three villages in the Pyrénées-Orientales department of France celebrate the Festival of the Bear or *Festa de l'Ós* in Catalan: Arles-sur-Tech, Prats-de-Mollo, and Saint-Laurent-de-Cerdans, all three located in the Haut-Vallespir valley. While each of these festivals has its own particular characteristics—the characters, costumes, and atmosphere can vary locally—they all share an age-old history and deep roots in the region. For the communities involved, this is one of the major events of the year. Bear festivals originated in the Middle Ages. In 1444, we find mention of "a bear and cub [presented] to all covered with black sheepskins"[1] at a carnival in Barcelona. This is the earliest written example that exists of a festival featuring a bear in Catalonia. Although the bear festival remains in only three villages today, historical sources mention many more all along the Pyrénées Mountains. They all depict the myth of Jean de l'Ours, a character with excessive strength who is half-man and half-bear, having been born to a woman who mated with a bear.

These festivals, traditionally celebrated on February 2, the date when the bear is said to come out of hibernation, symbolically mark the return of spring and fertility. Today, they can be summarized as the performance of a pretend bear hunt in a public space, with men, women, and children participating, either as spectators or actors. The people must capture the 'bear' or 'bears' so that they can be controlled and humanized. Before this stage of the enactment, for several hours the bear must frighten the villagers he finds along the way, especially young women, but also honor any important figures in the community, most often by inviting them to dance or applying a mark to their faces. The public plays along, chasing the bear, who lets himself be chased, in an atmosphere of shared excitement. Depending on the location, other characters also take part: the Leader, Trapper, Hunters, Barbers, Roseta, Bótes, Tortugues, Figueretes, Butifarrons, and more, playing the roles of antagonists, entertainers, or helpers for the bear. They interact with the bear and also perform among themselves and with the spectators in sketches that are mostly improvised. This entertainment is constantly accompanied by traditional music, with specific tunes such as "The Song of the Bear". The afternoon ends with the capture of the bear, who falls into the hands of the Leader, the Trapper, or the Barbers. They then 'shave' him on the village square. Through this symbolic act, the bear changes from a ferocious animal into a human, leaving behind nature for culture. This victory is celebrated with a big final dance, with the actors and their friends and family joining in the jubilations.

Part of the celebrations of carnival, this festival is one of the most important of the year for the locals. Everyone who lives in the village, young and old, makes a point of taking part in this festive

1 *Memorial de coses antigues memorables*, 1444. Historical Archives of the city of Barcelona.

CAT. 56 Charles Fréger, *Ours, Arles-sur-Tech*, from the series "Wilder Mann," 2010. Rouen, Charles Fréger

BEAR FESTIVALS IN VALLESPIR

social occasion. After a decrease in participation in the 1960s, the event has experienced renewed popularity for about a generation. In the past, the role of the bear was given to people on the margins of society, but today it is considered a sign of recognition and an honor.

Beyond the Pyrénées, such ceremonies can be found in many mountainous regions of Europe, particularly in Germany and Romania. As part of humanity's intangible cultural heritage, alongside two other bear celebrations held in Andorra, the Vallespir bear festivals are internationally recognized as an aspect of world culture it is important to preserve.

CAT. 53 Mehryl Levisse, *Le Culte de l'ours* (Bear Worship), 2017. Paris, Musée de la Chasse et de la Nature

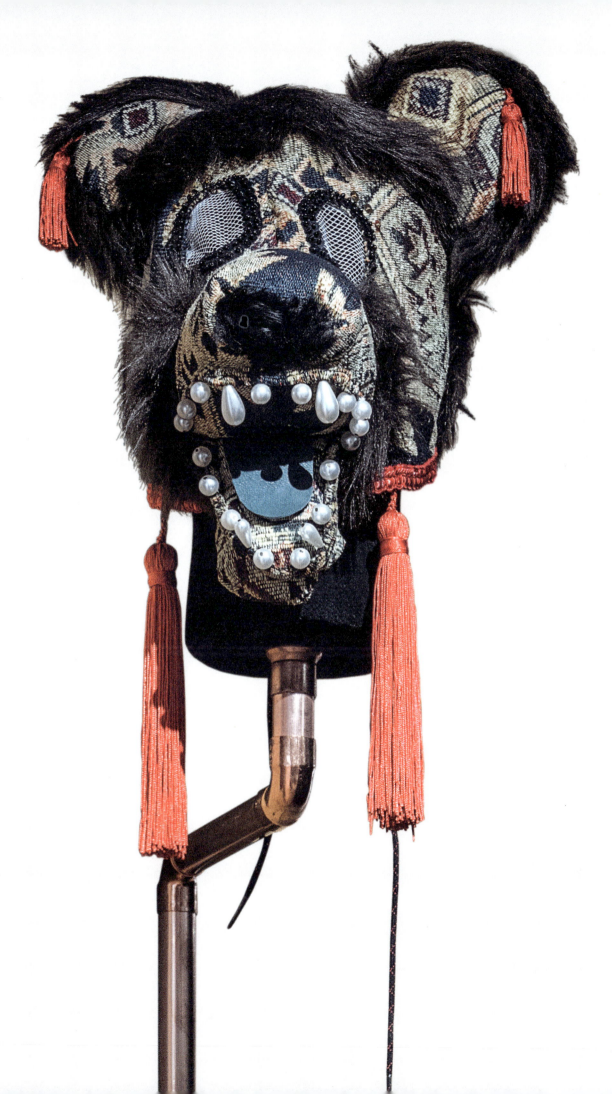

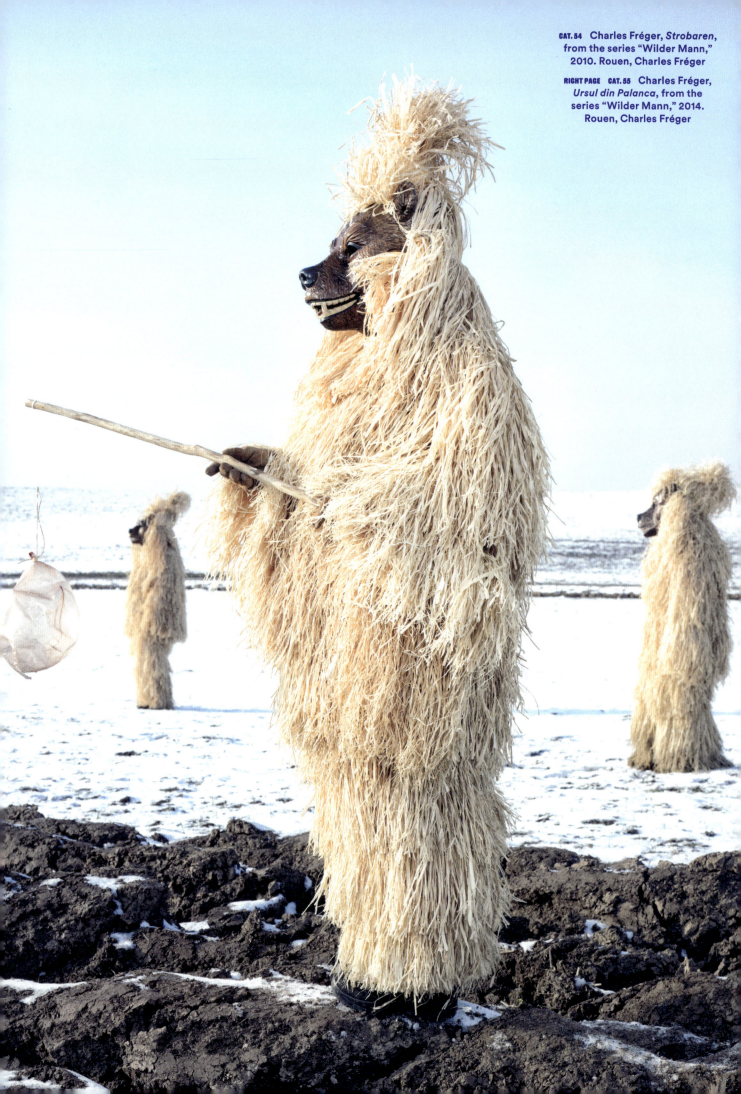

CAT. 54 Charles Fréger, *Strobaren*, from the series "Wilder Mann," 2010. Rouen, Charles Fréger

RIGHT PAGE CAT. 55 Charles Fréger, *Ursul din Palanca*, from the series "Wilder Mann," 2014. Rouen, Charles Fréger

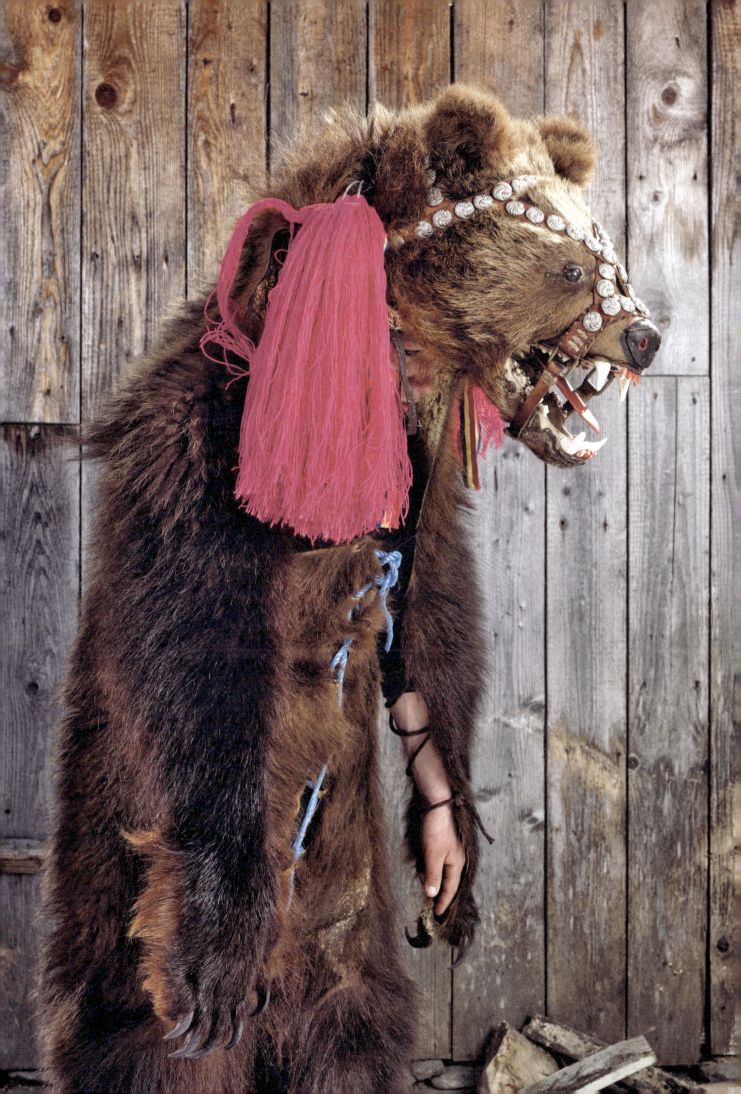

APPENDICES

EXHIBITED WORKS

In the following list, measurements are given in the order: height x length x width; or height x width x depth or thickness.

BEARS AND HUMANS THE PALEOLITHIC

CAT. 1
Red bear, Passage of the Bears
Chauvet-Pont-d'Arc cave, Ardèche, Aurignacian (37,000 to 33,000 BP)
Reproduction
REPR. P. 25

CAT. 2
Bear engraved on deer antler
Ker de Massat cave, Ariège, Magdalenian (17,000 to 14,000 BP)
Deer antler
7.7 × 4.8 × 1.7 cm
Toulouse, Muséum d'Histoire Naturelle
Inv. MHNT.PRE.2012.0.400
REPR. P. 22

CAT. 3
Pierced tooth, perforated bear canine (*Ursus spelaeus*). Duruthy jewelry
Duruthy cave, Landes, Upper Paleolithic (45,000 to 12,000 BCE)
Pierced and engraved bear tooth
9.4 × 3.5 × 2 cm
Toulouse, Muséum d'Histoire Naturelle
Inv. MHNT.PRE.2010.0.13.1

CAT. 4
Pierced tooth, perforated and engraved bear canine (*Ursus spelaeus*) (series of incised chevrons).
Duruthy jewelry
Duruthy cave, Landes, Upper Paleolithic (45,000 to 12,000 BCE)
Pierced and engraved bear tooth
9.2 × 2.9 × 1.7 cm
Toulouse, Muséum d'Histoire Naturelle
Inv. MHNT.PRE.2010.0.13.3

CAT. 5
Pierced tooth, perforated and engraved bear canine (*Ursus spelaeus*) with barbed patterns, "tooth with 4 arrows." Duruthy jewelry
Duruthy cave, Landes, Upper Paleolithic (45,000 to 12,000 BCE)
Pierced and engraved bear tooth
8.2 × 2.8 × 1.6 cm
Toulouse, Muséum d'Histoire Naturelle
Inv. MHNT.PRE.2010.0.13.4

CAT. 6
Pierced tooth, perforated bear canine (*Ursus spelaeus*) with champlevé engraving, "tooth with pike." Duruthy jewelry
Duruthy cave, Landes, Upper Paleolithic (45,000 to 12,000 BCE)
Pierced and engraved bear tooth
7.8 × 3.1 × 2.2 cm
Toulouse, Muséum d'Histoire Naturelle
Inv. MHNT.PRE.2010.0.13.5

CAT. 7
Le Collier de Rahan
France, 2004
Plastic, textile cord
30 × 20 cm
Paris, Les Arts Décoratifs
Inv. PR 2024.147.1

CAT. 8
Roger Lécureux (author), André Chéret (illustrator)
"Le Collier de griffes," *Pif Gadget, Rahan*, quarterly, no. 5
Paris, Éditions Vaillant, 1973
Magazine
28 × 21.9 × 0.5 cm
Paris, Bibliothèque du Musée des Arts Décoratifs, documentation department

BEAR MYTHS FROM ANTIQUITY TO THE EARLY MIDDLE AGES

CAT. 9
Figurine
Susa, Elam (present-day Iran), 4th–2nd millennium
Molded terra cotta
5.9 × 3.5 × 3 cm
Paris, Musée du Louvre, department of Eastern antiquities
Inv. SB 8813

CAT. 10
Figurine
Susa, Elam (present-day Iran), 4th–2nd millennium
Molded terra cotta
4 × 2 × 1.9 cm
Paris, Musée du Louvre, department of Eastern antiquities
Inv. SB 8818

CAT. 11
Vase cover
Cappadocia (present-day Turkey), Middle Bronze Age (2100 to 1550 BCE)
Molded terra cotta and pastillage
4.3 × 4.8 × 4 cm
Paris, Musée du Louvre, department of Eastern antiquities
Inv. CA 1398.B

CAT. 12
John Flamsteed (author)
"Ursa Major," in *Atlas Coelestes*
London, 1729
Geographical map
55.5 × 42.5 × 3.5 cm
Paris, Bibliothèque Nationale de France, department of maps
Inv. GE DD-1439 (13 RES)
REPR. P. 13

CAT. 13
John Flamsteed (author), Jean-Baptiste Fortin, Pierre-Charles Le Monnier, François Pasumot, Nicolas-Louis de La Caille (scientific publishers)
"Ursa Major," in *Atlas Céleste*
Paris, 1776
Printed monograph
22.5 × 16 × 3 cm
Paris, Bibliothèque Nationale de France, department of maps
Inv. GE FF-3289

CAT. 14
After Hendrik Goltzius
Callisto changée en ourse (Callisto changed into a bear)
The Netherlands, 1590
Print on paper
40 × 30 cm (with frame)
Crépy-en-Valois, Musée de l'Archerie et du Valois
Inv. 2018.0.19
REPR. P. 12

CAT. 15
Plate depicting Odin and a Berserker
Torslunda, Sweden, 6th century
Reproduction
Swedish History Museum, Stockholm
Inv. 618349_HST

CAT. 16
Gaston Phébus
Le Livre de la chasse
France, last quarter of the 15th century
Manuscript
41.5 × 29.5 × 4 cm
Paris, Bibliothèque Nationale de France, manuscripts department (f° 75 r°)
Français 617

CAT. 17
Gaston Phébus
Le Livre de la chasse (The Hunting Book)
France, before 1476
Red Moroccan leather binding with coat-of-arms and gilding; marbled flyleaves; parchment; 91 miniatures
36 × 26.3 × 5 cm
Paris, Bibliothèque Mazarine (f° 081 v°)
Inv. MAZ 3717
REPR. P. 14 LEFT

THE FALL OF THE BEAR

CAT. 18
Ensevelissement de saint Denis
Belgium, c. 1520
Wool and silk tapestry
113 × 190 cm
Paris, Musée des Arts Décoratifs, gift of Jules Maciet, 1890
Inv. 6199

CAT. 19
Costnitzer Concilium so gehalten worden im far taussend vier hundert und dreytzehen... Sampteiner eigentlichen Delineation derselbigen Potentaten Wappen und mit andern schönen Figuren...
Frankfurt-am-Main, printed by Paulum Reffelern for Siegmund Feyerabends, 1575
Typographical printing and engraving on laid paper
16.5 × 32.5 × 38.5 cm
Paris, Bibliothèque du Musée des Arts Décoratifs, bequest of Émile Peyre, 1905
Inv. BAD 11650
REPR. P. 16 BOTTOM

CAT. 20
Philip Galle
"Chasse à l'ours," in *Venationes*, plate XXVI
The Netherlands, c. 1585
Copper engraving
20.5 × 26.3 cm
Paris, Musée de la Chasse et de la Nature
Inv. 61.332

CAT. 21
Hubert Robert
Le Montreur d'ours (The Bear Tamer)
France, late 18th century
Oil on canvas
40.5 × 31.8 cm
Paris, private collection, courtesy of Galerie Talabardon & Gautier
REPR. P. 17

CAT. 22
Godefroy Engelmann
La Danse de l'ours
France, early 19th century
Lithograph
40.3 × 53 cm
Paris, Musée Carnavalet–Histoire de Paris
Inv. CARGMOE021279

CAT. 23
Léopold Chauveau
Le Roman de Renard
Paris, Éditions La Farandole, 1956
Book
28.5 × 18.7 cm
Paris, Vanryb Collection

CAT. 24
Marcus de Bye, after Marcus Gheeraerts the Elder
Les Ours
The Netherlands, 1664
Etching on laid paper
50 × 40 cm
Paris, Bibliothèque du Musée des Arts Décoratifs, gift of M. Guérin
Inv. Maciet 4/53-36

CAT. 25
Marcus de Bye, after Marcus Gheeraerts the Elder
Les Ours
The Netherlands, 1664
Etching on laid paper
50 × 40 cm
Paris, Bibliothèque du Musée des Arts Décoratifs, gift of M. Guérin
Inv. Maciet 4/53-37

CAT. 26
Charles Le Brun (author), Dominique-Vivant Denon (engraver)
Dissertation sur le traité de Charles Le Brun, concernant le rapport de la physionomie humaine avec celle des animaux (Essay concerning the Relationship between Human Physiognomy and that of the Animals)
Paris, copper engraving studio of the Musée Napoléon, 1806
Etching on laid paper
50 × 40 cm
Paris, Bibliothèque du Musée des Arts Décoratifs
Inv. Maciet 4/53-39
REPR. P. 15 RIGHT

CAT. 27
Jean de la Fontaine (author), Jean-Baptiste Oudry (illustrator), Jacques-Jean Pasquier (engraver)
L'Ours et l'Amateur des jardins (The Bear and the Lover of Gardens), in *Fables choisies, mises en vers par J. de La Fontaine*, vol. III
Paris, Desaint & Saillant / Durand, 1756
Etching on laid paper
43 × 30 cm
Paris, Bibliothèque du Musée des Arts Décoratifs, bequest of Lejeune Laroze, 1923
Inv. BAD 27145
REPR. P. 10

CAT. 28
Jean de la Fontaine (author), Jean-Baptiste Oudry (illustrator), Jacques-Jean Pasquier (engraver)
L'Ours et les deux compagnons, in *Fables choisies, mises en vers par J. de La Fontaine*, vol. III
Paris, Desaint & Saillant / Durand, 1756
Etching on laid paper
Paris, Bibliothèque du Musée des Arts Décoratifs, bequest of Lejeune Laroze, 1923
Inv. BAD 27145

CAT. 29
Jean de la Fontaine (author), Gustave Doré (illustrator)
L'Ours et l'Amateur des jardins, in *Fables de La Fontaine*
Paris, Hachette, 1890
End grain woodcut illustration on paper
H. 38 cm
Paris, Bibliothèque du Musée des Arts Décoratifs, gift of Hachette, February, 1898
Inv. BAD 6517

CAT. 30
Jean de La Fontaine (author), Gustave Doré (illustrator)
L'Ours et les deux compagnons, in *Fables de La Fontaine*
Paris, Hachette, 1890
End grain woodcut illustration on paper
H. 38 cm
Paris, Bibliothèque du Musée des Arts Décoratifs, gift of Hachette, February 1898
Inv. BAD 6517

CAT. 31
Jean de la Fontaine (author), Grandville (illustrator)
La Cour du lion (The Lion's Court), in *Fables de La Fontaine*, vol. I
Paris, Fournier Aîné, 1838
End grain woodcut illustration on paper
23 × 15.5 cm
Paris, Bibliothèque du Musée des Arts Décoratifs, gift of Paul Gasnault, 1898
Inv. BAD 7650
REPR. P. 15 LEFT

CAT. 32
Jean de la Fontaine (author), Grandville (illustrator)
La Lionne et l'ourse, in *Fables de La Fontaine*, vol. I
Paris, Fournier Aîné, 1838
End grain woodcut illustration on paper
23 × 15.5 cm
Paris, Bibliothèque du Musée des Arts Décoratifs, gift of Paul Gasnault, 1898
Inv. BAD 7650

CAT. 33
Jean-Baptiste Huet fils
Ours brun, dessiné d'après nature par Huet fils, peintre du Muséum d'histoire naturelle
France, 19th century
Etching in the crayon manner on laid paper
50 × 40 cm
Paris, Bibliothèque du Musée des Arts Décoratifs
Inv. Maciet 4/53-80

CAT. 34
Auguste Lançon (illustrator), M. Génin (author)
La Famille Martin, histoire de plusieurs ours
Paris, Hetzel, 1878
End grain woodcut illustrations on paper
50 × 40 cm
Paris, Bibliothèque du Musée des Arts Décoratifs
Inv. Maciet 4/53-56

CAT. 35
Auguste Lançon (illustrator), M. Génin (author)
La Famille Martin, histoire de plusieurs ours
Paris, Hetzel, 1878
End grain woodcut illustration on paper
50 × 40 cm
Paris, Bibliothèque du Musée des Arts Décoratifs
Inv. Maciet 4/53-59

CAT. 36
Jugend: Münchner illustrierte Wochenschrift für Kunst und Leben
No. 24 (cover), Munich, G. Hirth's Verlag, June 1903
Color printing on paper
50 × 40 cm
Paris, Bibliothèque du Musée des Arts Décoratifs
Inv. Maciet 4/53-69

CAT. 37
Anonymous (designer), Gubina et Cie Lith. Lyon (lithographer)
Graisse d'ours des Alpes préparée par Isnard Neveu, parfumeur à Paris
Lyon, 1839
Color lithograph on paper
43.5 × 27.5 cm
Paris, Musée des Arts Décoratifs
Inv. 12221

CAT. 38
Robert Southey
"The Story of the Three Bears," in *The Doctor*, vol. IV
London, Longman, Rees, Orme, Brown, Green and Longman, 1837
Book
27 × 14.1 × 3.8 cm
Paris, Bibliothèque Nationale de France, literature and art department
Inv. Z-61029

CAT. 39
Arthur Rackham (illustrator), Hans Christian Andersen (author), Charles Perrault (author)
The Arthur Rackham Fairy Book: A Book of Old Favourites with New Illustrations
London, George G. Harrap & Co. Ltd., 1933
Book
23 cm
Paris, Ville de Paris / Heure Joyeuse heritage fund, Françoise Sagan media library
Inv. FA in8 2840

CAT. 40
Frankl (Rol agency)
Ours savant faisant du vélo
France, 1925
Reproduction
Paris, Bibliothèque Nationale de France, department of prints and photography
Inv. EI-13 (1202)
REPR. P. 19

CAT. 41
Bear tamers in Romania
Bucharest, Ad. Maier & D. Stern Editions, early 20th century (postcard mailed in 1904)
Cardstock; ink
9 × 14.1 cm
Paris, Bibliothèque du Musée des Arts Décoratifs, documentation department

CAT. 42
Bear tamers in the Pyrénées
Saint-Girons-Foix, Éditions Fauré et ses Fils, early 20th century (postcard mailed in 1906)
Cardstock; ink
14 × 8.8 cm
Paris, Bibliothèque du Musée des Arts Décoratifs, documentation department

CAT. 43
Bear tamers in Savoy
Chambéry, Éditions E. Reynaud, early 20th century (postcard mailed in 1908)
Cardstock
9.1 × 14 cm
Paris, Bibliothèque du Musée des Arts Décoratifs, documentation department
REPR. P. 20

CAT. 44
Jean Roullet (manufacturer)
Bear playing a bass drum
France, 1880–1885
Fur; glass eyes; cardboard; wood; paper; steel
36 × 18 × 21 cm
Paris, Musée des Arts Décoratifs, purchase, 1988
Inv. 988.1201
REPR. P. 21

CAT. 45
Ives Manufacturing Co. (manufacturer)
Mechanical bear
United States, 1885
Real fur; synthetic fur; wooden body; glass eyes; metal chain and muzzle
17 × 20 × 24 cm
Paris, Musée des Arts Décoratifs, purchase, 1988
Inv. 989.90

CAT. 46
Elie Martin (manufacturer)
White bear
France, c. 1885
Sheep fur; frame of wood and cork; glass eyes; key-operated mechanics
21 × 14 × 41 cm
Paris, Musée des Arts Décoratifs, purchase, 1988
Inv. 988.488

CAT. 47
Maison Fernand Martin (manufacturer)
L'Ours Martin
France, 1903
Painted metal head; body covered in brown fabric
22 × 14 × 11 cm
Paris, Musée des Arts Décoratifs, purchase, 1983
Inv. 54219

CAT. 48
Roullet et E. Decamps (manufacturer)
Ours des Cocotiers culbuteur
France, c. 1900
Rabbit fur; glass eyes; compound paws; metal rings
28 × 20 × 18 cm
Paris, Musée des Arts Décoratifs, purchase, 1988
Inv. 988.535

CAT. 49
Anonymous (designer), Charles Levy American Posters (printer)
Mr et Mme Spessardi et leur groupe d'ours acrobates
Paris, undated
Color lithograph on paper
124.5 × 90 cm
Paris, Musée des Arts Décoratifs
Inv. 13748

CAT. 50
Anonymous (designer),
Charles Levy American
Posters (printer)
Tous les soirs. Cirque d'Hiver. Les ours sibériens
(Every Night. Winter Circus. Siberian Bears)
Paris, undated
Color lithograph on paper
124.5 × 90 cm
Paris, Musée des Arts Décoratifs
Inv. 13639
REPR. P. 18

THE FALLEN BEAR, A RELIC OF POWER

CAT. 51
Gustave Doré
Chasse à l'ours
France, 19th century
Lithograph
49 × 72 cm
Paris, Musée de la Chasse et de la Nature
Inv. 61.1439

CAT. 52
William Samuel Howitt, Matthew Dubourg
Seamen Killing a Polar Bear
UK, 19th century
Aquatint on paper
16.4 × 21.5 cm
Paris, Musée de la Chasse et de la Nature
Inv. 62.7.5

CAT. 53
Mehryl Levisse
Le Culte de l'ours (Bear Worship)
France, 2017
Tapestry; leather; sequins; beads; fur; pompoms
34 × 30 × 34 cm
Paris, Musée de la Chasse et de la Nature
Inv. 017.67
REPR. P. 119

CAT. 54
Charles Fréger
Strobaren, from the "Wilder Mann" series
France, 2010
101 × 77 cm
Rouen, Charles Fréger
REPR. P. 120

CAT. 55
Charles Fréger
Ursul din Palanca, from the "Wilder Mann" series
France, 2014
101 × 77 cm
Rouen, Charles Fréger
REPR. P. 121

CAT. 56
Charles Fréger
Ours, Arles-sur-Tech, from the "Wilder Mann" series
France, 2010
101 × 77 cm
Rouen, Charles Fréger
REPR. P. 116

THE HISTORY OF THE TEDDY BEAR

UNITED STATES

CAT. 57
Clifford Kennedy Berryman
Drawing the Line in Mississippi,
The Washington Post
United States, November 16, 1902
Reproduction
Courtesy of the Berryman Family Papers
Washington D.C., Archives of American Art, Smithsonian Institution
REPR. P. 28 LEFT

CAT. 58
Advertising panel for Ideal Toy teddy bears
United States, c. 1908
Wood
28 × 42.1 × 0.2 cm
Paris, Les Arts Décoratifs
REPR. P. 29 LEFT

CAT. 59
Seymour Eaton (author), V. Floyd Campbell (illustrator)
The Roosevelt Bears: Their Travels and Adventures
Philadelphia, Edward Stern, 1906
Book
Paris, Bibliothèque du Musée des Arts Décoratifs
Inv. BAD 2024-2253

CAT. 60
Sarah Tawney Lefferts (author), Louise Baquet (illustrator)
Mr. Cinnamon Bear
New York, Cupples & Leon, 1907 (1984 edition, S. Tancredi & Sons, Carmel Valley)
Book
16.5 × 14.5 × 1 cm
Paris, Bibliothèque du Musée des Arts Décoratifs, documentation department

CAT. 61
John Walter Bratton
The Teddy Bears' Picnic
United States, 1907 (British edition, London, B. Feldman and Co.)
Musical score on paper
30.8 × 25.3 × 0.1 cm
Paris, Bibliothèque du Musée des Arts Décoratifs, documentation department
REPR. P. 38 LEFT

CAT. 62
Ideal Toy Corp (manufacturer)
Teddy bear
United States, c. 1910
Stuffed mohair
45 × 22 × 14 cm
London, Victoria and Albert Museum, gift of Miss E. M. Jeeves
Inv. MISC.317-1985
REPR. P. 35

GERMANY

CAT. 63
Otto Neubrand
Portrait of Margarete Steiff
Germany, 1947
Oil on canvas
90 × 82 cm
Giengen an der Brenz, Margarete Steiff GmbH

CAT. 64
Die Modenwelt
Berlin, December 8, 1879
Reproduction

CAT. 65
Steiff
Catalogue
Germany (Giengen an der Brenz), 1897
Reproduction
Giengen an der Brenz, Margarete Steiff GmbH

CAT. 66
Anonymous
Portrait of Richard Steiff
Germany, early 20th century
Reproduction
Giengen an der Brenz, Margarete Steiff GmbH

CAT. 67
Anonymous
Margarete Steiff Working in the Steiff Factory
Germany (Giengen an der Brenz), late 19th–early 20th century
Reproduction
Giengen an der Brenz, Margarete Steiff GmbH

CAT. 68
Anonymous
Bär 55 PB
Germany (Giengen an der Brenz), 1903
Reproduction of a photograph
Giengen an der Brenz, Margarete Steiff GmbH
REPR. P. 26

CAT. 69
Steiff
Catalog of new items 1903–1904
Germany (Giengen an der Brenz), 1903
Reproduction
Giengen an der Brenz, Margarete Steiff GmbH
REPR. P. 30 TOP

CAT. 70
Richard Steiff
Bear Drawings
Germany (Stuttgart), 1894
Reproduction
Giengen an der Brenz, Margarete Steiff GmbH
REPR. P. 30 BOTTOM

CAT. 71
Richard Steiff
Bear Drawing
Germany (Stuttgart), 1894
Reproduction
Giengen an der Brenz, Margarete Steiff GmbH

CAT. 72
Steiff
Steiff Catalogue 1914
Germany (Giengen an der Brenz), 1914
Paper
30 × 13 × 0.5 cm
Giengen an der Brenz, Margarete Steiff GmbH

CAT. 73
Steiff
Steiff Catalogue 1919
Germany (Giengen an der Brenz), 1919
Paper
29 × 11 × 1 cm
Giengen an der Brenz, Margarete Steiff GmbH

CAT. 74
Steiff
Steiff Catalogue Paris
France (Paris), 1911
Paper
29 × 11 × 0.5 cm
Giengen an der Brenz, Margarete Steiff GmbH

CAT. 75
Paul Steiff
Sketchbook
1927
Paper
12 × 20 × 1.5 cm
Giengen an der Brenz, Margarete Steiff GmbH

CAT. 76
Paul Steiff
Sketchbook
1925
Paper
13 × 19 × 1 cm
Giengen an der Brenz, Margarete Steiff GmbH

CAT. 77
Paul Steiff
Bear Drawing
Germany, 1920–1930
Tracing paper
45 × 33 cm
Giengen an der Brenz, Margarete Steiff GmbH

CAT. 78
Paul Steiff
Bear Drawing
Germany, 1920–1930
Tracing paper
45 × 33 cm
Giengen an der Brenz, Margarete Steiff GmbH

CAT. 79
Paul Steiff
Bear Drawing
Germany, 1920–1930
Tracing paper
30 × 38 cm
Giengen an der Brenz, Margarete Steiff GmbH

CAT. 80
Steiff (manufacturer)
Elephant
Germany (Giengen an der Brenz), 1888
Felt
8 × 12 × 14 cm
Giengen an der Brenz, Margarete Steiff GmbH
REPR. P. 31

CAT. 81
Steiff (manufacturer)
Cat
Germany (Giengen an der Brenz), 1899
Velvet
15 × 6 × 15 cm
Giengen an der Brenz, Margarete Steiff GmbH

CAT. 82
Steiff (manufacturer)
Bird rattle
Germany (Giengen an der Brenz), 1898
Felt
28 × 12 × 6 cm
Giengen an der Brenz, Margarete Steiff GmbH

CAT. 83
Steiff (manufacturer)
Rabbit
Germany (Giengen an der Brenz), 1903
Wool plush
11 × 7 × 20 cm
Giengen an der Brenz, Margarete Steiff GmbH

CAT. 84
Steiff (manufacturer)
Bear on wheels
Germany (Giengen
an der Brenz), 1905
Sealskin
16 × 10 × 22 cm
Giengen an der Brenz,
Margarete Steiff GmbH

CAT. 85
Steiff (manufacturer)
Bear on a keel
Germany (Giengen
an der Brenz), 1897
Felt
20 × 7 × 9 cm
Giengen an der Brenz,
Margarete Steiff GmbH

CAT. 86
Steiff (manufacturer)
*English postman,
articulated doll*
Germany (Giengen
an der Brenz), 1903
Velvet and felt
50 × 11 × 7 cm
Giengen an der Brenz,
Margarete Steiff GmbH

CAT. 87
Steiff (manufacturer)
Bärle 5335
Germany (Giengen
an der Brenz), 1905
Mohair stuffed with wood
wool and kapok
50 × 24 × 15 cm
Giengen an der Brenz,
Margarete Steiff GmbH
REPR. P. 33

CAT. 88
Steiff (manufacturer)
Teddy bear
Germany (Giengen
an der Brenz), 1908
Mohair
46 × 27 × 15 cm
Giengen an der Brenz,
Margarete Steiff GmbH

CAT. 89
Steiff (manufacturer)
Teddy bear
Germany (Giengen
an der Brenz), c. 1910–
1912
Mohair plush; shaved
muzzle; felt paw pads
60 × 32 × 25 cm
Paris, Musée des Arts Décoratifs,
gift of Danièle Giraudy, 1994
Inv. 994.70.1
REPR. P. 34

CAT. 90
Steiff (manufacturer)
Dachshund on wheels
Germany (Giengen
an der Brenz), 1906
Velvet
37 × 7 × 19 cm
Giengen an der Brenz,
Margarete Steiff GmbH

CAT. 91
Steiff (manufacturer)
Bully
Germany (Giengen
an der Brenz), 1927
Mohair
27 × 17 × 13 cm
Giengen an der Brenz,
Margarete Steiff GmbH

CAT. 92
Steiff (manufacturer)
Squirrel
Germany (Giengen
an der Brenz), c. 1911
Velvet
20 × 14 × 6.5 cm
Paris, Musée des Arts Décoratifs,
purchase, 1995
Inv. 995.74.2

CAT. 93
Steiff (manufacturer)
Roly Poly Bär
Germany (Giengen
an der Brenz), 1909
Mohair
16 × 10 × 10 cm
Giengen an der Brenz,
Margarete Steiff GmbH

CAT. 94
Steiff (manufacturer)
Teddy bear
Germany (Giengen
an der Brenz), c. 1905
Mohair plush; chamois
paw pads
55 × 27 × 18 cm
Paris, Musée des Arts Décoratifs,
gift of Guy de Faramoud, 2001
Inv. 999.91.1

CAT. 95
Steiff (manufacturer)
Teddy bear
Germany (Giengen
an der Brenz), 1922
Mohair body, stuffed with
wood wool; glass eyes;
stitched nose and claws;
felt paw pads
30 × 18 × 13 cm
Paris, Musée des Arts Décoratifs,
gift of Jeanne and Guillaume
Gueller, 1988
Inv. 988.1101

CAT. 96
Steiff (manufacturer)
Bear 5317
Germany (Giengen
an der Brenz), 1916
Mohair; wood wool
24 × 18 × 13 cm
Giengen an der Brenz,
Margarete Steiff GmbH

CAT. 97
Steiff (manufacturer)
Bear 5328.2
Germany (Giengen
an der Brenz), 1921
Mohair; wood wool
40 × 27 × 13 cm
Giengen an der Brenz,
Margarete Steiff GmbH

CAT. 98
Steiff (manufacturer)
Bear 5325.2
Germany (Giengen
an der Brenz), 1927
Mohair; wood wool
32 × 17 × 11 cm
Giengen an der Brenz,
Margarete Steiff GmbH

CAT. 99
Steiff (manufacturer)
Teddy Baby
Germany (Giengen
an der Brenz), c. 1930
Plush; glass eyes; felt
mouth and paw pads;
stitched nose and claws;
collar of artificial leather
23 × 12 × 7.5 cm
Paris, Musée des Arts Décoratifs,
purchase, 1988
Inv. 988.512.3
REPR. P. 53

CAT. 100
Steiff (manufacturer)
Dicky
Germany (Giengen
an der Brenz), 1930
Mohair; wood wool
30 × 15 × 10 cm
Giengen an der Brenz,
Margarete Steiff GmbH
REPR. P. 52

CAT. 101
Steiff (manufacturer)
Petsy
Germany (Giengen
an der Brenz), 1928
Mohair
32 × 19 × 12 cm
Giengen an der Brenz,
Margarete Steiff GmbH

CAT. 102
Steiff (manufacturer)
*Steiff bear from the First
World War*
Germany (Giengen
an der Brenz), 1919
Paper stuffed animal
20 × 11 × 14 cm
Giengen an der Brenz,
Margarete Steiff GmbH

THE INSTANT SUCCESS OF THE TEDDY BEAR

CAT. 103
*Le Printemps, Les plus
jolis jouets sont au
Printemps, 1924-25*
Paris, Le Printemps, 1924
Color printing on paper
37.2 × 27.7 × 0.3 cm
Paris, Bibliothèque
du Musée des Arts Décoratifs
Inv. DJ 683 CAT

CAT. 104
*Galeries Lafayette,
Jouets, Vive Lafayette !
Étrennes, Mardi 30
novembre et pendant tout
le mois de décembre*
Paris, Galeries Lafayette,
1926
Color printing on paper
37.6 × 28.2 × 0.3 cm
Paris, Bibliothèque
du Musée des Arts Décoratifs
Inv. DJ 89 CAT

CAT. 105
*Grands magasins
du Louvre, Au Louvre,
Jouets, 1922-23*
Paris, Grands Magasins
du Louvre, 1922
Color printing on paper
27.1 × 18.6 × 0.3 cm
Paris, Bibliothèque
du Musée des Arts Décoratifs
Inv. DJ 681 CAT

CAT. 106
*Au Louvre. Jouets, 1925-
26*
Paris, Grands Magasins
du Louvre, 1925
Woodcut illustration
on paper
27.1 × 19.2 × 0.2 cm
Paris, Bibliothèque
du Musée des Arts Décoratifs
Inv. DJ 76 CAT
REPR. P. 38 RIGHT

CAT. 107
*Grands magasins
du Louvre, Au Louvre,
1930, Décembre 1929,
jouets étrennes*
Paris, Grands Magasins
du Louvre, 1929
Woodcut illustration
on paper
26.5 × 18.7 × 0.4 cm
Paris, Bibliothèque
du Musée des Arts Décoratifs
Inv. DJ 83 CAT

CAT. 108
*Grand Bazar de l'Hôtel
de Ville. Étrennes 1925*
Paris, Grand Bazar
de l'Hôtel de Ville, 1924
Color printing on paper
31 × 23.6 × 0.2 cm
Paris, Bibliothèque
du Musée des Arts Décoratifs
Inv. DJ 88 CAT
REPR. P. 39

CAT. 109
Raymond de La Nézière
(poster artist), Maurice
Dupuy Paris (printer)
Jouets Étrennes (New
Year's Toys)
France, c. 1925
Paper; color lithograph
88.5 × 124 cm
Paris, Musée des Arts Décoratifs
Inv. 20016
REPR. P. 42

CAT. 110
*Two children with a teddy
bear*
Early 20th century
(unsent postcard)
Cardstock
13.7 × 8.6 cm
Paris, Bibliothèque
du Musée des Arts Décoratifs,
documentation department
REPR. P. 41 LEFT

CAT. 111
*Mary with her little bear
behind*
England, Bamforth & Co.,
1907 (unsent postcard)
Cardstock
13.6 × 8.6 cm
Paris, Bibliothèque
du Musée des Arts Décoratifs,
documentation department

CAT. 112
*Seated girl holding
a teddy bear*
England, Rotary Real
Photographs, c. 1910
(postcard mailed in 1911)
Cardstock
13.6 × 8.4 cm
Paris, Bibliothèque
du Musée des Arts Décoratifs,
documentation department

CAT. 113
*Child with a teddy bear
and a doll*
1910–1920 (unsent
postcard)
Cardstock
14 × 9.1 cm
Paris, Bibliothèque
du Musée des Arts Décoratifs,
documentation department

CAT. 114
*Child playing with
a teddy bear*
Belgium, 1925 (postcard)
Cardstock
8.9 × 13.4 cm
Paris, Bibliothèque
du Musée des Arts Décoratifs,
documentation department
REPR. P. 41 TOP RIGHT

CAT. 115
*Child with a teddy bear
and a doll*
1930s (postcard)
Paper
13.9 × 8.9 cm
Paris, Bibliothèque
du Musée des Arts Décoratifs,
documentation department

CAT. 116
*Child standing near
a teddy bear and holding
another bear*
c. 1931 (postcard)
Cardstock
13.4 × 8.4 cm
Paris, Bibliothèque
du Musée des Arts Décoratifs,
documentation department

CAT. 117
Child posing near a teddy bear
Early 20th century
(unsent postcard)
Cardstock
13.5 × 8.4 cm
Paris, Bibliothèque du Musée des Arts Décoratifs, documentation department

CAT. 118
Two children posing with their toys
Early 20th century
(unsent postcard)
Cardstock
13.5 × 8.6 cm
Paris, Bibliothèque du Musée des Arts Décoratifs, documentation department

CAT. 119
Little boy posing with a teddy bear
Early 20th century
(unsent postcard)
Cardstock
13.9 × 8.9 cm
Paris, Bibliothèque du Musée des Arts Décoratifs, documentation department

CAT. 120
Henry René d'Allemagne (author), J. Vasquez (illustrator)
"La fosse aux ours," in *La Très Véridique Histoire de Nette et Tintin visitant le village du jouet*
Paris, Schemit, 1927
Reproduction
Paris, Bibliothèque du Musée des Arts Décoratifs

CAT. 121
Little girl with a teddy bear muff
Early 20th century
Reproduction

CAT. 122
White bear
Germany?, c. 1924
Mohair plush; stitched nose and claws; felt paw pads
36 × 16.5 × 12 cm
Paris, Musée des Arts Décoratifs, gift of Mme Sureau, 1988
Inv. 988.54

CAT. 123
Teddy bear
Germany or UK, 1927
Mohair plush; glass eyes; stitched nose; felt ears and paws; cardboard support
27 × 22 × 21 cm
Paris, Musée des Arts Décoratifs, purchase, 1993
Inv. 993.157.2
REPR. P. 51

CAT. 124
Pintel (manufacturer)
Mechanical bear
France, c. 1940
Plush; metal; wood; glass
19 × 9 × 10 cm
Paris, Musée des Arts Décoratifs, purchase, 1988
Inv. 988.485.2

CAT. 125
Bear and its baby
c. 1920
Synthetic plush; cardboard body; glass eyes; metal nose, feet, mechanism; wooden arms
17 × 8 × 9 cm
Paris, Musée des Arts Décoratifs, purchase, 1994
Inv. 994.45.4

CAT. 126
Établissements Lang or Armand Weill (manufacturer)
Bear on wheels
France, 1930
Plush, fabric; glass eyes; metal structure
21 × 13 × 29 cm
Paris, Musée des Arts Décoratifs, gift of Fisher-Price, 1982
Inv. 49697.B

CAT. 127
Pintel (manufacturer)
Bear on wheels
France, 1935–1940
Mohair plush; metal frame; rubber wheels
45 × 37 × 69 cm
Paris, Musée des Arts Décoratifs, purchase, 1988
Inv. 988.1163

CAT. 128
Articulated bears
France, c. 1910
Plush; glass eyes; silk ribbon; metal joints
9 × 6 × 4 cm
Paris, Musée des Arts Décoratifs, gift of Mademoiselle Zoubaloff, 1975
Inv. 45060.1-3

CAT. 129
Teddy bear
c. 1930–1940
Mohair plush; stitched nose
7.5 × 5 × 4 cm
Paris, Musée des Arts Décoratifs, gift of Mme Boucheron, 1995
Inv. 995.60.1.4

CAT. 130
Steiff (manufacturer)
Polar bear
Germany, 1909
Mohair
12 × 20 × 8 cm
Giengen an der Brenz, Margarete Steiff GmbH

CAT. 131
Articulated bear
France or Germany, c. 1910 or 1920
Plush; stitched muzzle and paws; felt paw pads
37 × 15 × 11 cm
Paris, Musée des Arts Décoratifs, gift of Mme A.C. Person-Zia, in memory of her uncle Jacques Dupanloup, 1994
Inv. 992.36.1

FRENCH AND ENGLISH BEARS

CAT. 132
Teddy bear
France, 1920
Stuffed mohair plush; glass eyes; stitched nose and claws; cotton paw pads
55 × 24 × 18 cm
Paris, Musée des Arts Décoratifs, purchase, 1988
Inv. 988.486

CAT. 133
White bear
France, 1935
Plush; glass eyes; muzzle of coated canvas
60 × 35 × 16 cm
Paris, Musée des Arts Décoratifs, purchase, 1994
Inv. 993.50.2

CAT. 134
Articulated bear
France, c. 1935
Cotton; plastic eyes; stitched muzzle and paws; ribbon
40 × 15 × 10 cm
Paris, Musée des Arts Décoratifs, purchase, 1987
Inv. 987.893.2
REPR. P. 44 TOP LEFT

CAT. 135
Articulated bear
France, c. 1935
Cotton; plastic eyes; stitched muzzle and paws; ribbon; metal joints
29.5 × 12 × 8.5 cm
Paris, Musée des Arts Décoratifs, purchase, 1987
Inv. 987.893.3
REPR. P. 44 TOP RIGHT

CAT. 136
Articulated bear
France, c. 1935
Plush; glass eyes; stitched muzzle; fabric paws
42 × 19 × 12 cm
Paris, Musée des Arts Décoratifs, purchase, 1987
Inv. 987.894
REPR. P. 44 BOTTOM

CAT. 137
Articulated bear
France, c. 1935
Cotton; plastic eyes; stitched muzzle and paws
41.5 × 19 cm; D. 10 cm
Paris, Musée des Arts Décoratifs, purchase, 1987
Inv. 987.893.1
REPR. P. 45

CAT. 138
Pink bear
France, 1935–1945
Velvet stuffed with wood shavings; stitched nose and claws; duffel paws
40 × 19 × 13 cm
Paris, Musée des Arts Décoratifs, purchase, 1986
Inv. 57818

CAT. 139
Pintel (manufacturer)
Growler
France, c. 1935
Mohair plush; glass eyes; stitched muzzle
49 × 30 × 15 cm
Paris, Musée des Arts Décoratifs, gift of Mme Bara, 1990
Inv. 990.331
REPR. P. 43

CAT. 140
Teddy bear
France, c. 1930
Mohair plush stuffed with wood shavings; glass eyes; stitched nose and claws; fabric paws
37 cm
Paris, Musée des Arts Décoratifs, gift of Mme Boucheron, 1995
Inv. 995.60.1.2

CAT. 141
Fadap (manufacturer)
Teddy bear
France, 1932–1934
Mohair plush; stitched nose
54 × 22 × 16 cm
Paris, Musée des Arts Décoratifs, gift of Fisher-Price, 1982
Inv. 49692.A
REPR. P. 46

CAT. 142
Georges Mange, known as Gogo (designer), Fadap (manufacturer)
Jacky
France, c. 1935
Mohair plush; glass eyes; stitched nose; fabric paw pads
42 × 23.5 × 13 cm
Paris, Musée des Arts Décoratifs, gift of Mme Boyré, 1994
Inv. 994.72.2

CAT. 143
Teddy bear
UK, c. 1935
Mohair plush; glass eyes with painted pupils; fabric nose; stitched mouth and claws
55 × 29 × 16 cm
Paris, Musée des Arts Décoratifs, purchase, 1994
Inv. 993.125.1

CAT. 144
Merrythought (manufacturer)
Bear with pink ribbon
UK, c. 1935
Plush with fabric paws; stitched claws and nose
51.5 × 23 × 12 cm
Paris, Musée des Arts Décoratifs
Inv. 994.130
REPR. P. 49

MADE AT HOME

CAT. 145
Anonymous, artisanal homemade production
Martin
France, 1916
Textile covering of wool canvas and cotton; cotton canvas paw pads; boot button eyes
30 × 14 × 7.5 cm
Paris, Musée des Arts Décoratifs, gift of Jeanne and Guillaume Gueller, 1988
Inv. 988.1100
REPR. P. 36

CAT. 146
Anonymous, artisanal homemade production
Bear
France, 1916
Stuffed fabric; stitched nose; bead
21 × 11 × 7 cm
Paris, Musée des Arts Décoratifs, gift of Mme A. Fuchs, 1994
Inv. 994.69

CAT. 147
Dressed bear
1930
Plush; glass eyes; felt paw pads; wool clothing
30 × 18 × 9.5 cm
Paris, Musée des Arts Décoratifs, purchase, 1988
Inv. 988.512.2

CAT. 148
Bimpo
c. 1932
Plush; fabric and felt clothing
29 × 18 × 9.5 cm
Paris, Musée des Arts Décoratifs, gift of Mme Tchertoff, 1983
Inv. 53951.A
REPR. P. 40

CAT. 149
Dressed bear
France, c. 1930
Plush; fabric paws; wool clothing
23 × 9 × 8 cm
Paris, Musée des Arts Décoratifs, purchase, 1996
Inv. 995.162.4.1

EARLY INNOVATIONS

CAT. 150
Pintel (manufacturer)
Pink bear
France, c. 1925 or 1935
Plush; glass eyes; stitched nose
53 × 29 × 20 cm
Paris, Musée des Arts Décoratifs, gift of Mme Berthier, 1982
Inv. 51176
REPR. P. 48

CAT. 151
Steiff (manufacturer)
Handbag
Germany, 1927
Mohair
15 × 10 × 23 cm
Giengen an der Brenz, Margarete Steiff GmbH
REPR. P. 50

CAT. 152
Steiff (manufacturer)
Boutonnière
Giengen an der Brenz, 1913
Mohair
4 × 5 × 5 cm
Giengen an der Brenz, Margarete Steiff GmbH

FICTIONAL BEARS

CAT. 153
A. A. Milne (author), E. H. Shepard (illustrator)
"Teddy Bear," in *When We Were Very Young*
London, Methuen & Co. Ltd., 1924 (1926 edition)
Book
19.5 × 13.3 cm × 1.4 cm
Paris, Vanryb Collection

CAT. 154
A. A. Milne (author), E. H. Shepard (illustrator)
"Furry Bear," in *Now We Are Six*
London, Methuen & Co. Ltd., 1927 (1928 edition)
Book
19.4 × 13 × 1.8 cm
Paris, Vanryb Collection

CAT. 155
A. A. Milne (author), E. H. Shepard (illustrator)
Winnie the Pooh
London, Methuen & Co. Ltd., 1926 (1940 edition)
Book
19.3 × 13.2 × 1.8 cm
Paris, Vanryb Collection

CAT. 156
A. A. Milne (author), E. H. Shepard (illustrator)
The House at Pooh Corner
London, Methuen & Co. Ltd., 1928 (1946 edition)
Book
18.8 × 13 × 2.7 cm
Paris, Vanryb Collection

CAT. 157
Wright R. John (designer), Hasbro (distributor), Walt Disney Company (license)
Winnie the Pooh
United States, 1987
Plush; stitched muzzle; terra cotta pot
Bear: 34 × 15 × 15 cm; Honey pot: 7 × [diam.] 11.5 cm
Paris, Musée des Arts Décoratifs, purchase, 1987
Inv. 987.886

CAT. 158
Orli-Jouet (manufacturer), Walt Disney Productions (license)
Winnie the Pooh
France, 1988
Polyacrylic; velvet nose
27 × 20 × 13.5 cm
Paris, Musée des Arts Décoratifs, gift of Orli-Jouet, 1985
Inv. 55967

CAT. 159
Anne Wilkinson
Winnie the Pooh, Piglet, Eeyore, and Tigger
UK, 1987
Winnie: plain weave; thin felt; printed eyes, nose, and mouth; flexible stuffing
24.5 × 17 × 12 cm
Tigger: plain weave; printed decorations; flexible stuffing
23.5 cm × 17 × 28.5 cm
Eeyore: plain weave; fringe of wool yarn; removable press stud of cotton canvas and wool fringe; ears of cotton canvas
17 × 12 × 39 cm
Piglet: plain weave; printed fabric
14 × 10 × 7 cm
Paris, Musée des Arts Décoratifs, gift of Anne Wilkinson, 1994
Inv. 992.439.1; 992.439.2; 992.439.3; 992.439.4

CAT. 160
Dakin (manufacturer)
Super Ted
United States (design), Korea (manufacture), 1984
Synthetic fibers
35 × 29 × 15 cm
Paris, Les Arts Décoratifs
PR 2024.105.1

CAT. 161
Bandai (manufacturer)
Gabby Bear
Japan (design), China (manufacture), 1986
Plush
52 × 31 × 16 cm
Paris, Musée des Arts Décoratifs, gift of Bandai, 1987
Inv. 987.900

CAT. 162
Real Soft Toys (manufacturer), Express Newspapers (license)
Rupert Bear
UK (?), 1986
Plush; wool; canvas
44 × 24 × 11 cm
Paris, Musée des Arts Décoratifs, purchase, 1988
Inv. 988.179

CAT. 163
A. Barille (designer), Pintel (manufacturer), ORTF (license)
Colargol
France, 1971
Plush; plastic; felt
31 × 17 × 12 cm
Paris, Musée des Arts Décoratifs, state purchase in 1982; attributed to the public interest organization "Les Arts Décoratifs" in 2008
Inv. 51457.B

CAT. 164
Les Petites Maries (manufacturer)
Nounours from "Bonne nuit les petits"
France, 1960s
Cotton, polyester
44 × 36 × 13 cm
Châteauroux, Les Petites Maries

CAT. 165
Les Petites Maries (manufacturer)
Oscar from "Bonne nuit les petits"
France, 1960s
Cotton, polyester
32.5 × 30 × 11 cm
Châteauroux, Les Petites Maries

CAT. 166
Palitoy (manufacturer), Kenner Parker Toys Inc. (distributor), American Greetings Corporation (license)
Prankster Care Bear
United States (design), UK (manufacture), 1983
Synthetic plush stuffed with synthetic fibers; plastic eyes and nose
34 × 18 × 13.5 cm
Paris, Musée des Arts Décoratifs, gift of Meccano, 1984
Inv. 54941.3

CAT. 167
Palitoy (manufacturer), Kenner Parker Toys Inc. (distributor), American Greetings Corporation (license)
Bedtime Care Bear
United States (design), UK (manufacture), 1983
Synthetic plush stuffed with synthetic fibers; plastic eyes and nose
32.4 × 20 × 17 cm
Paris, Musée des Arts Décoratifs, gift of Meccano, 1984
Inv. 54941.2

CAT. 168
Palitoy (manufacturer), Kenner Parker Toys Inc. (distributor), American Greetings Corporation (license)
Birthday Care Bear
United States (design), UK (manufacture), 1983
Synthetic plush stuffed with synthetic fibers; plastic eyes and nose
33 × 19 × 13 cm
Paris, Musée des Arts Décoratifs, gift of Meccano, 1984
Inv. 54941.1

CAT. 169
Howard Coster
Photograph of Winnie the Pooh with Christopher Robin and A. A. Milne
1926
Reproduction
London, National Portrait Gallery
NPG P715

CAT. 170
Photograph of Graham and Mary Shepard with the bear Growler
c. 1914
Reproduction
Guildford, Archives & Special Collections, Egmont UK Collection, University of Surrey UK, The Shepard Trust private collection
Ref No STPrivate-12-2

CAT. 171
E. H. Shepard
"Forgotten," in *Now We Are Six*
UK, December 1, 1926– March 31, 1927
Pencil on paper
35.4 × 21.9 cm
London, Victoria and Albert Museum, gift of E. H. Shepard
Inv. E.758-1973

CAT. 172
E. H. Shepard
Christopher Robin Carrying Winnie-the-Pooh Upstairs
UK, 1970
Colored ink drawing
35 × 29.5 cm
Guildford, Archives & Special Collections, Egmont UK Collection, University of Surrey
Inv. EGM_1_87

CAT. 173
E. H. Shepard
Winnie-the-Pooh Floating under a Balloon with Bees
UK, 1970
Colored ink drawing
35 × 29.5 cm
Guildford, Archives & Special Collections, Egmont UK Collection, University of Surrey
Inv. EGM_1_11
REPR. P. 57 BOTTOM LEFT

CAT. 174
E. H. Shepard
Winnie-the-Pooh Sitting on a Branch with Honey Pots in the Rain
UK, 1970
Colored ink drawing
29.5 × 35 cm
Guildford, Archives & Special Collections, Egmont UK Collection, University of Surrey
Inv. EGM_1_74
REPR. P. 57 TOP

CAT. 175
E. H. Shepard
Pooh with a Honey Pot on His Head
UK, 1926
Pencil on paper
17.9 × 22 cm
London, Victoria and Albert Museum, gift of E. H. Shepard
Inv. E.572-1973

CAT. 176
E. H. Shepard
"Eyore was nudged to the front," in *The House at Pooh Corner*
UK, 1928
Pencil on paper
17 × 22.7 cm
London, Victoria and Albert Museum, gift of E. H. Shepard
Inv. E.712-1973
REPR. P. 56 TOP

CAT. 177
E. H. Shepard
Christopher Robin Re-attaches Eeyore's Tail while Winnie-the-Pooh Watches
UK, 1970
Colored ink drawing
35 × 29.5 cm
Guildford, Archives & Special Collections, Egmont UK Collection, University of Surrey
Inv. EGM_1_32/1

CAT. 178
E. H. Shepard
Eeyore Looking at His Tail through His Legs
UK, 1970
Colored ink drawing
35 × 29.5 cm
Guildford, Archives & Special Collections, Egmont UK Collection, University of Surrey
Inv. EGM_1_32/3

CAT. 179
E. H. Shepard
Eeyore Sitting and Looking at His Tail over His Shoulder
UK, 1970
Colored ink drawing
35 × 29.5 cm
Guildford, Archives & Special Collections, Egmont UK Collection, University of Surrey
Inv. EGM_1_32/2

CAT. 180
E. H. Shepard
Winnie-the-Pooh Talking to Rabbit
UK, 1970
Colored ink drawing
29.5 × 35 cm
Guildford, Archives & Special Collections, Egmont UK Collection, University of Surrey
Inv. EGM 1_62

CAT. 181
E. H. Shepard
Winnie-the-Pooh in Owl's Parlour
UK, 1970
Colored ink drawing
29.5 × 35 cm
Guildford, Archives & Special Collections, Egmont UK Collection, University of Surrey
Inv. EGM_1_30

CAT. 182
E. H. Shepard
"It was an anxious moment," in *The World of Pooh*
UK, c. 1957
Pencil on paper
39.5 × 25.4 cm
London, Victoria and Albert Museum, gift of E. H. Shepard
Inv. E.721-1973

CAT. 183
E. H. Shepard
"That's a good idea" and "Pooh was getting something" in *The World of Pooh*
UK, c. 1957
Pencil on paper
40.5 × 25.2 cm
London, Victoria and Albert Museum, gift of E. H. Shepard
Inv. E.787-1973

CAT. 184
E. H. Shepard
Open it Pooh
UK, 1927
Pencil on paper
18 × 22 cm
London, Victoria and Albert Museum, gift of E. H. Shepard
Inv. E.606-1973

CAT. 185
E. H. Shepard
Winnie-the-Pooh with Parcel and Friends
UK, 1970
Colored ink drawing
29.5 × 35 cm
Guildford, Archives & Special Collections, Egmont UK Collection, University of Surrey
Inv. EGM_1_85

CAT. 186
E. H. Shepard
Tigger Falling out of a Tree, with Christopher Robin, Piglet, Eeyore, Winnie-the-Pooh and Roo Waiting to Catch Him
UK, 1970
Colored ink drawing
35 × 29.5 cm
Guildford, Archives & Special Collections, Egmont UK Collection, University of Surrey
Inv. EGM_2_30
REPR. P. 57 BOTTOM RIGHT

CAT. 187
E. H. Shepard
"So it was signed" in *The House at Pooh Corner*
UK, 1928
Pencil on paper
17.7 × 21.9 cm
London, Victoria and Albert Museum, gift of E. H. Shepard
Inv. E.710-1973
REPR. P. 56 BOTTOM

CAT. 188
Marie Colmont (author), Feodor Rojankovsky (illustrator)
Michka
Paris, Flammarion, "Les Albums du Père Castor," 1941
Book
17 × 19 cm
Paris, Ville de Paris / Heure Joyeuse heritage fund, Françoise Sagan media library
Inv. FA in8 1793

CAT. 189
Feodor Rojankovsky
Unused draft of cover for *Michka*
France, 1941
Gouache on Canson paper; pencil and charcoal
17 × 19 cm
Meuzac, Maison du Père Castor
Inv. 237 1 Fi 2391
REPR. P. 58

CAT. 190
Gérard Franquin
Michka: "Michka et le pot de miel," p. 11; "Michka endormi," p. 14; "Michka distribue un jouet," p. 19
France, 1941
Felt on tracing with adhesive; printed Canson paper with mixed media
29.7 × 21 cm
Meuzac, Maison du Père Castor
Inv. 231 1 Fi 1125

CAT. 191
Gérard Franquin
Michka et le traîneau du Père Noël; *Michka distribue un jouet*; *Michka se place dans la chaussure*
France, 1941
Felt on tracing paper with adhesive; printed Canson paper with mixed media
29.7 × 21 cm
Meuzac, Maison du Père Castor
Inv. 231 1 Fi 1127

CAT. 192
Michael Bond (author), Peggy Fortnum (illustrator)
Paddington at Large
London, Collins, 1962 (1966 edition)
Book
21 × 13 cm
Paris, Ville de Paris / Heure Joyeuse heritage fund, Françoise Sagan media library
Inv. NE in8 10360

CAT. 193
Gabrielle Design Bears (manufacturer)
Paddington
UK, 1974
Velvet-style cover with woven bottom; animal fibers; felt coat and hat; plastic (?) eyes and nose; duffel-style coat with wood button; hard stuffing
55 × 34 × 19 cm
Paris, Musée des Arts Décoratifs, gift of Service Libre Confort, 1981
Inv. 49097
REPR. P. 60 BOTTOM RIGHT

CAT. 194
Gabrielle Design Bears (manufacturer)
Aunt Lucy
UK, 1974
Woven canvas; knit shawl; printed cotton canvas skirt; woven ribbon on the skirt; linen canvas underpants; wool felt hat; hard stuffing
48 × 30 × 18 cm
Paris, Musée des Arts Décoratifs, gift of Service Libre Confort, 1982
Inv. 51574

CAT. 195
Janet and Allan Ahlberg
The Bear Nobody Wanted
London, Puffin Books, 1992
Book
19.8 × 12.9 × 1.2 cm
Paris, Bibliothèque du Musée des Arts Décoratifs, documentation department

CAT. 196
Janet and Allan Ahlberg
L'Ours que Personne N'aimait
Paris, Gallimard, 1993
Book
17.8 × 10.9 × 1 cm
Paris, Bibliothèque du Musée des Arts Décoratifs, documentation department

CAT. 197
Margaret Wise Brown (author), Garth Williams (illustrator)
Little Fur Family
New York, Harper & Brothers, 1946
Fur; paper; cardboard
10 × 8 cm
Paris, Ville de Paris / Heure Joyeuse heritage fund, Françoise Sagan media library
Inv. FA in12 2
REPR. P. 61

CAT. 198
Olga Lecaye (illustrator), Grégoire Solotareff (author)
Original drawing for *Je suis perdu*
France, 2002
Gouache on paper
31 × 23 cm
Paris, Grégoire Solotareff Collection

CAT. 199
Olga Lecaye
Original drawing for *Je suis perdu*
France, 2002
Gouache on paper
31 × 23 cm
Paris, Grégoire Solotareff Collection

CAT. 200
Steiff
Teddy bear that inspired *Je suis perdu*
Germany, 2002
Mohair
17 × 11 × 14 cm
Paris, Grégoire Solotareff Collection

CAT. 201
Steiff
Teddy bear that inspired *Mitch*
Germany, 1980s
Mohair
26 × 20 cm
Paris, Grégoire Solotareff Collection

CAT. 202
Nadja (illustrator), Grégoire Solotareff (author)
Original drawing for *Mitch*
France, 1990
Acrylic on paper
31.5 × 50 cm
Paris, Grégoire Solotareff Collection

CAT. 203
Marie Wabbes
Portrait of Plushkine
Belgium (Maransart), 2022
Pastel and watercolor on paper
35 × 25 cm
Lasne, Marie Wabbes

CAT. 204
Marie Wabbes
Portrait of Toudou
Belgium (Maransart), 2022
Watercolor and pencil on paper
35.4 × 24.6 cm
Lasne, Marie Wabbes

CAT. 205
Marie Wabbes
Teddy Bear Portrait
Belgium (Maransart), 2022
Pastel on paper
35 × 31 cm
Lasne, Marie Wabbes

CAT. 206
Plushkine
Plush
32 × 17.5 × 9.5 cm
Lasne, Marie Wabbes

CAT. 207
Toudou
Plush
46 × 22 × 13.5 cm
Lasne, Marie Wabbes

CAT. 208
Nounours
Plush
34 × 26 × 12.5 cm
Lasne, Marie Wabbes

CAT. 209
Jez Alborough
Où est mon nounours?
Paris, Kaléidoscope, 1992
Book
30.8 × 25.7 × 0.8 cm
Paris, Vanryb Collection

CAT. 210
Don Freeman
Corduroy
New York, Viking, 1968 (2011 edition)
Board book
23.3 × 27 × 1.6 cm
Paris, Bibliothèque du Musée des Arts Décoratifs, documentation department

CAT. 211
Danièle Bour
Original drawing for *Petit Ours brun joue à la dînette*
France, March 1999
Arches paper; Linel gouache
30 × 47.7 cm
Paris, Les Arts Décoratifs
PR 2024.142.1
REPR. P. 60 TOP

CAT. 212
Danièle Bour
Original drawing for *Petit Ours brun et les chocolats de Noël*
France, December 2009
Arches paper; Linel gouache
30 × 48 cm
Paris, Les Arts Décoratifs
PR 2024.142.2

CAT. 213
Gabrielle Vincent
Original drawing for *Au bonheur des ours* (To the Happiness of Bears)
Belgium, 1993
Cardstock; pencil; watercolor
23 × 18 cm
Charleroi, Fondation Monique Martin / Gabrielle Vincent
Inv. 2015-GV-1208

CAT. 214
Gabrielle Vincent
Original drawing for *Au bonheur des ours* (To the Happiness of Bears)
Belgium, 1993
Cardstock; pencil; watercolor
18 × 50 cm
Charleroi, Fondation Monique Martin / Gabrielle Vincent
Inv. 2015-GV-1203
REPR. PP. 58–59

CAT. 215
Gabrielle Vincent
Original drawing for *La Naissance de Célestine* (The Birth of Célestine)
Belgium, 1987
Flexible paper; sepia
15 × 21 cm
Charleroi, Fondation Monique Martin / Gabrielle Vincent
Inv. 2012-GV-873
REPR. P. 59

CAT. 216
Satomi Ichikawa
Y a-t-il des ours en Afrique?
Paris, L'École des Loisirs, 1998
Book
27 × 22 cm
Paris, Satomi Ichikawa

CAT. 217
Satomi Ichikawa, Maryann Cusimano Love
You Are My I Love You – Japanese edition
Tokyo (Japan), Kōdansha, 2002
26 × 21 cm
Paris, Satomi Ichikawa

CAT. 218
Satomi Ichikawa, Maryann Cusimano Love
You Are My Wonders – Japanese edition
Kobe (Japan), BL Publishing Co., 2013
26 × 21 cm
Paris, Satomi Ichikawa

CAT. 219
Diego, Satomi Ichikawa's former teddy bear
Found in Bern (Switzerland)
c. 1920
30 × 18 cm
Paris, Satomi Ichikawa

CAT. 220
Paul, Satomi Ichikawa's teddy bear
Found in London (England)
c. 1910
31 × 18 cm
Paris, Satomi Ichikawa

CAT. 221
Barbara, Satomi Ichikawa's teddy bear
Found in New York (United States)
c. 1950
39 × 18 cm
Paris, Satomi Ichikawa

CAT. 222
Choco, Satomi Ichikawa's teddy bear
Found in Paris
c. 1950
18 × 7 cm
Paris, Satomi Ichikawa

CAT. 223
Satomi Ichikawa
Mes collections, ours filles
Paris, 2009
Drawing, watercolor on paper
35 × 57 cm
Paris, Satomi Ichikawa

CAT. 224
Satomi Ichikawa
Mes collections, ours garçons
Paris, 2009
Drawing, watercolor on paper
35 × 57 cm
Paris, Satomi Ichikawa

CAT. 225
Satomi Ichikawa
Miniature teddy bear
England and France (Paris), 1996–2000
Fabric
approx. 7 cm
Paris, Satomi Ichikawa

CAT. 226
Satomi Ichikawa
Miniature teddy bear
England and France (Paris), 1996–2000
Fabric
approx. 7 cm
Paris, Satomi Ichikawa

CAT. 227
Satomi Ichikawa
Miniature teddy bear
England and France (Paris), 1996–2000
Fabric
approx. 7 cm
Paris, Satomi Ichikawa

CAT. 228
Mike Young (author), Siriol Production (production)
Credits of *Super Ted*
UK, produced in 1982, broadcast in France in 1983
Video
45 sec.
© 1984 Petalcraft Demonstrations Ltd.

CAT. 229
Hans de Beer
Little Polar Bear on Its Piece of Ice, original drawing for the cover of the book *Little Polar Bear*
The Netherlands, 1987
Watercolor
39.7 × 29.9 cm
Zurich, NordSüd Verlag AG
REPR. P. 54

CAT. 230
Hans de Beer
Little Polar Bear Looking at His Father Teaching Him How to Swim and Fish
The Netherlands, 1987
Watercolor
39.7 × 29.9 cm
Zurich, NordSüd Verlag AG

CAT. 231
Hans de Beer
Little Polar Bear and the Whale, Coming back to the North Pole
The Netherlands, 1987
Watercolor
35 × 29.9 cm
Zurich, NordSüd Verlag AG

CAT. 232
Hans de Beer, Steiff
Little Polar Bear teddy bear
Germany (Giengen an der Brenz), 2003
22 × 16 × 14 cm
Giengen an der Brenz, Margarete Steiff GmbH

CAT. 233
Elzbieta
Où vont les bébés?
Rodez, Les Éditions du Rouergue, 1997 (2008 edition)
Book
28 × 22.7 cm
Paris, Ville de Paris / Heure Joyeuse heritage fund, Françoise Sagan media library
Inv. NE in4 4837

CAT. 234
Elzbieta
Original drawing for *Où vont les bébés?*
France, 1997
Drawing, mixed media
approx. 50 cm
Paris, Ville de Paris / Heure Joyeuse heritage fund, Françoise Sagan media library
Inv. DO-D2 Elzbieta où vont les bébés 9

CAT. 235
Elzbieta
Original drawing for *Où vont les bébés?*
France, 1997
Drawing, mixed media
approx. 50 cm
Paris, Ville de Paris / Heure Joyeuse heritage fund, Françoise Sagan media library
Inv. DO-D2 Elzbieta où vont les bébés 25

CAT. 236
Applause Inc. (manufacturer)
Baloo
United States (design), 1992
Synthetic plush; velvet jersey; plastic eyes
23 × 16 × 16 cm
Paris, Musée des Arts Décoratifs, purchase, 1994
Inv. 994.52

CAT. 237
Rudyard Kipling
The Jungle Book
London (UK), Macmillan and Co., 1894 (1917 edition)
Book
17 × 11 cm
Paris, Ville de Paris / Heure Joyeuse heritage fund, Françoise Sagan media library
Inv. FA in8 2291

CAT. 238
Martin Waddell (author), Barbara Firth (illustrator)
Tu ne dors pas, petit ours?
Paris, L'École des loisirs, 1990
Book
19 × 14 cm
Paris, Ville de Paris / Heure Joyeuse heritage fund, Françoise Sagan media library
Inv. E in4 2858

CAT. 239
Ann Rocard (author), Maryse Lamigeon (illustrator)
Boucles d'or et les trois ours
Paris, Éditions Nathan, 1988 (2004 edition)
Book
18 × 16 × 0.3 cm
Paris, Bibliothèque du Musée des Arts Décoratifs, documentation department

CAT. 240
Else Holmelund Minarik (author), Maurice Sendak (illustrator)
Petit-ours en visite
Paris, L'École des loisirs, 1970
Offset printing on paper
20.6 × 15.5 cm
Paris, Bibliothèque du Musée des Arts Décoratifs
Inv. BAD 90500

CAT. 241
Else Holmelund Minarik,
Maurice Sendak
(designers), Kidpower
(manufacturer)
Little Bear
United States (design),
China (manufacture),
1998
Polyester fibers
41 × 32 × 16 cm
Paris, Les Arts Décoratifs
PR 2024.75.1

CAT. 242
Danièle Bour (designer),
Boulgom (manufacturer)
Petit Ours Brun (Little
Brown Bear)
France, c. 1989
Synthetic plush body;
plastic eyes glued to felt
base; plastic nose; fabric
clothing
34 × 21.5 × 12 cm
Paris, Musée des Arts Décoratifs
Inv. 993.110
REPR. P. 60 BOTTOM LEFT

FROM THE BEAR TO THE *DOUDOU*

CAT. 243
*Donald Winnicott and
a young patient*
c. 1950–1970
Reproduction

CAT. 244
Charles M. Schulz
"Linus and his blanket,"
Peanuts
June 1, 1954
Reproduction
REPR. P. 66

CAT. 245
Teddy bear
France, c. 1945–1950
Plush; glass eyes; fabric
ribbon
13.5 × 8 × 5 cm
Paris, Musée des Arts Décoratifs,
purchase, 1988
Inv. 988.48.1

CAT. 246
Articulated bear
France, c. 1945–1950
Plush bear; glass eyes;
velvet muzzle with
stitching; stuffed body
30 × 12 × 8.5 cm
Paris, Musée des Arts Décoratifs,
purchase, 1988
Inv. 988.47

CAT. 247
Pintel (manufacturer)
Teddy bear
France, c. 1955
Plush; glass eyes
58 × 28 × 15 cm
Paris, Musée des Arts Décoratifs,
gift of Fisher-Price, 1982
Inv. 49692.C

CAT. 248
Articulated bear
France, c. 1950
Plush stuffed with straw
or wood shavings; glass
eyes; stitched nose and
claws; joints attached
with visible rivets
43 × 17 × 11.5 cm
Paris, Musée des Arts Décoratifs,
purchase, 1988
Inv. 988.46

CAT. 249
Teddy bear
UK, 1950
Mohair plush stuffed with
wood shavings; glass
eyes; stitched nose
46 × 25 × 14.5 cm
Paris, Musée des Arts Décoratifs,
purchase, 1994
Inv. 992.695.2

CAT. 250
White bear
1950
Mohair plush stuffed with
wood shavings; stitched
nose
59 × 29 × 14 cm
Paris, Musée des Arts Décoratifs,
purchase, 1994
Inv. 992.695.1
REPR. P. 67

CAT. 251
Les Jouets Enchantés
(manufacturer)
Michka
France, c. 1950–1955
Mohair body, stuffed with
wood wool; painted glass
eyes; fabric nose; velvet
pads on paws
53.5 × 25 × 16.5 cm
Paris, Musée des Arts Décoratifs,
purchase, 1994
Inv. 993.135.3
REPR. P. 68

CAT. 252
JPM (manufacturer)
Teddy bear
France, c. 1950
Rayon plush toy, stuffed
with wood shavings;
glass eyes; rubber nose;
ears edged with velvet
14 × 6 × 6 cm
Paris, Musée des Arts Décoratifs,
purchase, 1994
Inv. 993.135.8

CAT. 253
Bear with red ribbon
France, c. 1950
Fur; plastic eyes and
muzzle
41 × 20 × 15 cm
Paris, Musée des Arts Décoratifs,
gift of Mme Deledalle, 1994
Inv. 992.623

CAT. 254
Gégé (manufacturer)
Marching bear
France, c. 1950
Hard plastic covered with
synthetic fur; plastic
eyes, muzzle, and paws
42 × 16 × 10 cm
Paris, Musée des Arts Décoratifs,
gift of Monica Burckhardt, 1994
Inv. 992.613

CAT. 255
Steiff (manufacturer)
Zotty
Germany (Giengen
an der Brenz), 1952
Mohair
22 × 14 × 8 cm
Giengen an der Brenz,
Margarete Steiff GmbH
REPR. P. 69

CAT. 256
Renate Müller
Bär in overalls with a little
horse
Germany (Sonneberg),
2024
Leather and burlap,
stuffed with wood wool
42 × 34 × 16.5 cm
Paris, Les Arts Décoratifs
Inv. PR 2024.180.1

THE 1960S AND THE POSSIBILITIES OF SYNTHETIC MATERIALS

CAT. 257
Teddy bear
France, 1965
Synthetic plush; plastic
eyes; fabric nose;
stitched mouth; felt paw
pads
26 × 17 × 8 cm
Paris, Musée des Arts Décoratifs,
purchase, 1994
Inv. 993.135.6

CAT. 258
Chanteclair
(manufacturer)
Teddy bear
France, 1960–1965
Nylon plush; plastic eyes
and nose; felt tongue
52 × 34 × 15 cm
Paris, Musée des Arts Décoratifs,
purchase, 1994
Inv. 993.135.5

CAT. 259
Teddy bear
France, c. 1960
Synthetic fur; plastic
eyes and muzzle
28 × 27 × 10 cm
Paris, Musée des Arts Décoratifs,
gift of Mme Deledalle, 1994
Inv. 992.624

CAT. 260
Le Jouet Bourré
(manufacturer)
White bear
France, c. 1955–1960
Synthetic plush; foam
stuffing; glass eyes; felt
nose and tongue
37.5 × 19 × 11.5 cm
Paris, Musée des Arts Décoratifs,
purchase, 1994
Inv. 993.135.2
REPR. P. 70

CAT. 261
Steiff (manufacturer)
Cosy Teddy
Germany (Giengen
an der Brenz), 1964
Dralon
28 × 23 × 10 cm
Giengen an der Brenz,
Margarete Steiff GmbH

CAT. 262
Steiff (manufacturer)
Petsy
Germany (Giengen
an der Brenz), 1961
Dralon
30 × 37 × 14 cm
Giengen an der Brenz,
Margarete Steiff GmbH

CAT. 263
Wendy Boston Playsafe
Toys (manufacturer)
Wendy Boston
UK, 1950s
Synthetic plush;
synthetic stuffing
35 × 23 × 10 cm
Paris, Les Arts Décoratifs
PR 2024.74.1
REPR. P. 73

NEW MATERIALS

CAT. 264
Boulgom (manufacturer)
Doudoux
France, 1979
White nylon plush;
printed fabric
28 × 21.5 × 11 cm
Paris, Musée des Arts Décoratifs,
gift of Boulgom, 1981
Inv. 46996
REPR. P. 76

CAT. 265
Fisher-Price
(manufacturer)
Puffalump Bears
United States, 1986
Fabric; plastic eyes
40 cm (pink bear), 25 cm
(yellow bear)
Paris, Musée des Arts Décoratifs,
gift of Fisher-Price, 1989
Inv. 989.12
REPR. PP. 74–75

CAT. 266
Nounours (manufacturer)
Peluche-ours
France, 1988
Textile covering, velvet-
style fabric; synthetic
fiber fur; velvet paw
pads; plastic (?) eyes and
nose
47 × 35 cm
Paris, Musée des Arts Décoratifs,
gift of Nounours, 1994
Inv. 991.414
REPR. P. 83

SOFTNESS AND ROUNDNESS

CAT. 267
Gund (manufacturer)
Cosy Bear
United States (design),
Korea (manufacture),
1985
Synthetic plush; plastic
eyes; stitched nose; soft
stuffing
31 × 20 × 25 cm
Paris, Musée des Arts Décoratifs,
gift of Gund, 1994
Inv. 991.385.2
REPR. P. 78

CAT. 268
Gund (manufacturer)
Teddy bear
United States, 1993
Synthetic plush; plastic
eyes; stitched nose; soft
stuffing
36 × 24 × 30 cm
Paris, Musée des Arts Décoratifs,
gift of Gund, 1994
Inv. 994.119

CAT. 269
Ajena (manufacturer)
Bear
France, 1993
Smooth plush; plastic
eyes; plush nose
35 × 25 × 12 cm
Paris, Musée des Arts Décoratifs,
gift of Aux Nations-Nounours,
1994
Inv. 993.140.8

CAT. 270
Trudi (manufacturer)
Monsieur Nours
Italy (design), China (manufacture), 2010
21 × 24 × 11 cm
Synthetic fibers; plastic; polyester; body filled with synthetic beans
Paris, Musée des Arts Décoratifs, gift of Mao Pitiot, 2022
Inv. 2022.144.2
REPR. P. 82

CAT. 271
Aux Nations (manufacturer)
Teddy bear
France, 1987
41 × 19 × 15 cm
Velvet-style textile covering with fabric; synthetic fibers; plastic (?) eyes; stitched line for the mouth; type of short-pile velvet for the paws
Paris, Musée des Arts Décoratifs, gift of Aux Nations, 1988
Inv. 988.794

SLEEP

CAT. 272
Fisher-Price (manufacturer)
Teddy Betsy Bear
United States (design), Korea (manufacture), 1986
Synthetic plush; plastic eyes and eyelids; fabric clothing
30 × 13 × 15.5 cm
Paris, Musée des Arts Décoratifs, gift of Fisher-Price, 1989
Inv. 989.7
REPR. P. 62

CAT. 273
Fisher-Price (manufacturer)
Bear in a snuggle suit
United States, 1986
Synthetic plush; fabric
44 × 31 × 8 cm
Paris, Musée des Arts Décoratifs, gift of Fisher-Price, 1989
Inv. 989.13

CUDDLING

CAT. 274
Dakin (manufacturer)
Huggy Bears
United States (design), Korea (manufacture), 1980
Synthetic plush
22 × 14 × 10 cm
Paris, Musée des Arts Décoratifs, gift of Jouets du Val d'Oise, 1981
Inv. 49346
REPR. P. 79

CAT. 275
Ajena (manufacturer)
Peluche-ours
France, 1985
Velvet-style fabric covering over knitted textile; synthetic fibers; identical textile on the muzzle and ears; plastic and stitched pieces for the ears, nose, and mouth; shoelace; soft stuffing of polyester wadding
31 × 38 × 26 cm
Paris, Musée des Arts Décoratifs, gift of Ajena, 1994
Inv. 991.404

CAT. 276
Ajena (manufacturer)
Groupi
France, 1978
Velvet-style textile covering and synthetic fibers (probably polyester); polyurethane foam stuffing; plastic eyes and nose
24 × 15 × 18 cm
Paris, Musée des Arts Décoratifs, gift of Ajena, 1981
Inv. 47225
REPR. P. 80

CAT. 277
Carte Blanche Greetings Ltd. TM
Me To You, Tatty Teddy teddy bear
UK, 2000s
Synthetic plush
28 × 31 × 26 cm
Paris, Vanryb Collection

COLOR

CAT. 278
Skine (manufacturer)
Teddy bear
France, 1984
Synthetic fur; plastic eyes and nose
39 × 19 × 12.5 cm
Paris, Musée des Arts Décoratifs, gift of Skine, 1984
Inv. 55555
REPR. P. 81

CAT. 279
Käthe Kruse (manufacturer)
Teddy bear
Germany, 1993
Terrycloth and stuffed jersey
30.5 × 16 × 12.5 cm
Paris, Musée des Arts Décoratifs, purchase, 1994
Inv. 994.51.2

CAT. 280
Pamplemousse Peluches (manufacturer)
Robertto
France (Cerizy), 2018 (design), June 2024 (manufacture)
Synthetic fur; Liberty fabric; bell
24 × 22 cm
Paris, Les Arts Décoratifs
PR 2024.104.5

THE DOUDOU

CAT. 281
Doudou ours (Bear doudou)
2010s
Velvet-style fabric; synthetic fibers; fabric appliqués with machine stitching
30 × 30 × 6 cm
Paris, Musée des Arts Décoratifs, gift of Antonin and Amélia Zunt-Radot, 2021
Inv. 2021.161.3
REPR. P. 72

CAT. 282
Pamplemousse Peluches (manufacturer)
Doudou Cachou
France (Cerizy), 2019 (design), June 2024 (manufacture)
Cotton gauze; linen; polyester fibers
25 × 20 × 4.5 cm
Paris, Les Arts Décoratifs
PR 2024.104.4

CAT. 283
FLATOUTbear (manufacturer)
Baby Milk
Australia, 2001 (design), China, 2001 (manufacture)
Australian sheepskin; plastic eyes
20 × 17.5 × 5 cm
Paris, Les Arts Décoratifs
PR 2024.102.2

CAT. 284
Benoît Piéron
Peluche psychopompe VIII
France, 2022
Patchwork of used sheets from Paris hospitals
20 × 43 × 8.5 cm
Paris, courtesy of Benoît Piéron & Sultana
REPR. P. 64

CAT. 285
Annette Messager
Sein nounours (Teddy Bear Breast), "Mes trophées" (My Trophies) series
France, 2015
Painted black and white photograph
27.7 × 27.7 cm
Paris, courtesy of the artist and Marian Goodman Gallery
Inv. 17612
REPR. P. 71

CAT. 286
Annette Messager
Peluche protectrice
France, 2023
Various objects; black paper; plush; metal
19 × 18 × 20 cm
Paris, courtesy of the artist and Marian Goodman Gallery
Inv. 28754
REPR. P. 77 TOP

CAT. 287
Carole Benzaken
Doudou
France, 2023
Acrylic; oil on canvas
Diam. 30 cm
Paris, Brussels, Galerie Nathalie Obadia
REPR. P. 77 BOTTOM

CAT. 288
Julien Béziat (author-illustrator)
Original illustration for *Le Mange-Doudous*
France, 2013
Acrylic and pencil on paper
38 × 57 cm
Bordeaux, Julien Béziat
REPR. P. 65

CAT. 289
Julien Béziat (author-illustrator)
Original illustration for *Le Mange-Doudous*
France, 2013
Acrylic and pencil on paper
38 × 57 cm
Bordeaux, Julien Béziat

CAT. 290
Julien Béziat (author-illustrator)
Original illustration for *Le Mange-Doudous*
France, 2013
Acrylic and pencil on paper
38 × 57 cm
Bordeaux, collection of Julien Béziat

CAT. 291
Julien Béziat (author-illustrator)
Original illustration for *Le Mange-Doudous*
France, 2013
Acrylic and pencil on paper
38 × 57 cm
Bordeaux, Julien Béziat

CAT. 292
Ulala Imai
Care
Japan, 2024
Oil on canvas
181.8 × 227.3 cm
Brussels, Belgium, courtesy of the artist and Xavier Hufkens
Inv. IMAI24104
REPR. P. 100

TEDDY BEARS TODAY: A SYMBOL

A POWERFUL SYMBOL

CAT. 293
Tomi Ungerer (Jean Thomas Ungerer)
Otto (Untitled)
Ireland, 1999
Pencil and color ink wash on paper
29.7 × 21 cm
Strasbourg, Tomi Ungerer Museum – International Illustration Centre
Inv. 99.2008.46.3

CAT. 294
Tomi Ungerer (Jean Thomas Ungerer)
Otto (Untitled)
Ireland, 1999
Pencil and color ink wash on paper
29.7 × 21 cm
Strasbourg, Musée Tomi Ungerer - Centre international de l'Illustration
Inv. 99.2008.46.5

CAT. 295
Tomi Ungerer (Jean Thomas Ungerer)
Otto (Untitled)
Ireland, 1999
Pencil and color ink wash on paper
29.7 × 21 cm
Strasbourg, Musée Tomi Ungerer - Centre international de l'Illustration
Inv. 99.2008.46.9
REPR. P. 103

CAT. 296
Tomi Ungerer
(Jean Thomas Ungerer)
Otto (Untitled)
Ireland, 1999
Pencil and color ink wash on paper
29.7 × 21 cm
Strasbourg, Musée Tomi Ungerer - Centre international de l'Illustration
Inv. 99.2008.46.12

CAT. 297
Tomi Ungerer
(Jean Thomas Ungerer)
Otto (Untitled)
Ireland, 1999
Pencil and color ink wash on paper
29.6 × 41.7 cm
Strasbourg, Musée Tomi Ungerer - Centre international de l'Illustration
Inv. 99.2008.46.15

CAT. 298
Tomi Ungerer
(Jean Thomas Ungerer)
Otto (Untitled)
Ireland, 1999
Pencil and color ink wash on paper
29.7 × 21 cm
Strasbourg, Musée Tomi Ungerer - Centre international de l'Illustration
Inv. 99.2008.46.14

CAT. 299
Tomi Ungerer
(Jean Thomas Ungerer)
Otto (Untitled)
Ireland, 1999
Pencil and color ink wash on paper
29.7 × 21 cm
Strasbourg, Musée Tomi Ungerer–Centre International de l'Illustration
Inv. 99.2008.46.28

CAT. 300
Tomi Ungerer
(Jean Thomas Ungerer)
Otto (Untitled)
Ireland, 1999
Pencil and color ink wash on paper
29.7 × 21 cm
Strasbourg, Musée Tomi Ungerer - Centre international de l'Illustration
Inv. 99.2008.46.29

CAT. 301
Mike Kelley
Ahh… Youth!
United States, 1991
Photographic print with silver color bleaching
261.6 × 49.85 cm (overall dimensions); 60 × 41 cm (each photo)
Paris, MJS Collection

CAT. 302
L'obs, no. 2934, January 21, 2021
Les Enfants de la pitié
France, 2021
Reproduction

CAT. 303
Lieutenant Jim Hoeft
Teddy bear in the rubble of the town of Gori, during the conflict between Georgia and Russia
Georgia, 2008
Reproduction of a photograph
REPR. P. 101 TOP LEFT

CAT. 304
Memorial for Mike Kelley, Highland Park
Los Angeles, 2012
Reproduction
Los Angeles, Mike Kelley Foundation for the Arts
REPR. P. 101 TOP RIGHT

BEYOND TENDERNESS: HELPING CHILDREN

CAT. 305
Secretary of State in charge of children and families, Mme Bovary agency (design)
Poster for the national campaign to raise awareness of shaken baby syndrome
France, 2021
Reproduction
REPR. P. 102 BOTTOM

CAT. 306
Minister of the Interior and the Overseas Departments
In the car, everyone buckles up
France, 2023
Reproduction

CAT. 307
Innocence en Danger
Official image of the organization Innocence in Danger
France, 2010s
Reproduction

CAT. 308
Sigikid (manufacturer)
Bear doll
Germany, 1993
Painted plastic head and plush body; plush mask on wooden handle
47 × 24 × 23 cm
Paris, Musée des Arts Décoratifs, gift of Sigikid, 1995
Inv. 994.107.2
REPR. P. 98

CAT. 309
La Pelucherie (manufacturer)
Mon Albert Invincible (My Invincible Albert)
France (design), Italy (manufacture), 2020
Polyester; plastic; cotton
24 × 23 × 20 cm
Paris, Musée des Arts Décoratifs, gift of La Pelucherie, 2022
Inv. 2022.142.1.1-3
REPR. P. 105 BOTTOM LEFT

CAT. 310
Steiff (manufacturer)
Ted
Germany (Giengen an der Brenz), 1905–1907
Gas mask and hand-crafted clothing (London, 1939–1945)
Stuffed mohair; fabric; metal
24 × 27 × 15 cm
London, Victoria and Albert Museum, gift of Mrs. Elizabeth Bury
Inv. MISC.787:1 to 8-1992
REPR. P. 104

CAT. 311
National Federation of French Firemen (designer), O60 (manufacturer)
Pompy
France (design), China (manufacture), 2015
Polyester plush; imitation suede; eyes stitched with brown and black thread; heat transfer printing; Dacron hollow fiber stuffing
24 × 21.5 × 11 cm
Paris, Les Arts Décoratifs
PR 2024.76.1
REPR. P. 105 TOP LEFT

CAT. 312
Martin Kittsteiner (designer), Sigikid (manufacturer)
Dolly
Germany, 2003 (design), China, 2004 (manufacture)
Textiles; soft stuffing
20 × 36.5 × 25 cm
Paris, Les Arts Décoratifs
PR 2024.94.1

CAT. 313
Laurence Bartoletti, Marie Clergue, Catherine Didelot, Laure Godini, Rémi Gros, Marguerite Héliot, Cécile Huguet-Broquet, Sonia Kermiche, Déborah Mattana, Anne Monier Vanryb, Alice Mimran-Didelot, Mailys Pradier, and Karine Simon, employees of the Musée des Arts Décoratifs, from a pattern by the Australian Red Cross
Trauma Teddies
France (Paris), 2024
Knitted or crocheted cotton and acrylic thread, stitching
Les Arts Décoratifs and private collections
REPR. P. 105 BOTTOM RIGHT (LAURE GODINI)

CAT. 314
Good Bears of the World (brand), Muffin Enterprises (distributor)
Goody
United States (design), China (manufacture), 2022
Synthetic material
27 × 21 × 11 cm
Paris, Les Arts Décoratifs
PR 2024.80.1
REPR. P. 105 TOP RIGHT

CAT. 315
Banque Française Mutualiste (BFM), for the Fondation de l'Avenir
Your Friend for Life surgeon bear
c. 2001
Assembly of cotton and sewn polyester
25 × 20.5 × 15 cm
Le Kremlin-Bicêtre, Musée de l'Assistance Publique–Hôpitaux de Paris
Inv. AP 2001.4.1

CAT. 316
Association Lions Club Dijon Doyen
Malou Bear
France (design), China (manufacture), 2018
Polyester
Paris, Les Arts Décoratifs
PR 2024.70.1

CAT. 317
Béké-Bobo (manufacturer)
Little therapeutic bear cub
Canada, 2024
Oeko-Tex certified fabrics; organic grains
Paris, Les Arts Décoratifs
PR 2024.103.1

CAT. 318
Per Ivar Ledang, Nanna Iversson (designers), Ikea (manufacturer)
Brum, UNICEF Teddy Bear
Sweden (design), Vietnam (manufacture), 2003
33 × 26 × 6 cm
Polyester, polyurethane foam stuffing; polyoxymethylene frame; nylon
Paris, Vanryb Collection

CAT. 319
PharmaVie Association
Miniature version of "Hôpital de mon doudou"
France (Paris), 2024
Medium 10; glue; paint; varnish; polycarbonate window; metal
Paris, Les Arts Décoratifs

CAT. 320
PharmaVie Association (designer), Manufacturas Artesanía Española (manufacturer)
Toudou
France, 2015 (design), Spain, July 2024 (manufacture)
Knit t-shirt; exterior of 100% polyester; interior of recycled polyester fiber from PET bottles
30 × 25 × 15 cm
Paris, Les Arts Décoratifs
PR 2024.99.1

CAT. 321
PharmaVie Association (designer), Manufacturas Artesanía Española (manufacturer)
Super Toudou
France, 2015 (design), Spain, November 2022 (manufacture)
Cape and mask of polyester (94%) and spandex (6%), exterior of polyester; interior of recycled polyester fiber from PET bottles
31 × 26.5 × 14.5 cm
Paris, Les Arts Décoratifs
PR 2024.99.2

CAT. 322
La Pelucherie (manufacturer)
Mon ours Lucien
France (design), 1976, Italy (manufacture), 2023
Polyester
26 × 64 × 44 cm
Paris, Les Arts Décoratifs
PR 2024.100.1

CAT. 323
Aurora World (manufacturer)
Eco Nation Teddy Bear
United States, 2023 (design), Indonesia, 2023 (manufacture)
Recycled plastic; natural materials; cardboard; water-based inks
22.5 × 18 × 15 cm
Paris, Les Arts Décoratifs
PR 2024.61.1

CAT. 324
Steiff (manufacturer)
Hansel
Germany (Giengen an der Brenz), 2020
Hemp; pineapple leather
36 × 22 × 15 cm
Giengen an der Brenz, Margarete Steiff GmbH

CAT. 325
Steiff (manufacturer)
Harlekin
Germany (Giengen an der Brenz), 2023
Paper; cotton; corn fiber
30 × 18 × 10 cm
Giengen an der Brenz, Margarete Steiff GmbH

CAT. 326
Steiff (manufacturer)
Tom, from the series "Teddies for Tomorrow"
Germany (Giengen an der Brenz), 2021
Recycled PET plastic
30 cm
Giengen an der Brenz, Margarete Steiff GmbH

CAT. 327
Steiff (manufacturer)
Petsy, from the series "Teddies for Tomorrow"
Germany (Giengen an der Brenz), 2022
Bamboo viscose and recycled PET plastic
24 × 13 × 8 cm
Giengen an der Brenz, Margarete Steiff GmbH

CAT. 328
Steiff (manufacturer)
Linus, from the series "Teddies for Tomorrow"
Germany, 2021
Linen; cotton; wood; wood shavings
35 × 22 × 12 cm
Giengen an der Brenz, Margarete Steiff GmbH

CAT. 329
Blanchet (manufacturer)
Teddy bear
France, 1988
Plush; plastic eyes; velvet nose; ribbon
37 × 24 × 13 cm
Paris, Musée des Arts Décoratifs, gift of Blanchet, 1994
Inv. 991.411

CAT. 330
Les Petites Maries (manufacturer)
Martin
France (Châteauroux), 2000s (design), 2024 (manufacture)
Polyester synthetic fur
34 × 29 × 27 cm
Paris, Les Arts Décoratifs
PR 2024.150.1

CAT. 331
Les Petites Maries (manufacturer)
Toinou
France (Châteauroux), 2000s (design), 2024 (manufacture)
Polyester synthetic fur
38 × 32 × 8 cm
Paris, Les Arts Décoratifs
PR 2024.150.2

CAT. 332
Pamplemousse Peluches (manufacturer)
Robert
France (Cerizy), 2017 (design), June 2024 (manufacture)
Synthetic fur; Liberty fabric; stitched eyes and nose
approx. 34 × 29 × 28 cm
Paris, Les Arts Décoratifs
PR 2024.104.2

CAT. 333
Pamplemousse Peluches (manufacturer)
Paul Émile
France (Cerizy), 2020 (design), June 2024 (manufacture)
Synthetic fur; fabric appliqué nose; stitched eyes
approx. 35 × 29 × 30 cm
Paris, Les Arts Décoratifs
PR 2024.104.1

CAT. 334
Adada (manufacturer)
Jermaine the Bear Cub
France, 2020 (design), 2021 (manufacture)
Organic cotton (80%) and polyester (20%) fabric; fabric woven and dyed in France, face and paws stitched by hand; polyester stuffing
42 × 20 × 12 cm
Paris, Les Arts Décoratifs
PR 2024.71.1

CAT. 335
Alexia Naumovic (designer and manufacturer)
Bob bear
France (Orgeval), 2016 (design and manufacture)
Beige polyester microfiber fabric; machine stitching, stuffed with polyester wadding
24 × 18 × 20 cm
Paris, Les Arts Décoratifs
PR 2024.127.8

CAT. 336
Big Stuffed (manufacturer)
Bear prototype
France (Paris), 2024
Textile
Paris, Big Stuffed

CAT. 337
L'Île à Mousse
Little Benoît and its assembly kit
France (Cornac), 2024
Paper pattern; glass eyes; joint systems; pearl cotton to stitch the nose; mohair fabric offcut; foam for stuffing
19 cm (bear)
Paris, Les Arts Décoratifs
PR 2024.151.1

CAT. 338
Briac Ragot (video director), Michael Nyman (music)
Stuffed Animal Production Process at Pamplemousse Peluches
Video
1 min. 59 sec.
Cerizy, Pamplemousse Peluches

ASSORTMENT OF DOUDOUS BELONGING TO MAD STAFF

CAT. 339
Ajénor, 1988, Paris, Anne Monier Vanryb, curator of the toy collection
Fabien, c. 1980, Paris, Charlotte Paris, lecturer
Birthday Bear, 1983, Rosny-sous-Bois, Nicolas Polowski, manager of the international development and production department
Grocopain, 1983, Nantes, Mathieu Rousset-Perrier, curator of the medieval, Renaissance, and jewelry collections
Jaunet, 1966, Stéphane Le Masle, deputy department manager, Ateliers du Carrousel
Jaurès, 1971, Paris, Ariane James-Sarazin, curator of the 17th and 18th century collections
Joseph, 1979, Paris, Marie-Pierre Ribère, assistant curator of the fashion and textile collection from 1800 to the present day
Bear, 1963, Laurence Bartoletti, documentary researcher for the 20th and 21st-century jewelry collections
White bear, c. 1988 or 1990, Lucy Winklemann, lecturer
Teddy bear, 2000s, Lucas Brianceau, front desk staff
Paddington, c. 1980, Paris, Sophie Motsch, assistant curator in the department of 17th and 18th centuries
Sephora, late 1990s to early 2000s, Cahors, Sarah Ben Hamida, project manager of the collections department
Winnie the Pooh, 2000s, Montreuil, Loïs Ercolano, art handler
Zotty, 1985, Le Mans, Hélène Renaudin, assistant curator of the fashion and textile collection pre 1800

CAT. 340
Sylvain Reymondon (graphic designer)
Collecting photographs of bears from visitors to the Musée des Arts Décoratifs
2024
Vidéo
Paris, Musée des Arts décoratifs

CAT. 341
Philippe Labourel
Nounours des Gobelins (The Teddy Bears of Les Gobelins)
France (Paris), 2018 (design)
Textile
140 cm
Paris
REPR. P. 108 TOP

CAT. 342
Charlemagne Palestine
Boudoir Peluchoir
France (Paris), 2024
Stuffed animals; textile; sound installation
Brussels, Charlemagne Palestine

TEDDY BEARS TODAY: CHILDHOOD AND NOSTALGIA

BEARS FOR COLLECTORS

CAT. 343
Stella Bolland (designer)
Rory
UK, 1993
Mohair plush; hard stuffing; glass eyes; stitched nose; suede paw pads
42 × 25 × 16 cm
Paris, Musée des Arts Décoratifs, gift of Jean-Louis Burckhardt, 1994
Inv. 993.147
REPR. P. 109

CAT. 344
Hermann Teddy (manufacturer)
Nostalgia Bear
Germany, 1993
Flat mohair plush; hard stuffing; stitched nose and claws; fabric ribbon
48 × 26 cm × 18.5 cm
Paris, Musée des Arts Décoratifs, gift of Hermann Teddy Original, 1994
Inv. 993.149.3

CAT. 345
Hermann Teddy (manufacturer)
Nostalgic Bear
Germany, 2023
Exterior in beige/gold bouclé mohair; imitation suede paws; nose stitched with brown thread; black plastic eyes; brown grosgrain ribbon tied with a wooden heart-shaped button; stuffing of wood and wool
31.5 × 18.5 × 12 cm
Paris, Les Arts Décoratifs
PR 2024.78.3

CAT. 346
Hermann Teddy (manufacturer)
Hanna
Germany, spring 2023
Exterior in brown bouclé mohair; imitation suede paws; nose stitched with black thread; black plastic eyes; dress of mint-colored fabric with a floral pattern and a white collar with openwork embroidery and a gray-blue velvet bow; arms and legs stuffed with wood and wool and head and body stuffed with synthetic fibers
19.5 × 12.5 × 7 cm
Paris, Les Arts Décoratifs
PR 2024.78.1

CAT. 347
Dean's Rag Book Bear (manufacturer)
Teddy
UK, 1992
Mohair plush; plastic eyes; fabric bow; stitched muzzle
37 × 18 × 13 cm
Paris, Musée des Arts Décoratifs, purchase, 1994
Inv. 993.28.4

CAT. 348
Clemens (manufacturer)
White bear
Germany, 1992
Mohair plush; glass eyes; nose stitched with wool; felt paw pads
25 × 17 × 11 cm
Paris, Musée des Arts Décoratifs, purchase, 1994
Inv. 993.113.3

CAT. 349
Canterbury Bears (manufacturer)
Grégory bear
UK, 1988
Mohair plush; glass eyes; stitched nose; imitation suede paw pads
43 × 24 × 17.5 cm
Paris, Musée des Arts Décoratifs, purchase, 1988
Inv. 988.901

CAT. 350
Ty (manufacturer)
Halo the Angel Bear
United States (design), China (manufacture), 1998
Stuffed synthetic textiles
22 × 22 × 7 cm
Paris, Vanryb Collection

CAT. 351
Steiff (manufacturer)
Teddybär Flower
Germany (Giengen an der Brenz), 2004
Mohair
33 × 24 × 14 cm
Giengen an der Brenz, Margarete Steiff GmbH

CAT. 352
Steiff (manufacturer)
Alfonso
Germany (Giengen an der Brenz), 1908, new version of 1992
Mohair; fabric clothes
33 × 20 × 12 cm
Paris, Musée des Arts Décoratifs, purchase, 1994
Inv. 993.146.4

Brands

CAT. 353
Chipie (manufacturer)
Teddy bear
France (Carcassonne), 1967
Stuffed cotton
43 × 47 cm
Paris, Musée des Arts Décoratifs
Inv. RI 2019.9.2

CAT. 354
Lulu Castagnette
Teddy bear
France (design), China (manufacture), 2000
Stuffed textiles; knit cotton sweater
18 × 18 × 11 cm
Paris, Vanryb Collection

CAT. 355
Moschino (manufacturer), Jérémy Scott (designer), Alexandra Kosinski (perfumer)
Moschino Toy
Milan, 2014
Plastic; paper
50 ml
Milan, Moschino

CAT. 356
Louis Vuitton
Louis Doudou in canvas with monogram pattern
France, 2023
Polyamide; cotton; polyester; acrylic; polyurethane; VVN leather
32 × 21 × 11 cm
Paris, Louis Vuitton Collection
Inv. 2023.008.002570

CAT. 357
Hermès
Herpluch Bear
France
Wool
27.5 × 23 × 9 cm
Paris, Conservatoire des Créations Hermès
Inv. MJE-0181

AN AMUSING GOOD LUCK CHARM

CAT. 358
Philippe Starck (designer), Moulin Roty (manufacturer)
Teddy Bear Band
France, 1996
Cotton; plastic
30 × 32 × 30 cm
Paris, Musée des Arts Décoratifs, gift of Philippe Starck, 2018
Inv. 2018.99.5
REPR. P. 112

CAT. 359
Jean-Charles de Castelbajac
Angel bear
France, 1993
Plush; fabric wings; glass eyes
37 × 27 × 14.5 cm
Paris, Musée des Arts Décoratifs, gift of Jean-Charles de Castelbajac, 1994
Inv. 994.127.2.A

CAT. 360
Steiff (manufacturer)
Bear in kimono
Germany (Giengen an der Brenz), c. 2012
Mohair
28 × 22 × 12 cm
Giengen an der Brenz, Margarete Steiff GmbH

CAT. 361
The Divine Charlotte in a Dior Dress
2010s
Textile
38 × 22 cm
New York, @thedivinecharlotte, Andrew Martin Weber and Beejan Land Collection
REPR. P. 94

CAT. 362
Jean-Charles de Castelbajac
Nounours coat
France (Paris), 1988
Plush bear; synthetic fur; synthetic fibers
100 × 80 cm
Paris, Musée des Arts Décoratifs
PR 996.29.1
REPR. P. 96

CAT. 363
Moschino
Black Teddy Bear Coat and Belt, fall-winter collection 1988–1989
Italy (Milan), 1988
Wool; metal; plush bear
100 × 44 cm; circumference 124 cm
Milan, Moschino
REPR. P. 97

CAT. 364
Marc Jacobs for Louis Vuitton
Look 11 Spring-Summer 2005
France, 2005
Cashmere (coat); cotton (shirt and pants); velvet, leather, and cotton (stuffed animal); cotton and leather (shoes)
Paris, Louis Vuitton Collection
Inv. 2005.004.002370, 2005.004.002371, 2005.004.002372, 2005.004.002373, 2005.004.02374

CAT. 365
AP Collection
Chubby Baloo armchair
Belgium, 2023
Plush bear with synthetic textiles; metal
100 × 100 × 106 cm
Strepy-Bracquegnies, AP Collection

CAT. 366
Vivienne Westwood
Teddy jewelry
UK, late 20th–early 21st century
Metal
Anonymous collector

CAT. 367
Lisa Walker
Necklace
2009
Plush
50 cm
Paris, Musée des Arts Décoratifs, gift of Caroline Van Hoek, 2012
Inv. 2012.59.1

THE FASHION SHOW

CAT. 368
Paco Rabanne
Teddy bear
France, c. 1990
Synthetic fur; mother-of-pearl; metal
15.1 × 10 × 6.5 cm
Paris, Musée des Arts Décoratifs, former Loïc Allio Collection, purchased with the support of the French Ministry of Culture heritage fund and thanks to the patronage of Hermès Sellier, Solanet et Fibelage, and Ancelle et Associés, 2012
Inv. 2012.48.3087
REPR. P. 92

CAT. 369
Patrick Lavoix for Christian Dior Homme
Teddy bear
France, 1994
Textile covering of velvet-style fabric and synthetic fibers; stitched nose; plastic eyes; checkered cotton canvas shirt; silk canvas vest and tie with square pattern in a print ranging from light to dark; pants and jacket of fine wool canvas in a houndstooth pattern; tie pin of metal and glass (?)
48 × 29 cm
Paris, Musée des Arts Décoratifs, gift of Christian Dior, 1996
Inv. 996.44.1
REPR. P. 84

CAT. 370
Ralph Lauren (designer), Steiff (manufacturer)
Chairman Bear II
Germany (Giengen an der Brenz), 1994
Textile covering, velvet-style fabric; fur of animal fibers (wool); paw pads of thin felt; stitched details; plastic (?) eyes; shirt of striped cotton canvas; tie of silk serge; jacket and pants of wool in houndstooth pattern with synthetic lining
42.5 × 30 × 17 cm
Paris, Musée des Arts Décoratifs, gift of Ralph Lauren, 1996
Inv. 996.46.1
REPR. P. 86

CAT. 371
Ralph Lauren (designer), Steiff (manufacturer)
Chairman Bear II, Son
Germany (Giengen an der Brenz), 1994
Textile covering, velvet-style fabric; fur of animal fibers (wool); paw pads of thin felt; stitched details; plastic (?) eyes; clothing of denim (cotton serge), cotton knit sweater
34 × 25 × 13 cm
Paris, Musée des Arts Décoratifs, gift of Ralph Lauren, 1996
Inv. 996.46.2
REPR. P. 87

CAT. 372
Naf Naf
Teddy bear
France, 1994
Velvet
35 × 23 cm
Paris, Musée des Arts Décoratifs, gift of Naf Naf, 1996
Inv. 996.55.1

CAT. 373
Sonia Rykiel
Teddy bear
Paris, 1994
Textile covering, velvet-style fabric; synthetic fibers (probably polyester); plastic eyes and nose; shorts of synthetic satin; sweater, gloves, and socks of acrylic and wool knit; boa and flowers styled as an aigrette
50 × 37 cm
Paris, Musée des Arts Décoratifs, gift of Sonia Rykiel, 1996
Inv. 996.62.2
REPR. P. 88

CAT. 374
Sonia Rykiel
Teddy bear
Paris, 1994
Textile covering, velvet-style fabric; synthetic fibers (probably polyester); plastic eyes and nose; cotton (?) shirt; woolen twill (?) suit
47 × 25 cm
Paris, Musée des Arts Décoratifs, gift of Sonia Rykiel, 1996
Inv. 996.62.1
REPR. P. 89

CAT. 375
Cacharel
Teddy bear
Nîmes, 1994
Textile covering, velvet-style fabric; synthetic fibers (probably polyester); cotton clothing
36 × 28 × 13 cm
Paris, Musée des Arts Décoratifs, gift of Cacharel, 1996
Inv. 996.61.2
REPR. P. 90

CAT. 376
Chevignon Kids
Teddy bear
France, 1994
Felted duffel; jacket of polyester, wool, polyamide, leather, lining of acetate and viscose; cotton and polyester pants
50.5 × 33.5 × 15 cm
Paris, Musée des Arts Décoratifs, gift of Chevignon Kids, 1996
Inv. 996.57.1

CAT. 377
Catimini
Bear
France, 1994
Burlap; child's dress
approx. 51 × 46 cm
Paris, Musée des Arts Décoratifs, gift of Catimini, 1996
Inv. 996.54.1

CAT. 378
Hermès (designer), Steiff (manufacturer)
Steiff teddy bear dressed by Hermès
France and Germany, 1992
Sound box; cashmere sweater; wool pants; silk shirt
34 × 27 × 13 cm
Paris, Conservatoire des Créations Hermès
REPR. P. 93

CAT. 379
Steiff (manufacturer)
Karl Lagerfeld teddy bear
Germany (Giengen an der Brenz), 2009
Alpaca
40 × 16 × 11 cm
Giengen an der Brenz, Margarete Steiff GmbH
REPR. P. 95

CAT. 380
Koché
Teddy bear
France, 2024
Textiles
Paris, Les Arts Décoratifs
PR 2024.155.1

CAT. 381
Marine Serre
Teddy bear
France, 2024
Textiles
Paris, Marine Serre

CAT. 382
A-Poc Able Issey Miyake (designer), Issey Miyake Inc. (manufacturer)
Teddy bear
Japan, 2024
Brewed Protein fabric (obtained from fermented plants); polyester; polyurethane
Paris, Les Arts Décoratifs
PR 2024.152.1

CAT. 383
Adrian Appiolaza for Moschino
Teddy bear
Italy, 2024
Textiles
Paris, Les Arts Décoratifs
PR 2024.154.1

CAT. 384
Steiff (manufacturer)
Ours en peluche Jean Paul Gaultier, l'Ours terrible de la mode (Jean Paul Gaultier Teddy Bear, Fashion's Terrible Bear)
Germany (Giengen an der Brenz), 2005
Mohair
35 × 23 × 13 cm
Giengen an der Brenz, Margarete Steiff GmbH
REPR. P. 91

ADULTS AND DOUDOUS

CAT. 385
Line Friends
Heating pad
Korea (design), China (manufacture), 2010s
7 × 9 cm
Paris, Vanryb Collection

CAT. 386
Line Friends
Mask
Korea (design), China (manufacture), 2010s
approx. length 19 cm
Paris, Vanryb Collection

CAT. 387
Hermès
Arche de Noé ours coin purse
2004
Barenia calfskin; Swift calfskin
9 × 9 × 1 cm
Paris, Conservatoire des Créations Hermès
Inv. CPM-0480

CAT. 388
Hermès
Tie *5297 T*
2007
Silk twill
75 × 9.3 × 0.3 cm
Paris, Conservatoire des Créations Hermès
Inv. TSO-4325

CAT. 389
Hermès
Nounours pendant
1998
Gold; silver; ruby
25 × 2 × 0.3 cm
Paris, Conservatoire des Créations Hermès
Inv. BCO-0553

CAT. 390
San-X (manufacturer)
Rilakkuma makeup bag
Japan (design), 2020s
Synthetic textiles
13 × 23 × 13 cm
Paris, Vanryb Collection

CAT. 391
Build-A-Bear (manufacturer)
Maggie
United States (design), Vietnam and China (manufacture), 2024
Plush; plastic; textile
43.5 × 32 × 21 cm
Paris, Les Arts Décoratifs
PR 2024.148.1
REPR. P. 111

CAT. 392
Sigikid (manufacturer)
The Philosophical Bear
Germany (design), 1998
Textile
30 × 33 × 33 cm
Paris, Musée des Arts Décoratifs, gift of Susana Restier Poças, 2021
Inv. 2021.162.1.1-4

CAT. 393
AP Collection
Gilbert
Belgium, 2023
Synthetic textiles
28 x 22 × 18 cm
Paris, Les Arts Décoratifs
PR 2024.153.1

CAT. 394
Ours pour la Saint-Valentin (Valentine's Day Bear)
China (manufacture), 2020s
Textile; synthetic materials
20 × 22 × 17 cm
Paris, Les Arts Décoratifs
PR 2024.149.1
REPR. P. 110

CAT. 395
Steiff (manufacturer)
Steiff Rocks! The Rolling Stones
Germany (Giengen an der Brenz), 2023
Mohair
35 × 22 × 12 cm
Giengen an der Brenz, Margarete Steiff GmbH

CAT. 396
Granada Television (producer), ITV (broadcaster), Charles Sturridge and Michael Lindsay-Hogg (directors), Derek Granger (screenwriter)
Clip of the series *Brideshead Revisited*, episode 1, "Et in Arcadia ego"
UK, 1981
1 min. 37 sec.
REPR. P. 107 BOTTOM

CAT. 397
Institut National de l'Audiovisuel, Antenne 2 (producer)
Nightly News: "Teddy Bears"
France, December 25, 1982
2 min. 54 sec.
Paris, Institut National de l'Audiovisuel
Inv. 25.12.1977

CAT. 398
Movie poster for *Ted*
2012
Paper
43 × 27.9 cm
Paris, Bibliothèque du Musée des Arts Décoratifs, documentation department
REPR. P. 108 BOTTOM

CAT. 399
Jonathan Stedall
John Betjeman, Archibald Ormsy-Gore, and Jumbo sur le tournage de *Summoned by Bells*
UK, 1976
Reproduction
REPR. P. 107 TOP

CAT. 400
Poster for the exhibition "Archie and the Poet"
Tom Brown's School Museum, Uffington, 2023
Paper
Paris, Bibliothèque du Musée des Arts Décoratifs, documentation department

CAT. 401
Anonymous
Teddy bear made by soldiers in the trenches during the World War I
1914–1918
Carded canvas with cellulose fibers; metal joints; stitched nose and mouth (cotton thread); paint on the joints and around the nose; glass eyes; stuffed with straw-like plant fibers
10.5 × 4.5 × 3.5 cm
Paris, Vanryb Collection
REPR. P. 106

CAT. 402
Unagi Travel
"We found autumn in the Kikngetsutei Teahouse", group of stuffed animals on a tour organized by Unagi Travel, at the Ritsurin Garden in Kagawa Prefecture
Japon (Takamatsu, Kagawa), 2023
Reproduction

CAT. 403
Unagi Travel
"Welcome!", group of stuffed animals on a tour organized by Unagi Travel, in front of Ryokan Sawanoya in Shibuya
Japon (Yanaka, Tokyo), 2024
Reproduction

CAT. 404
Loïc Dubigeon (designer), Hermès (designer)
Confident des Cœurs scarf
France, 2000
Silk twill
90 × 90 cm
Paris, Conservatoire des Créations Hermès
Inv. SSO-4130

CAT. 405
Lintas Paris (agency), Paul Berville (director), 1/33 Productions (producer)
[Cajoline] *The Song*
1981
Video
20 sec.
Paris, Musée des Arts Décoratifs, 2010
Inv. 981 F 796.21

CAT. 406
Lintas Paris (agency), Hubert Lauth and Bernard Guillon (authors), Jean-David Lefebvre (director), Gilbert Einaudi (composer), Melody Movies (production), Graffiti (editing/musical production)
[Cajoline] *The Bathroom*
1984
Video
30 sec.
Paris, Musée des Arts Décoratifs, 2010
Inv. 984 F 170a.31

CAT. 407
Lintas Paris (agency), Gary Young (director), AAA (production), Graffiti (editing/musical production)
[Cajoline] *Laundry Basket*
France (adaptation of a foreign film), 1985
Video
30 sec.
Paris, Musée des Arts Décoratifs, 2010
Inv. 985 F 192a.43

CAT. 408
Enjoy (agency), Christophe Caudel (director), Première Heure (production)
[Jemini / Grumly] *Green Light*
2002
Video
10 sec.
Paris, Musée des Arts Décoratifs, gift of Club des Directeurs Artistiques, 2017
Inv. RI 2017.5.155

CAT. 409
Enjoy (agency), Christophe Caudel (director), Première Heure (production)
[Jemini / Grumly] *Machine*
2002
Video
10 sec.
Paris, Musée des Arts Décoratifs, gift of Club des Directeurs Artistiques, 2017
Inv. RI 2017.5.156

CAT. 410
Enjoy (agency), Christophe Caudel (director), Première Heure (production)
[Jemini / Grumly] *Telephone*
2002
Video
10 sec.
Paris, Musée des Arts Décoratifs, gift of Club des Directeurs Artistiques, 2017
Inv. RI 2017.5.158

CAT. 411
Enjoy (agency), Christophe Caudel (director), Première Heure (production)
[Jemini / Grumly] *Banana*
2002
Video
10 sec.
Paris, Musée des Arts Décoratifs, gift of Club des Directeurs Artistiques, 2017
Inv. RI 2017.5.160

CAT. 412
Enjoy (agency), Christophe Caudel (director), Première Heure (production)
[Jemini / Grumly] *Dutch*
2002
Video
10 sec.
Paris, Musée des Arts Décoratifs, gift of Club des Directeurs Artistiques, 2017
Inv. RI 2017.5.162

CAT. 413
Enjoy (agency), Christophe Caudel (director), Première Heure (production)
[Jemini / Grumly] *Massacre*
2002
Video
10 sec.
Paris, Musée des Arts Décoratifs, gift of Club des Directeurs Artistiques, 2017
Inv. RI 2017.5.163

CAT. 414
Enjoy (agency), Christophe Caudel (director), Première Heure (production)
[Jemini / Grumly] *Peach*
2002
Video
10 sec.
Paris, Musée des Arts Décoratifs, gift of Club des Directeurs Artistiques, 2017
Inv. RI 2017.5.165

CAT. 415
Enjoy (agency), Christophe Caudel (director), Première Heure (production)
[Jemini / Grumly] *Goat*
2002
Video
10 sec.
Paris, Musée des Arts Décoratifs, gift of Club des Directeurs Artistiques, 2017
Inv. RI 2017.5.166

CAT. 416
Enjoy (agency), Christophe Caudel (director), Première Heure (production)
[Jemini / Grumly] *olé*
2002
Video
10 sec.
Paris, Musée des Arts Décoratifs, gift of Club des Directeurs Artistiques, 2017
Inv. RI 2017.5.167

THE BEAR TOMORROW

CAT. 417
Musée d'Orsay (designer)
Ours Blanc Pompon stuffed animal
France (design), China (manufacture), 2020s
Polyester
11 × 23 cm
Paris, Vanryb Collection

CAT. 418
Nounours
Stuffed panda
France, 1980s or 1990s
Synthetic textiles
36 × 25 × 35 cm
Paris, Musée des Arts Décoratifs, gift of Ajena, 1994
Inv. 991.403

CAT. 419
Steiff (manufacturer)
Knut l'Ourson (Knut the polar bear)
Germany (Giengen an der Brenz), 2007
Synthetic textiles
14.5 × 23 × 16 cm
Paris, Vanryb Collection
REPR. P. 115

CAT. 420
"Be Worried, Be Very Worried," *Time*, vol. CLXVII, no. 14
April 3, 2006
Magazine
26.8 × 20 × 0.2 cm
Paris, Bibliothèque du Musée des Arts Décoratifs, documentation department

CAT. 421
Pôles Actions
The Polar Bears, from the Ice Floes to the Headlines
France, 2012
Reproduction
Catherine and Rémy Marion, Pôles Actions Association

CAT. 422
Science & Univers
Réchauffement climatique, no. 31, February 2019
Paris, Bibliothèque du Musée des Arts Décoratifs, documentation department

CAT. 423
L214
Poster for COP21
France, 2015
Reproduction

CAT. 424
Paulo Grangeon (sculptor), WWF (organizer)
"1600 Pandas" action in Hong Kong
Hong Kong, 2014
Reproduction

CAT. 425
Esa Ojala, Konsta Ojala
It's Gettin Hot in Herre. Global Temperature Will Rise 14-58°C During the Next 100 years
Finland, 2005
Paper (offset color printing)
100.2 × 70 cm
Paris, Musée des Arts Décoratifs, gift of Esa and Konsta Ojala, 2014
Inv. 2014.180.1

BIBLIOGRAPHY

Philippe Ariès, *L'Enfant et la Vie familiale sous l'Ancien Régime*, Paris, Seuil, 1975.

Annemarie Bilclough and Emma Laws, *Winnie-the-Pooh: Exploring a Classic: The World of A. A. Milne and E. H. Shepard*, London, exh. cat. (London, Victoria and Albert Museum, 9 Dec. 2017–8 Apr. 2018), London, V&A Publishing, 2018.

Sophie Bobbé and Jean-Pierre Raffin, *L'Abécédaire de l'ours*, Paris, Flammarion, 1997.

Sophie Bobbé, *L'Ours et le Loup. Essai d'anthropologie symbolique*, Paris, Éditions de la Maison des sciences de l'homme, 2002.

Jürgen and Marianne Cieslik, *Button in Ear: The History of the Teddy Bear and his friends*, Juliers, Marianne Cieslik Verlag, 1989.

Jean Clottes (ed.), *La Grotte Chauvet. L'art des origines*, Paris, Seuil, 2001.

Pauline Cockrill, *The Teddy Bear Encyclopedia*, London, Dorling Kindersley, 1993.

Becchi Egle and Dominique Julia (dir.), *Histoire de l'enfance en Occident*, t. I, *De l'Antiquité au XVIIe siècle*; t. II, *Du XVIIIe siècle à nos jours*, Paris, Seuil, 1998.

Corinne Maillet, *Le Marketing adulescent. Comment les marques s'adressent à l'enfant qui sommeille en nous*, Paris, Pearson Education France, 2005.

Leyla Maniera, *Christie's Century of Teddy Bears*, London-New York, Pavilion – Watson-Guptill Publications, 2001.

Roger Maud'huy, *Mythes et légendes de l'ours*, Ciboure, Pimientos, 2012.

Owen T. Nevin, Ian Convery, and Peter Davis (eds), *The Bear: Culture, Nature, Heritage*, Martlesham, Boydell & Brewer, 2019.

Michel Pastoureau, *L'Ours. Histoire d'un roi déchu*, Paris, Seuil, "La Librairie du XXIe siècle", 2007.

Francis Petter (dir.), *D'ours en ours*, exh. cat. (Paris, Muséum National d'Histoire Naturelle – Jardin des Plantes, July 1988–Aug. 1989), Paris, Muséum National d'Histoire Naturelle, 1988.

Anne-Sophie Tribot, Nathalie Blanc, Thierry Brassac, François Guilhaumon, Nicolas Casajus, and Nicolas Mouquet, "What Makes a Teddy Bear Comforting? A participatory study reveals the prevalence of sensory characteristics and emotional bonds in the perception of comforting teddy bears", *Journal of Positive Psychology*, vol. XIX, no. 2, pp. 379–392.

Philippe Walter, *Arthur, l'ours et le roi*, Paris, Imago, 2002.

Donald Woods Winnicott, *Playing and Reality*, London, Tavistock, 1971; *Jeu et réalité. L'espace potentiel*, translated by Claude Monod and Jean-Bertrand Pontalis, Paris, Gallimard, "Connaissance de l'inconscient", 1975.

This book was published on the occasion of the exhibition "My Teddy Bear", presented at the Musée des Arts Décoratifs, Paris, from December 4, 2024 to June 22, 2025.

Exhibition concept by Les Arts Décoratifs, Paris

The exhibition was made possible thanks to the International Council, and to Andrew J. Martin-Weber and Beejan Land on behalf of The Divine Charlotte. Special thanks to Margarete Steiff GmbH for their support and exhibit pieces.

LES ARTS DÉCORATIFS

President
Johannes Huth

Chief Executive Officer
Sylvie Corréard

Interim Museum Director
Bénédicte Gady

Director of International Development and Production
Yvon Figueras

Head of Communication
Olivier Hassler

Director of Development
Nathalie Coulon

EXHIBITION

Curatorial team

Anne Monier Vanryb
Curator, Musée des Arts Décoratifs, Collection of Toys

In collaboration with
Marie-Lou Canovas,
Assistant Curator at the Musée des Arts Décoratifs, Collection of Toys

Production

Head of Production
Stéphane Perl

Project Manager
Amélie Bouxin
Inès Lafon

Interns
Isis Braud
Siona Goudjil

Scenography
Marion Golmard

Signage
Sylvain Reymondon —
Atelier bruits

CATALOG

Head of Publications and Images Department
Catherine Ojalvo

Editorial Coordination and Iconography
Pauline Bessin
and Catherine Ojalvo

Shooting and Digitization Coordination
Amélie Segonds

Translation from French
Kate Deimling

Copy Editing
Penelope Iremonger

Graphic Design
Lisa Sturacci

ACKNOWLEDGEMENTS

We would like to thank Frank Rheinboldt, Manuela Fustig, Ralf Fahrig, and Ian Munro at Steiff, who graciously opened their archives and production sites to us.

We would like to thank the generous donors of this exhibition:

Cerizy, Pamplemousse Peluches, Hélène Montgomery

Champigny-sur-Marne, La Boutique officielle des sapeurs-pompiers de France, Marie Spratley

Chaumont, Danièle Bour

Châteauroux, Les Petites Maries, Bastien Bonnefoy, Hortense Lebkowski

Cornac, L'île à Mousse, Sandra Maréchal

Dijon, Lions Club, Jean-François Gondellier

Groslay, Frenchflair, Nathalie Aiach

Hamburg, Martin Kittsteiner

Hirschaid, Hermann Teddy, Ulrike Gerbig

Ivry-sur-Seine, Pharmavie, Marie-Claude Santini and Alix Achard

Milan, Moschino, Adrian Appiolaza, Andrea Caravita

Orgeval, Alexia Naumovic

Paris, Adada, Véronique Lacaze

Paris, Koché: Christelle Kocher, Julien Lacroix

Paris, Issey Miyake, Marie Chalmel-Régnier, Michi Yamaguchi

Paris, La Pelucherie, Natacha Benarous, Alexandra Rapaport-Zambrowski

Sonneberg, Renate and Friedemann Müller

Strépy-Bracquegnies, AP Collection, Alexis and Pauline Verstatten

Talloires, Aurora World, Muriel Rossi

Uffington, Uffington Museum, Gary Gibbons

We are extremely grateful to the following institutions, artists, and collectors whose generous loans have made this exhibition possible:

Bordeaux, Julien Béziat

Bruxelles, Xavier Hufkens, Julie Hottner

Bruxelles, Charlemagne Palestine, Lionel Hubert, Aude Stoclet

Charleroi, Fondation Monique Martin, Émeline Attout

Crépy-en-Valois, Musée de l'Archerie et du Valois, Virginie Douat, Manuela Dominguez

Giengen an der Brenz, Margarete Steiff GmbH, Manuela Fustig

Guildford, University of Surrey, Helen Roberts

Lasnes, Marie Wabbes

London, Victoria and Albert Museum, Tristram Hunt, Annemarie Bilclough, William Newton, Liz Wilkinson

Meuzac, Maison du Père Castor, Roxane Sterckeman, Anaïs Charles

Paris, Bibliothèque Mazarine, Yann Sordet, Marianne Besseyre, Agnès Rico

Paris, Bibliothèque Nationale de France, Gilles Pécout, Laurence Engel (Department of Manuscripts), Sabine Maffre (Department of Maps and Plans), Julie Garel-Grislin

Paris, Big Stuffed, Dana Muskat

Paris, Collection Myriam et Jacques Salomon

Paris, Nadja Fejto

Paris, Marian Goodman, Laura Turcan, Carole Billy

Paris, Hermès, Marie-Amélie Tharaud, Anne Rossignol

Paris, Satomi Ichikawa

Paris, Médiathèque Françoise Sagan, Maria Robert, Hélène Valloteau

Paris, Musée de l'Assistance Publique – Hôpitaux de Paris, Agnès Virole, Alexane Pasquier

Paris, musée Carnavalet – Histoire de Paris, Valérie Fours, Charlotte Lacour, Alexandra Mauduit

Paris, Musée de la Chasse et de la Nature, Gaëlle Le Page, Rémy Provendier

Paris, Musée du Louvre, Laurence des Cars; Department of Oriental Antiquities: Ariane Thomas, Jorge Vasquez

Paris, Les Nounours des Gobelins, Philippe Labourel

Paris, Galerie Nathalie Obadia, Maïmiti Cazalis, Eva Ben Dhiab

Paris, Marine Serre, Jessica Boukris

Paris, Grégoire Solotareff

Paris, Galerie Sultana, Guillaume Sultana, Antoine Cantiny, Valentina Rosace

Paris, Talabardon et Gautier, Bertrand Gautier, Marie-Élise Dupuis

Paris, Louis Vuitton, Aurélie Samuel, Coline Manesse, Bleue-Marine Massard

Rouen, Charles Fréger

Strasbourg, musée Tomi-Ungerer, Centre international de l'illustration, Anna Sailer, Thomas Deetjen

Toulouse, Museum d'Histoire Naturelle, Francis Duranthon, Guillaume Fleury, Alexandre Mille

Zürich, NordSüd Verlag, Herwig Bitsche, Nina Grünberger, Hanna Lang, Janine Moor

And the people working at Les Arts Décoratifs who have loaned their teddy bears: Sarah Ben Hamida, Lucas Brianceau, Loïs Ercolano, Ariane James-Sarazin, Stéphane Le Masle, Sophie Motsch, Charlotte Paris, Nicolas Polowski, Hélène Renaudin, Marie-Pierre Ribère, and Lucy Winkelmann

As well as those who prefer to remain anonymous.

Anne Monier-Vanryb warmly thanks Marie Mila for her precious editing, Aurore Bayle-Loudet, Pauline Maurus, and Ludovic Raffalli for their advice, Blanche de Lestrange and Cédric Fauq for their expertise in contemporary art Lucas Vanryb, Jeannine and Maurice Monier, Dominique Monier, and Dominique and Bernard Delfosse for their contributions to her collection of plush toys.

We are grateful to all those who, through their expert advice, documentation, and valuable support, have contributed to the preparation of the exhibition and its catalog: Geneviève Pinçon and Sophie Goedert from the Centre National de Préhistoire, Sanae Azuma, Julie Bonpas Bernet, Jean-Gérald Castex, Annica Ewing, Odile Josselin, Daniel Maghen, Catherine and Rémy Marion, Francesca Moroni, Christophe Myotte, Katarina Nimmervoll, Benoît Piéron, Élisabeth Regner, Diane Reverdy, Anne Simon.

At Les Arts Décoratifs we warmly thank

Christine Macel, Museum Director until October 2024;

Those who have knitted and crocheted the *Trauma Teddies*: Laurence Bartoletti, Catherine Didelot, Laure Godini, Rémi Gros, Cécile Huguet-Broquet, Sonia Kermiche, Sophie Lemahieu, Déborah Mattana, Alice Mimran-Didelot, Maïlys Pradier, Béatrice Quette, Karine Simon;

The Curatorial Department, in particular, Axelle Baroin, Bénédicte Gady, Amélie Gastaut, Pauline Juppin, Mathieu Rousset-Perrier;

The Library and Documentary Resources, in particular, Anne-Laure Charrier-Ranoux, Laure Haberschill, Véronique Sevestre, Barbara Topalov;

The Collection Department, in particular, Florence Bertin, Emmanuelle Garcin, Cécile Huguet-Broquet, Estelle Savoye, and the entire management service;

The Inventory Department, in particular, Marie Clergue, Louise Marx;

The Publications and Images Department, and Christophe Dellière;

The Education and Culture Department, in particular, Isabelle Grassart, Amandine Loayza-Desfontaines, Iman Hamdani, Marguerite Héliot;

The Development Department, in particular, Mélite de Foucaud, Diane Doré;

The Administrative and Financial Department, in particular, Viviane Besombes, Nour Mouhaidine;

The Communication Department, in particular, Guillaume Del Rio, Jade Deschamps, Laure Godini, Sarah Liebelin-Manfredi, Anne-Cécile Lourenço, Isabelle Mendoza, Louanne Nicolas;

The Building and Security Department, in particular, Pascale Guigou;

And, finally, in the Director's and President's Office, Sophie Malville, Xavier Montagnon, Liliia Polshcha.

PHOTO CREDITS

Archives Hermès © Hermès 2024 : p. 93.

Avaaz.org : p. 101 (bottom).

Courtesy Carole Benzaken et galerie Nathalie Obadia, Paris/Bruxelles. Photo Bertrand Huet / tutti image: p. 77 (bottom).

© Courtesy of the Berryman Family Papers, 1829-1984. Archives of American Art, Smithsonian Institution: pp. 27 (left), 28 (left).

© Les Arts Décoratifs, Paris: pp. 10, 15, 16 (bottom), 18, 20, 38, 39, 41 (left and top right), 42, 60 (top and bottom left), 65, 68, 70, 74–75, 78, 79, 80, 81, 108 (bas), 109; photos © Christophe Dellière: front cover, pp. 21, 29 (left), 34, 36, 40, 43, 44, 45, 46, 48, 49, 51, 53, 60 (bottom right), 62, 67, 72, 73, 76, 82, 83, 84, 86, 87, 88, 89, 90, 92, 105, 106, 110, 111, 115; photos © Jean Tholance: pp. 96, 98, 112.

Bibliothèque nationale de France, département Cartes et plans: p. 13.

Bibliothèque nationale de France, département Estampes et photographie: back cover (detail), pp. 11 (detail), 19.

Bibliothèque Mazarine, Paris: p. 14 (left)

Collection particulière, par courtoisie de la galerie Talabardon & Gautier, Paris / Art Digital Studio: p. 17.

Collection de la Maison du Père Castor, Meuzac; avec l'aimable autorisation des Éditions Flammarion: p. 58 (bottom).

Photographie © Alexandre Dolique: p. 108 (top).

Cliché V. Feruglio, crédit ministère de la Culture: p. 25.

Courtesy Ulala Imai and Xavier Hufkens, Brussels / photo-credit Thomas Merle: p. 100.

ITV/Shutterstock: p. 107 (bottom).

Courtesy of Mike Kelley Foundation for the Arts / photo Jennie Warren: p. 101 (right).

Margarete Steiff GmbH, Giengen/Brenz: pp. 26, 27 (right), 29 (right), 30, 31, 32, 37, 91, 95; photos © Justin Kocian | justimages.de: pp. 33, 50, 52, 69.

Médiathèque Simone Veil, Valenciennes: p. 16 (top).

Photo courtesy Annette Messager et Marian Goodman Gallery © Rebecca Fanuele: p. 71 ; © Atelier Annette Messager: p. 77 (top).

Photographie © Patrick Morio: p. 14 (right).

Courtesy Moschino: p. 97.

© Musée de l'Archerie et du Valois: pp. 11, 12.

© Musée de la Chasse et de la Nature, Paris / photo Béatrice Hatala © Adagp, Paris, 2024: p. 119.

Service de numérisation interne / Musées de la Ville de Strasbourg: p. 103.

MHNT.PRE.2012.0.400 © Guillaume Fleury, Muséum de Toulouse: p. 22.

Pamplemousse Peluches, photographie Philippe Barbosa | https://www.philippebarbosa.com/: p. 113.

PEANUTS © 1954 Peanuts Worldwide LLC. Dist. By ANDREWS MCMEEL SYNDICATION. Reprinted with permission. All rights reserved: pp. 63 (detail), 66.

Photogramme d'un documentaire de Jonathan Stedall/Jonathan Stedall Estate: p. 107 (top).

© Courtesy Benoît Piéron et Sultana, photo © Grégory Copitet: p. 64.

Secrétariat d'État en charge de l'enfance et des familles, DICOM des ministères sociaux / agence Madame Bovary: p. 102 (bottom).

Photographie Illias Terlinck: p. 102 (top).

© Theodore Roosevelt Digital Library. Dickinson State University: p. 28 (right).

U.S. Navy photo by Lt. Jim Hoeft: p. 101 (top left).

© Victoria and Albert Museum, London: pp. 35, 41 (bottom right), 56, 104.

@thedivinecharlotte, collection Andrew Martin Weber et Beejan Land, photo © Studio Harcourt: p. 94.

COPYRIGHTS

Carole Benzaken © Adagp, Paris, 2024: p. 77 (bottom).

© Julien Béziat (auteur illustrateur): p. 65.

Petit Ours Brun illustration originale Danièle Bour © Bayard p. 60 (top)

John Cuneo, *The New Yorker*, © Condé Nast: p. 114.

© Charles Fréger: pp. 116, 120, 121.

© Ulala Imai: p. 100.

© Mike Kelley Foundation for the Arts, © Adagp, Paris, 2024: p. 101 (right).

Mehryl Ferri Levisse © Adagp, Paris, 2024: p. 119.

Media Rights Capital/Universal Pictures: pp. 99 (detail), 108 (bottom).

Annette Messager © Adagp, Paris, 2024: pp. 71, 77 (top).

Kleiner Eisbär, wohin fährst du? written and illustrated by Hans de Beer © 1987 NordSüd Verlag AG, Zurich/Switzerland: p. 54.

© Charlemagne Palestine: p. 102 (top).

© Benoît Piéron: p. 64.

© Feodor Rojankovsky: p. 58 (bottom).

EGM/1/11 et EGM/1/74: hand-coloured illustration for Winnie-the-Pooh. From the Egmont UK Collection, University of Surrey. Line illustrations copyright © The Trustees of The Shepard Trust. Colouring of the line illustrations copyright © 1970 and 1973 The Trustees of The Shepard Trust and HarperCollins*Publishers* Limited. No re-use without permission: pp. 57 (top and bottom left).

EGM/2/30: hand-coloured illustration for *The House at Pooh Corner*. From the Egmont UK Collection, University of Surrey. Line illustrations copyright © The Trustees of The Shepard Trust. Colouring of the line illustrations copyright © 1970 and 1974 The Trustees of The Shepard Trust and HarperCollins*Publishers* Limited. No re-use without permission: p. 57 (bottom right).

Line illustrations copyright © The Trustees of The Shepard Trust: p. 56.

© 1999 Diogenes Verlag AG Zürich, Switzerland / Tomi Ungerer Estate. All rights reserved: p. 103.

© Gabrielle Vincent / Fondation Monique Martin: pp. 58–59 (top), 59 (bottom).

Despite our best efforts, we have been unable to identify the rights holders for certain works. Please accept our apologies and we would be grateful if you could contact us.

Photoengraving
Fotimprim, Paris

Paper
Munken Print White 115 g

Printed in November 2024 by Média Graphic, Rennes (France)

ISBN 978-2-38314-027-6

© Les Arts Décoratifs, 2024

Cover captions
Front: Steiff, *Teddy bear* (detail), c. 1910-1912 (CAT. 89)
Back: Frankl, *Trained Bear Riding a Bicycle* (detail), 1925 (CAT. 40)